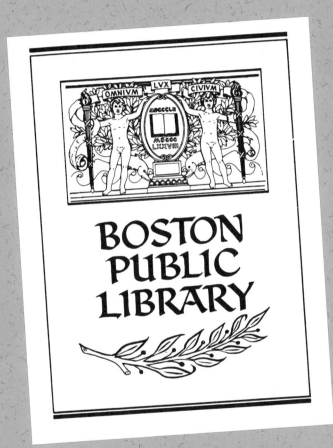

DOWN FROM THE PEDESTAL

Also by

Maxine Harris

Sisters of the Shadow

Women of the Asylum (with Jeffrey Geller)

MOVING

Beyond

Idealized

IMAGES oF

WOMANHOOD

MAXINE HARRIS

Down FROM
THE
PEDESTAL

DOUBLEDAY

NEW YORK LONDON

TORONTO SYDNEY

AUCKLAND

PUBLISHED BY DOUBLEDAY
a division of Bantam Doubleday Dell Publishing Group, Inc.
1540 Broadway, New York, NY 10036

DOUBLEDAY and the portrayal of an anchor with a dolphin are
trademarks of Doubleday, a division of Bantam Doubleday Dell
Publishing Group, Inc.

Library of Congress Cataloging-in-Publication data
Harris, Maxine.
 Down from the pedestal : moving beyond idealized images of
womanhood / Maxine Harris. — 1st ed. in the U.S.A.
 p. cm.
 Includes bibliographical references.
 1. Women—Psychology. 2. Femininity (Psychology) 3. Identity
(Psychology) I. Title.
HQ1206.H325 1994
155.3'33—dc20 93-1926
 CIP

ISBN: 0-385-46994-2

10 9 8 7 6 5 4 3 2 1

For my mother, Sara Harris,
whose loving example has guided me
in living my own life

CONTENTS

PART II

Preface

Early in 1990 while I was baby-sitting for my three-year-old niece, I absentmindedly began to file my nails. Curious to learn what this strange ritual was all about, she asked me what I was doing. I told her that I was filing my nails in order to give them a nice shape. In typical three-year-old fashion, she followed that up by asking me why I wanted nicely shaped nails. Figuring that I would satisfy her once and for all, I said, "So that I will be pretty." She then asked what was for me the unanswerable question, "Why do you want to be pretty?" Four months later, after she had gone swimming, I offered this same niece a T-shirt to wear over her sundress so that she would not be

chilly. She declined, and by way of explanation said, "Then I won't look beautiful." Somewhere in that four-month period, the image of the Pretty Little Girl had begun to shape her developing sense of self.

Nearly a year later, a friend called to ask my advice on the demise of his latest romance. The relationship had been progressing well and he was beginning to think that he had at last found someone with whom he could share his life when, seemingly with no provocation, the woman ended the relationship. She told my friend that he had no idea who she really was. She accused him of looking for a combination of Sex Goddess and Super Mom; she, however, was a real person who wanted to be heard and seen, not an image to be put on a pedestal. At first, my friend was baffled, then he began to consider that maybe he was trapped by these idealized images of womanhood. In his pursuit of what Sam Keen calls Woman, my friend was unable to approach real women.[1]

Almost fifty years ago, Simone de Beauvoir had warned us that the positive images which keep us securely perched on pedestals are far more difficult to ignore than the negative images which leave us feeling bad about ourselves.[2] When we identify with the images that are valued by our families, honored by our culture, and immortalized by our mythologies, we win love and approval for ourselves. In my clinical practice of psychotherapy, women who wanted to descend the pedestal talked with me about how they felt adored but invisible behind the masks of the Eternal Girl or the Faithful Wife. Who they were as individuals was obscured by the images which dictated how they should behave and what they should want.

From the time a girl first sits on her parent's lap and listens to a fairy tale, she becomes both fascinated and haunted by those images which show girls how to be girls and women how to be women. These images of what it means to be a good and acceptable woman determine how we live our lives, how we define our relationships, and how we raise our children. At each stage of her life, as a young woman, as a midlife woman, and as an older woman, a woman must decide her relationship to the images which sit on the pedestal. The particular images

change: the Dutiful Daughter is replaced by the Selfless Mother who gives way to the Sweet Old Lady. There are always images, however, static and predictable, tempting us to abandon the quest for a personal and authentic life.

I was nearly finished with a draft of *Down from the Pedestal* when the 1992 Republican convention launched the battle of the images. In the name of family values, the Republicans were pitting the Happy Homemaker and the Grand Mother against the diabolical Career Woman (a twentieth-century version of the demonic mother of mythology and fairy-tale fame who destroys the earth and cannibalizes her children all in the pursuit of her own self-aggrandizement). I watched with a combination of interest, horror, and despair as Hillary Clinton "toned down her image," minimizing her personal success, dynamism, and competence. At the same time, Barbara Bush and Marilyn Quayle seemed to forget that in addition to being devoted wives, they were also personally ambitious and powerful women. These women were not standing for themselves, who they were as real people had become irrelevant; they were embodiments of images on pedestals, inspiring both fear and admiration.

One Republican speaker declared that the election represented a battle for the soul of America; yet I saw no comparable contest between two warring images of manhood. The images facing off across the battle line were images of women. The rhetoric about the soul of America was misguided; it was the soul of American women that was at stake. We were debating about what would constitute acceptable images of womanhood as we moved into the twenty-first century.

While some were advocating a revival of the nineteenth-century True Woman who embodied a commitment to traditional family values, others were championing a twenty-first-century version of the New Woman who succeeded the True Woman with a promise that women could have it all—career, independence, romance, and motherhood as well. These images were one-hundred-year-old icons now dressed up to suit a new generation. Despite the potent sway of both these idealized images, it was clear to me that the answer to the question of how a

woman lives her life did not lie in images—not in these tried and true images, not in the goddess images of the New Age, not in any images.

In order to create a life that is truly her own, a woman must dare to live outside the confining dictates of images. When an image or story is used temporarily, as a disposable guide, it can assist in the process of creating oneself. It seems obvious, however, that reading the text of one's life from someone else's story does not make for an authentic life. Yet women continue to cling to the images which have both guided and trapped them in the past. As one woman who was beginning to abandon her allegiance to the image of the Selfless Mother told me, "I feel like a prisoner that has been let out and still feels the ropes. Part of my problem may be that I don't know what to do with that freedom."

Not knowing what to do with the freedom is exactly what keeps women securely perched on pedestals. At first, we might be tempted to think that the alternative to images is actions. "Don't just stand there, do something." In fact, early cartoon depictions of the first feminists showed women running off of pedestals, breaking chains, and smashing images. Ironically, it is just this impulsive and destructive action which women have always feared when they contemplate abandoning idealized images. As one woman only half-jokingly asked me, "If I stop being the Faithful Wife, do I have to get a divorce?"

This call to action, "just do something," has been a long-standing male solution to the dilemma of how to live an authentic life. In business, sports, or in relationships, when men are confronted with a puzzle or a roadblock, they resort to action. Sometimes the action is creative and well thought through; sometimes it is misguided or shortsighted, but in either case, something gets done. Yet, as the proponents of the men's movement have rightly cautioned, action without focus, activity without theme, can be just as empty as an attachment to static images.

If the alternative to images does not lie in actions, where does it lie?

For years, I had been searching for a way to understand the

sense of shared experience I felt with women who were living lives very different from my own. I gradually became aware that women in my family, close friends, and women I was treating in my clinical practice all shared with me certain *life themes.* These common themes connected our very different lives.

My sister Janet, a social worker and the mother of two children, spends much of her time taking care of people. If she is not giving her daughter a bath or reading a story to her son, she is trying to help a runaway adolescent find a place to live. I do not do any of these things; yet the theme of nurturance connects my life to my sister's.

My sister Karen, a painter and gallery curator, devotes herself to creating paintings on canvas. Each day she emerges from her studio exhausted and covered with paint. I have never felt comfortable with a paintbrush; yet the theme of creativity links her life with mine.

My patient Shana was a prostitute and a cocaine addict. She is now trying hard to change her life by going back to school for her high school diploma and by learning how to parent her three children. Her life has been very different from mine; in order to survive she has had to do things I only read about; yet the theme of transformation reverberates through her life just as it does through mine.

At each stage of her life, certain *themes of living* give order and coherence to a woman's experience. These themes are not images; they do not suggest only a few limited stories; nor are they just activities, specific behaviors that keep women busy. Themes form the underlying structure of our lives. They are the continuous threads which unite the different activities of a single life into a coherent whole; they are also the connections which link us to women leading lives that at first glance might appear very different from our own.

When I first began graduate school in clinical psychology almost twenty-five years ago, I remember feeling daunted by all there was to know. How could I possibly learn enough to understand the complexity of a human life? One of my professors, sensing my concern, took me aside and told me not to worry. All I had to do, he said, was focus on the big *themes of*

living. There were not all that many of them and they were the same for each of us regardless of what we actually *did* in our lives.

At each stage of her life, as a young woman, as a midlife woman, and as an older woman, a woman's experience is ordered by certain age-specific big themes. And while circumstance, talent, and individual preference obviously affect the ultimate shape a life will take, the big themes of women's lives remain surprisingly consistent across women whose lives take very different turns.

Young women, whether they are in college, working, traveling, living at home, or are in love or alone, deal with themes of exploration, anticipation, and preparation. They try out different relationships, different interests, and even different identities. Yet this often limitless and seemingly unfocused activity all coheres around the theme of experimentation.

As women move into midlife, they do not necessarily leave behind all sense of exploration, but themes of investigation and experimentation no longer predominate. The activities of a midlife woman are now organized around themes of creativity, nurturance, transformation, and preservation. These themes of midlife can underlie activities as diverse as raising children, growing roses, or writing poetry.

In the last part of their lives, women turn their attention to themes of integration, resolution, and reestablishing priorities. It is, in the words of Rachel Siegel, "a time to go to the heart of the matter."[3] Whether women are widowed, living with spouses, working, or retired, they focus in on what is essential and important and sift away that which is peripheral and secondary. The sifting and prioritizing can be done with relationships, with personal interests, or quite concretely, with the mementos of a lifetime stored away in the attic.

By articulating the themes which predominate at each stage of a woman's life, we not only give coherence to each individual woman's life—seemingly disconnected events in a single life now share a thematic bond—but we also become aware of the thematic links among women who are leading what on the surface seem like very different lives. No longer do women who are making different life choices seem radically different from

one another. A woman who raises children and a woman who tends a garden are *both* nurturers. At the same stage of their lives, women engage in similar ways of being in the world, reflecting the same underlying and organizing age-appropriate themes.

Down from the Pedestal is about the images which trap women and the life themes which can liberate and give meaning to their lives. The first part of this book discusses the images of womanhood, what they are at each stage of a woman's life, where they come from, and how they trap us. The second part of the book is about the concept of life themes and how they provide a healthier framework for understanding a woman's life.

A similar format could be used to understand the life stories of men, who, like women, must contend with the idealized images which entrap them and with life themes which can free them. There is nothing exclusively female about the concepts of idealized images and life themes. However, this book is not about men, it is about women, and therefore the particular images and themes that I have chosen to discuss are female ones.

In order to understand the life themes that structure the diverse experiences of young, midlife, and older women, I interviewed seventy women. These women, who ranged in age from nineteen to seventy-five years, were self-selected to participate in the project. They resided in four large East Coast cities and made themselves available for two hours of clinical interviewing.

I decided to interview women who felt interested in understanding their lives. Within a short time of letting it be known that I was interested in speaking with women about their adult lives, I had more women wishing to be interviewed than I could possibly have seen. By the end of the project, women who had heard from friends about my work were calling me, asking for the opportunity to talk uninterrupted for two hours with someone about how they understood their lives.

The format was a modified, clinical interview. I began with a very general question, asking women to tell me how they understood where they were currently in their lives. From this very general starting point, I then proceeded to ask questions

that would help me to understand how the woman had arrived at this particular point in her own life development and also to speculate with her on how she envisioned the future. This open-ended question was similar to the format used by others who have asked women to describe their adult lives, to begin writing their own autobiographies, and to describe themselves to themselves.[4,5]

Because I was interested in finding out the story behind the woman's story, that is, how she understood her own life experience and how she made sense of who she was, I often found myself pushing women to dig deep within themselves to answer questions for me. Many women reported that the interview gave them a chance to be honest with themselves. I subsequently heard from a number of women who continued the internal dialogue begun during the interview, processing further what they had spoken about with me and coming to a clearer understanding of where they were in their own lives. Most women found the experience tremendously helpful and were eager to refer friends, relatives, and colleagues to me for interviews.

Because I wanted to understand the way in which women make sense of their lives, to know the themes which organize experience, I felt a need to go beneath the usual public persona that both men and women present to the world when asked to describe themselves. While I was certainly interested in the roles women play, the categories they use to present themselves in a public arena, and the images with which they identify, I was equally interested in the private dialogue that a woman has with herself about her own life.

It has been suggested that the categories for a new feminist psychology will come from the narratives that women tell.[6] I would only echo that sentiment and add that while women must be willing to tell their narratives, we must be willing to listen, to truly listen, hearing the story behind the story; for it is in the deep inner dialogue that a woman has with her private self that the real meaning and themes of her life will be revealed.

The ideas in this book flow not only from my interviews with the seventy women who generously volunteered their time, but

also from a dialogue over the last twenty years with women who have sought my help in psychotherapy and from the many women whom I have taught and counseled in the process of their professional development as clinicians and psychotherapists.

All of the stories in this book are true and recount the lives and experiences of real women. Of course, the names and identifying details have been changed.

Acknowledgments

This book would not have been possible without the many women who consented to be interviewed, giving generously of their time and of themselves. Many women had already spent hours thinking about their lives before the interview began. Women rearranged their schedules in order to be interviewed at the end of already busy days. Others contacted me after the interview to add additional insights. While I was unable to tell the story of every woman with whom I spoke, each woman's experience helped me to formulate the ideas contained in *Down from the Pedestal*.

Although they were not interviewed for this book, I would

like to thank my many patients who shared their lives with me with openness and candor.

Over the years I have been nurtured and stimulated by the writing of many creative women. In particular, the work of Jean Baker Miller, Carol Gilligan, Carolyn Heilbrun, Riane Eisler, Adrienne Rich, and Sara Ruddick has helped to clarify my current thinking.

My agents Leslie Breed and Gail Ross believed in this project and worked hard to find it a suitable home.

I owe a special thanks to Deb Futter, my editor at Doubleday, whose insight and thoughtfulness helped me to produce the best book I could and whose enthusiasm and energy made working with her a pleasure. Sallye Leventhal advocated for this project at Doubleday in its early stages and Julie Duquet designed a cover that is both creative and true to the spirit of the book.

Sybil Trader deserves special credit for painstakingly transcribing the taped interviews. Friends Helen Bergman, Charles Bethel, Roger Fallot, and Marilyn Sperling read early versions of the manuscript and offered valuable feedback.

My family, Janet Ennis, Karen Harris, and Sara Harris provided encouragement and creative advice at several points throughout the project. Their love and support were invaluable.

I almost do not know where to begin to acknowledge the help and support I received from my husband, Mark Smith. He was editor, mentor, confidant, friend, and cheerleader. Most of all, his love and unselfish support provided a secure base from which I felt free to do my best work.

DOWN FROM THE PEDESTAL

PART One

Chapter 1

The Power
of Images

More than a half century ago, Virginia Woolf declared, "It is far harder to kill a phantom than a reality."[1] She was referring to the image of the angel in the house, an image popular in her time of the good woman who sacrificed herself for the care of her husband, her children, and her home. Woolf told her 1931 audience of would-be professional women that the image of the idealized angel in the house was a phantom that profoundly influenced the way in which women lived their lives, yet as with all phantoms, it was elusive and difficult to destroy.

The images which trap women in the last half of the twentieth century are different; the angel no longer sits securely on

the pedestal. This image has been replaced by others that now affect the way in which we live our lives, determining what it means to be a good and acceptable woman. Woolf's words, true more than a half century ago, are still true today. It remains difficult to kill the images of our imagination.

Just what is this thing we call an image? Images have been called capitalized personalities.[2] They are not mother, wife, or woman, but rather they are Mother, Wife, and Woman. Images do not represent ordinary women going about the activities of their lives, mothering, loving, and working. Rather, they are ideals, fantasized possibilities of what we want another person to be, what we imagine that person to be, or what we dream that person might be for us. Capitalized personalities are the images of our imagination, and in order to be them, women must ascend the pedestal and deny their own identities.

I am reminded of the story of Cinderella's stepsisters who, in an effort to attain the prince, squeezed their feet into a slipper that was too tight and constricting. One of the sisters was compelled to cut off her toes, the other amputated her heel, all in an attempt to fit into a shoe that belonged to someone else. Generally, when we read the story of Cinderella we see these sisters as unsympathetic characters. It is Cinderella waiting for her prince who is the heroine of the story. Yet these sisters present us with a story which resonates with the experiences of many modern women. Unable to fit into the images that have been presented to us, we often do damage to our essential selves, amputating important parts of who we are so that we can squeeze ourselves into the images that have been constructed by others. Not insignificantly, the slipper which the sisters tried to fit was made of glass. It was never intended for a real woman who would obviously be unable to walk in a glass slipper; only a woman who existed as a figment of our imagination could wear a glass slipper; only a woman who had ceased to be real and had ascended the pedestal as an idealized image of femininity could possibly own a slipper made of glass.

Sam Keen, one of the architects of the men's movement, maintains that while women do not pose a problem for men, Woman poses an enormous problem.[3] "Woman" is that "larger-than-life shadowy female figure who inhabits our imag-

ination, informs our emotions, and indirectly gives shape to many of our actions."[4] The idealized image of Woman has become as entrapping for men as it is for women.

In trying to find the woman on the pedestal, a man not only loses sight of his own goals, but sacrifices any possibility he might have for a relationship with a real woman. Real women, after all, never live up to our idealizations. Yet, despite her unreality and perhaps even because of it, the image of Woman holds incredible power over men.[5] If men are ever to have actual and healthy heterosexual relationships, they must turn Woman into ordinary women with whom they might truly share a reciprocal relationship. While Keen's admonition certainly has relevance for men, it is even more important for the women who become trapped by these idealized images. If women cannot descend the pedestal and cease being Woman, then not only will they fail to have relationships that are authentic, they will cease to have lives that are authentic.

Images with archetypal power, capitalized personalities, are born when symbol and emotion coalesce.[6] In contrast, our everyday lives are filled with utilitarian symbols and signs that do not ascend pedestals and have little power to influence the way in which we live our lives or the manner in which we define reality for ourselves. Take for example the collection of traffic symbols that make up the lexicon of the highway. The yield sign conveys information; it does not, however, carry an emotional charge. It is in no way an image, a capitalized personality. The Statue of Liberty, on the other hand, is a symbol of freedom about which most Americans have tremendous feeling.[7] When we see the Statue of Liberty, even the most cynical among us are filled with emotion, many are overcome by tears, and we feel a sense of purpose larger than ourselves. The Statue of Liberty is an image, an archetype of freedom.

The power that Ronald Reagan had to inspire the population may well have derived from the fact that he embodied the image of the Good Father—a man who is wise, kindly, and strong. His presidency symbolized the triumph of good over evil, and despite the failure of many of his policies, Reagan himself was able to inspire tremendous feeling and loyalty, not only among his followers, but in the general population as well.

During the Republican convention of 1992, the audience was mesmerized once again by Reagan, standing tall as the embodiment of the image of the Good Father. One young man in the audience, overcome by feeling, said, "I just love the guy, he was the Presidency for me." Without realizing it, this man described Reagan, not as a human being, not as a real president with weaknesses as well as strengths, but as a capitalized personality, the Presidency.

Images have the power to enchant and bewitch us. They are magical, combining passion and fancy.[8] As such, images fill us with a sense of wonder and awe. They are idealizations that transcend everyday life.

Beyond their emotional impact, however, images offer us an invariant pattern of how to live our lives. They provide a prescription for how to behave. The idealized Mother does certain things; the ideal Wife behaves in particular ways. When one is identified with an image, one's life is set out in a clear and straightforward manner. The action of an image is like the action of the characters in a play who follow a prewritten script that always reads the same. In the hands of a good and accomplished actor, we might even be fooled into believing that some of the action is spontaneous and genuine. However, if we see the play enough times we know that the script never varies, it does not matter who plays the part, the part is always the same. The image does not change depending on who reads the lines.

One can imagine a Kafkaesque story in which a character is trapped by an image of how to live his life.[9] The story may have the man identified with the image of the Good Soldier or the Ruthless Businessman. At the end of his life, he looks back and sees that his life has been a series of failures and missed opportunities. Distressed, he begs a magician for a chance to live his life one more time. He wants to go back and repair the mistakes that he has made, yet, when he is given his wish and granted the opportunity to go back in time and redo his life, he is unable to do anything but repeat the script. The story always plays the same way and one imagines that no matter how many opportunities he is given to return and do his life again, it would repeat itself in a never-ending succession of sameness. When one is trapped by an image, overly identified with its

prescribed pattern of behavior, one relinquishes choice and self-determination in living one's life.

In its most trivialized form, an image presents us with a recipe for how to live. Like all recipes, it prescribes something unchanging and reducible to a very simple formula. Almost two hundred years ago, a gentleman searching for a wife wrote out his formula for the perfect companion. His personal recipe for the feminine woman went as follows: "ten grains of neatness, two of industry and two of amiability, a teacup full of 'brains'—acquired knowledge, talents to be immersed in a silver cup—with a handful of flowers of beauty flung in."[10] A woman who wanted to live up to this idealized image of feminine perfection had only to follow the recipe. As long as she selected the ingredients correctly, measured them out in accurate proportions, and mixed them in the proper order, she would successfully ascend the pedestal of the Good Wife.

At first glance, one might be tempted to confuse an image with a social role, since both define relationships and prescribe behaviors. The two are quite different, however. A social role varies with the expectations of different groups and changes when circumstances change.[11] It is a social convenience to be used and then discarded, with little power to inspire loyalty or passion. An image, by contrast, is invariant across place and time. Regardless of the circumstance or the players involved, an image always looks the same. If we think of the role of wife, we imagine a set of social conventions. A particular woman can play the role of wife some of the time, relinquishing it at other times. The role also varies depending on the personal characteristics of the woman who plays it. The image of the Faithful Wife, however, is constant. A woman identified with the image of the Faithful Wife is always the same. Her characteristics do not change if her husband mistreats her; they do not change as she grows older; they do not change even if she is widowed. Faithful Wives are always Faithful Wives.

Some of the difference between social roles and images becomes clearer when we consider the role of the leader versus the image of the Fearless Leader. The role of leader is context-bound. Different groups have different expectations of what it means to be a leader.[12] The Boy Scouts want their leader to

behave differently than the leader of the U.N. General Assembly who might be expected to be rather formal and task-oriented. Similarly, different circumstances will demand different behaviors of the same leader. Climbing a dangerous mountain, the leader of a Boy Scout troop may need to be directive and authoritarian. Sitting around the campfire discussing the day's adventures, he may be more facilitative and egalitarian.

Now consider the image of the Fearless Leader. This image transcends both time and circumstance and appears immutable. Recently I had the occasion to see the 1938 Sergei Eisenstein film *Alexander Nevsky,* which tells the story of a thirteenth-century Fearless Leader who rescues the Russian empire from invading German armies. When I first decided to see the film, I was concerned that it would seem dated and that I would be unable to resonate to such a stylized image of a leader in a film designed to promote Soviet propaganda on the eve of World War II. My actual experience in watching the film was quite different. Alexander Nevsky was immediately recognizable to me. He was the Fearless Leader, strong and bold, willing to die for his country, and able to rally the populace to a just cause. He was the living embodiment of that New Hampshire slogan, "Live Free or Die." It did not matter that the film was made more than fifty years ago or that the action of the film took place centuries before that. Alexander Nevsky was as known to me as if he lived today, and as I watched the film I could not help but be inspired by his determination and moved by his courage.

Part of the power of images comes from their universality. We recognize them across context and over time. The outward dress of the image does not disguise its inner meaning. This universal lure which draws us to images also makes them dangerous as models for living our lives. The pattern is *too* clear, the behavior is *too* recognizable. Images leave little room for individual differences. "One size fits all" often translates into one size fits none.

Idealized images of what it means to be a Good Woman are the equivalent of blueprint patterns of womanhood. They stamp out multiple copies with little variation. When I was a young girl, I spent many Saturday afternoons making plaster

of Paris molds at a local arts and craft center. The molds varied by degree of difficulty; beginners started with simple forms and progressed to more complicated ones. While it was more challenging and fun to work on the more intricate images, once I had mastered the craft, I became bored with the sameness of even the most complex forms. It is the very essence of a mold to produce identical products. Some molds may be more interesting than others, but they are molds nonetheless. It is the same with images. Some may be more complicated, more varied, or more inclusive, however, they are all rigid and static prescriptions for how one should live life.

In colonial New England, the idealized image of the Good Wife became so accepted as a standard for how women should live their lives that women were referred to as "Good Wife."[13] A woman was called, for example, Good Wife Jones or Good Wife Smith. Wife, which had once been a role or perhaps even a title, became elevated to the status of an ideal. The Good Wife was a loving mother, an obedient companion, a stand-in for her husband when he was sick, a good homemaker, a friendly neighbor, and a devout Christian.[14] As long as she followed this particular recipe, a woman was entitled to be called "Good Wife." She was not recognized as a flesh-and-blood woman with particular interests or needs of her own who was different from other women. Her very name defined her essence. To be a married woman in colonial New England meant that one had to be a Good Wife.

It is fitting that images sit on pedestals. Like Lot's wife who made the mistake of having a mind of her own and turning to look back when she was instructed not to do so, an image is like a woman turned to stone. It is rigid and immobile. If it moves at all, it moves by someone else's doing. An image can exist quite well on the narrow and circumscribed platform of a pedestal. To move would mean to fall off and break.

At the beginning of *Fire in the Belly*, Sam Keen recounts a story in which a friend tells him that the fundamental question of a man's life must be, "Where are you going?"[15] This is a question about action, it is a question about intentionality, and purpose. A woman does not begin her life story with the question "Where am I going?" If she did, she would find life de-

fined by the images on the pedestal to be unacceptable. Images on pedestals go nowhere. Autonomous movement is not the province of images. Images exist solely to be admired, to be gazed at, to be the object of other people's fantasies, and to be used in the construction of other people's stories. When a woman identifies with an image, she does not have to write her own story, she does not have to ask herself the all-important question "Where am I going?"

The Origin of Images

Images of what it means to be a woman are all around us. The Museum of Womanhood contains many pedestals. Some images are part of the museum's permanent collection, they always have a place of honor and we can barely walk into the museum without noticing them. Others are part of a rotating display; they come out for a time, remain on view, and then get put away only to be replaced by other images. It actually might be easier for a woman to avoid identifying with images if there were only one or two from which to choose. In that case, if the image seemed especially alien, a woman might be able to turn away. However, there are so many choices. We are presented with idealized images by our families, by our relationships, and by our culture.

Family Images

One of the first places that we learn of specific idealized images of womanhood is from our personal families. Each woman extends back in time to her mother, grandmother, and to her foremothers in the distant past.[16] At times, these life stories of women who lived long ago become elevated to the status of images, personal patron saints. They have ceased to be real women and have been mythologized into icons, images that guide us, having taken on a larger-than-life character. One of the women with whom I spoke in the course of working on this book had such an idealized image of a great-grandmother. When I asked her what she knew of her great-grandmother's

actual life, she responded that in fact she knew very little. I probed a bit further and asked her if she had any desire to dig into the history of her great-grandmother's life and to find out what this woman's experience had really been like. She responded with horror and could not understand why I would want to tamper with the image. The image itself served her well and she did not want it altered by the reality of her great-grandmother's life.

Perhaps more than any other story that we hear, we are profoundly influenced by the story of our own mother's life. This story is in no way equaled by any other life story, it is Our Mother's Story. As children, we are prone to see our mothers as godlike. We depend on them for our very survival and it seems for a time as if they can do no wrong. Before we begin to learn about their real lives, our mothers have already been put up onto pedestals. It is no wonder that we fail to see the real woman who also happens to be Our Mother. Instead we see an image of womanhood, an idealization of what it means to be a woman. Unlike more universal images that are known to us all, this image is a highly personal image, one to which only a few interested daughters are privy. It is an image nonetheless, and it has the power to mold how we live our lives, sometimes constricting the range of ways in which we might actualize our own possibilities.

For each woman, her mother's life and, perhaps more importantly, her mother's story serve as a backdrop against which she creates her own life experience.[17] Whether we rebel against the image our mother created or choose to emulate her life experience, we use our mother as a measuring stick against which we evaluate our own life. "We feel her ghost in almost every waking minute."[18] The image of our mother is an image of a life lived that is difficult for us to ignore.

The image that we form of our personal mothers comes from several different sources. First of all, we have what our mothers say about their lives. Often mothers will talk as experts on life to their daughters, describing the way in which they have lived their lives and the choices that they have made. They may instruct their daughters to follow the same course or alternatively to pursue a different course. Mothers give messages "be like

me" or "do not be like me." Sometimes, to their daughters' confusion, they give both messages.

In addition to what a daughter hears her mother say about her life, a daughter also sees the way in which her mother actually lives her life. It has been suggested that a mother's life, her particular behaviors, lay out for her daughter the options of how a woman can live her life.[19] At times, a mother's actions are in keeping with her words. In such a case, the daughter has not only her mother's self-proclaimed advice on how to live, but has also her mother's behaviors which are in keeping with her prescriptions. Sometimes a mother's words and her actions are not consonant. The mother says "live a certain way," but her actions belie her words. She lives her life very differently from how she describes her life to her daughter.

A daughter must also contend with the unlived life of her mother.[20] Each mother in choosing a particular course also chooses not to live a certain way. It is often the unlived life of a mother that influences the way in which a daughter will actualize her own possibilities. Once again, mothers vary in how aware they are of their unlived possibilities. Some mothers are very conscious of the road not chosen and will talk explicitly to their daughters about the path that they did not take, sometimes with satisfaction, other times with regret.

Taking this highly personal data about her mother's life, a daughter forms an image of her mother and of the life that her mother has lived. This image reflects not only the real experience of her mother but also the daughter's fantasy of her mother's life and thereby takes on mythic dimensions. This story may be idealized and romanticized, or it may be turned into the story of a monster, a demon mother who haunts the daughter throughout her life. If we understand the importance of a mother's life and the power of the mother's story to become a myth for her daughter, we can understand the proliferation of angry biographies by daughters of famous mothers. These daughters are writing about the mothers that they experienced, but they are also writing about the image of the Demonized Mother as they invented her.

The ways in which a woman may respond to the image she has of her mother are many and varied. A woman cannot help

but be influenced by this image. When the image is an especially strict formula which the daughter feels she must follow exactly, then that daughter becomes the prisoner of her mother's life experience. The daughter does not freely choose how she will define her own life. The image of her mother, rather than merely suggesting and highlighting particular possibilities, serves as a rigid mold, a mold that either must be filled exactly or repudiated entirely. When a woman feels trapped by the story of her mother, the woman may carry with her a great deal of pain, anger, and resentment. It is as if she is not free to live her own life but she must live her life within the confines and the limits set by her mother's life. Charlene Baldridge, in a book of letters between mothers and daughters, writes to her daughter Lou describing the pain of a woman who feels imprisoned by the images of her ancestors: "The circle must be completed. You are my eternity woman-child of mine and I am sorry for this and this is the sorrow of every woman and this is the knowledge: I forgive my mother, my grandmother, my great grandmother, and my great, great grandmother. It is all I can do. The awareness that one inherits, that one can do nothing but inherit and with that inheritance there is of course a certain amount of pain."[21]

Relational Images

Every time we enter into a relationship, we see an idealized image reflected in the eyes of the other. Wife, Mother, Lover, and Daughter are not real women striving to have meaningful connections, rather they are women on pedestals fulfilling the fantasies of their companions. Psychologists studying the behavior of women have informed us about the importance that all relationships have in the lives of women.[22,23] Human connections matter to women, and women will not only alter their behaviors but redefine their primary identities, their own sense of who they are, in order to maintain relationships.

Over the course of her life, a woman will use the success of her relationships as one measure of the overall success and acceptability of her life. Her core values reflect her commitment to connections with others, and a woman will often value caring

and concern for others above absolute rules and standards of judgment when making decisions about what is right or wrong.[24]

Because of the important role that relationships play in the lives of women, women not only spend a great deal of time being in and nurturing relationships, but they also invest energy in thinking about relationships. Women know that relationships need to be understood, and that such an understanding requires commitment, energy, and work. None of us comes into this world with an automatic understanding of what it means to be connected to another person; rather, we must develop the skills necessary to be in relationships. It is in the course of studying and understanding what it means to be connected to another person that women discover the idealized relational images of womanhood.

When he asked his now famous question "What do women want?" Freud was merely asking the kind of question that women always ask in their relationships. Women want to know what their husbands want, what their friends want, and what their employers want. Part of being in a relationship is learning how to read the expectations of the other person. Consequently, women become especially adept at reading and understanding the often subtle signals sent by their companions.

Recently I was talking with a friend who is the father of a fifteen-year-old girl; he was telling me how impressed he was by his daughter's ability to understand interpersonal nuance. She seemed able to know what other people meant even when they were not explicit in their communication. While his daughter was certainly an intelligent and lively young woman, she seemed to me no different from many other young women. She was merely learning how to be a woman, how to read relationships, and how to understand how they work.

By coming to know what other people want, women come to see the image reflected in the other's eye. However, the ability to read interpersonal cues is obviously a mixed virtue. Positively, it allows women to have more empathy and ultimately more successful relationships. Negatively, as women begin to read interpersonal cues, they become aware for the first time of the existence of idealized images. This awareness, when cou-

pled with the desire to maintain relationships at any price, renders women especially vulnerable to identifying with idealized relational images.

Many of our oldest stories also introduce women by their relational status. We meet Hera as Zeus's wife. Zeus, however, is introduced as the ruler of Olympus, not as Hera's husband. Sarah is Abraham's wife and the mother, in her old age, of Isaac. Women in these stories are identified by their relational status, men by their personal accomplishments.

As young girls, we pay attention to these messages. The stories tell us not only of the relational status of important women, but they also tell us that we better learn about these relational connections because these are the ways in which women get noticed in the world. Young girls ask themselves, "Just who are these characters—Wife, Mother, Daughter—and how do I learn to be one of these?"

Beyond what we are able to learn for ourselves, we are also socialized by our families to these idealizations of women-in-relationship. Specifically, our mothers first teach us how to be women in relationships. One of the jobs of a mother is to socialize her daughter to become a woman acceptable to her culture, a woman who will know how to behave when she is invited to join the interpersonal drama.[25] Interestingly, a number of women told me of their pride at becoming grandmothers. They were proud not only to have a healthy and lively grandchild, but they were proud that they had successfully taught their daughters how to be mothers. It was a tribute to their own lives and a testament to the good training they had given their daughters that their daughters had learned how to behave in a mothering relationship. It is no wonder then that mothers sometimes see their daughters' lives as a reflection on their own lives. After all, a mother can rightly say, "I taught her what she knows about how to be a woman."

We also see these relational images reflected in the eyes of the important men in our lives. Many of the verbal lessons that I learned about how to be a girl came from my father, who would occasionally tell me that certain behaviors were "ladylike" or "not ladylike." At the time it never occurred to me to question my father's right to comment on what it meant to be a

girl. My father had grown up in a family without sisters, a family that was dominated by important men. Yet I assumed that he must know what it meant to be a Good Daughter, and if that meant being "ladylike," then that is what I would do. While my father had no personal experience with being a woman in the world, he did have experience with idealized images of women. By telling me how to behave and by instructing me in ladylike behavior, he was giving me his version of an idealized image.

Thus by reading the subtle and not-so-subtle cues which we receive from our mothers, fathers, and our cultures, we learn how to be women in relationship—not everyday women living our lives as best we can—but idealized images of women in connection—Mother, Daughter, and Wife.

Cultural Images

Beyond the more immediate influence of our mothers, fathers, and families, we also receive messages from the broader cultural environment as to what it means to be an acceptable woman. Cultural images are transmitted by our immediate social group; they are also reflected in the ideals and traditions of our society. Finally, we learn about cultural ideals from the folklore and fairy tales we hear as children.

In addition to belonging to a family, each of us belongs to a racial, ethnic, or social subgroup, and within that group we are bombarded by images of womanhood particular to our group. Often these images reflect the stereotypes of people outside our own ethnic group, and those stereotypes become institutionalized in the popular media's portrayal of the Jewish American Princess, the Dumb Blonde, or the barefoot and pregnant Soul Sister.

At first glance it might appear that since these are not particularly positive images, they might have little if any power to influence the lives of real women. After all, who would want to model herself after the negative stereotype of the Jewish American Princess or the Dumb Blonde. While it is certainly true that these are not positive images, they are nonetheless ideal types, exemplars of a category, and they present us with rigid and well-defined images of women.

One woman, for example, grew up being warned not to behave in any way that might cause her to be likened to the image of the Jewish American Princess—the spoiled, pushy, and demanding young woman who is never satisfied unless she is getting her way. For this woman the image became something to avoid. Not wanting to be seen as a Princess, she denied many of her own needs, her own desires, and certainly her assertiveness. She often allowed herself to quite literally fall to the back of the line rather than be seen by others as being pushy and thus conforming to the negative image of what it meant to be a Jewish woman.

Another woman experienced a rift with her sisters over the image of the Dumb Blonde. She came from a family in which all of her siblings were blond, buxom, and pretty. She, however, had brown hair, brown eyes, and few curves. Because she looked different, she felt separate from her sisters. Her sisters, embarrassed by their resemblance to the image of the Dumb Blonde, felt disparaged by her. They could not believe that she did not see them as silly, stupid women since the entire family had grown up with jokes about Dumb Blondes as part of their dinner conversation. Throughout their adolescence and into adulthood, the negative image of the stupid but attractive woman was a source of tension and dissension for all the women in this family, regardless of their hair color.

For still another woman, the image of the barefoot and pregnant black teenager had a major influence in determining how she structured her own experience. Within her own middle-class family, this image was devalued and dismissed; yet, among her peers, the pregnant Soul Sister was an omnipresent image and she felt a strong pull to conform to the outlines of the image and, as she herself says, "get pregnant and ruin my life." The image was so powerful that it was difficult for her to choose to live differently even when she knew that the path laid out by the image led ultimately to self-destruction.

What is most significant about many of these cultural stereotypes is not that they exist, but that they remain powerful and structuring images for women despite their negative connotations. When images are placed on pedestals, we have difficulty ignoring them even when to identify with them might mean

subjecting ourselves to public scorn and self-hate. To avoid even negative cultural images demands a great deal of energy.

Beyond one's immediate social group, the larger culture also presents us with images of idealized womanhood. Popular fiction, media portrayals, and religious exhortations, all present us with an ideal image of what it means to be a woman within our society. While these societal idealizations are powerful, they are inherently transitory. Cultural ideals are tied to a particular historical context; they often have no existence or relevance outside of a narrow time frame and are applicable only to women living in a particular social and cultural space. For example, images of the All-American girl, the True Woman, the Lady of Leisure, all occupied American consciousness for a time. They were not, however, images that existed across cultures or for very long periods of time. They each had their brief moment in the sun and then they each passed from the scene. Significantly, they were always replaced by other cultural images. At any given time in our history, our society always embraces a particular ideal of womanhood which then exerts influence over the lives of women who live during that particular period in time.

A brief review of some of the images that have sat on the pedestal of cultural idealization gives a sense of the many and varied ways in which Americans have imaged women over the last one hundred and fifty years. In the 1830s, for example, the Cult of True Womanhood defined the True Woman as the woman who spent her time in the kitchen and in the nursery.[26] The True Woman proved her womanliness by having many children. In fact, the more children she had the better woman she was. In 1848, an obstetrics and gynecology textbook described a woman by saying, "She has a head almost too small for intellect but just big enough for love."[27] This anatomical finding was not seen as being problematic since the True Woman spent her time loving and nurturing, not being intellectual.

By the end of the nineteenth century, however, the True Woman was challenged by the New Woman, a very different image of idealized femininity. The New Woman was educated, intellectual, and economically independent. Still a nurturing

and caretaking female, she turned much of her caretaking attention to the world outside of her home. Writers, professionals, and reformers filled the ranks of New Womanhood. These women actualized their "female potential" in a variety of ways besides being mothers and homemakers. They championed the rights of prisoners, mentally ill patients, and poor working women.[28]

Because of their high-minded sense of purpose, New Women were often seen as being rather serious and somewhat dour.

By the 1920s the New Woman was challenged by a fun-loving alternative—the Flapper. The Flapper was the idealized young, sexually aware woman who, in marked contrast to the somewhat prudish reformers that preceded her, was out for a good time.[29] The Flapper was our first good-time girl.

Zelda Fitzgerald, in talking about her own daughter, said, "I don't want my daughter to be a genius, I want her to be a flapper because flappers are brave and gay and beautiful."[30] The Flapper was a young woman who had fun, who indulged herself, but who eventually settled down and got married. It is important to remember that even for this feisty and independent woman, marriage was still the ultimate goal. Nineteen hundred and twenty-one, the height of the Flapper's ascendancy, marked the first Miss America beauty pageant, an event which crowned the best exemplar of fun-loving and wholesome femininity.

Two new cultural images appeared during the years surrounding World War II. Rosie the Riveter was the spunky and patriotic housewife who threw her apron aside and assumed her place on the assembly line to help the war effort. She was such a powerful image of "never-say-die" patriotism that her picture graced numerous propaganda posters. Despite her popularity, Rosie disappeared when the soldiers came home only to be replaced by the Happy Homemaker. Smiling in her all-electric kitchen with her neatly coiffed hair and her simple but tasteful pearls, the Happy Homemaker was there to make her husband feel that fighting for his country had been worthwhile.

By 1975, we find another example of idealized womanhood in Marabel Morgan's version of the Total Woman. The Total

Woman was a woman who surrendered herself to her husband in every way.[31] Morgan maintained that a Total Woman's job was to cater to her man's special quirks whether those quirks be in salad, sex, or sports. The Total Woman was a version of the Total Wife. She was cook, nurse, and lover to her husband, and it was Morgan's contention that Total Women were gifts from God to men.

As we can see, the life span of each of these cultural images is relatively short. Consequently, women who attach themselves to particular cultural images might well feel confused and even disoriented when those images no longer seem potent and are replaced by other competing images. Because cultural images are not mutually exclusive, it is also possible for more than one to be influential at the same time. In the 1992 presidential election, Marilyn Quayle and Hillary Clinton presented us with a revived competition between the True Woman and the New Woman. Marilyn Quayle, in her appeal to traditional family values, portrayed herself as a modern-day incarnation of True Womanhood. Hillary Clinton, on the other hand, with her focus on career and her commitment to action and ideals outside the home, was a modern version of the New Woman, that independent and autonomous woman who one hundred years ago was seen as a challenge to the values and traditions of True Womanhood. When cultural images clash, it might well make for good press, however, it can cause confusion for women who are uncertain as to which image holds the greatest promise for fulfillment and happiness.

In contrast to time-bound cultural ideals, the images presented to us in folklore and fairy tales are images which transcend time. They originate in very old stories and suggest a truth that we take to be eternal. Part of the power of these fairy-tale images derives from our having first been introduced to them as children. As girls and boys, we live in a world of black and white, good and evil, a world in which things are absolute, and fixed for all time. Recently, I tried to offer a sympathetic explanation for the behavior of the sea witch in Walt Disney's *The Little Mermaid* to my four-year-old niece. She looked at me as if I had lost my mind. As far as she was con-

cerned, the sea witch was an evil creature, no ifs, ands, or buts. Children do not live in the world of alternative explanations; for them, bad is bad, good is good, and there is no in-between ground. Consequently, the images and idealizations to which we are introduced in childhood retain an absolute power both for us and over us, perhaps in a way that no stories we hear subsequently ever do.

Feminist Andrea Dworkin contends that women live in and through fairy tales.[32] Our fairy tales tell us about the Wicked Witch, the Beautiful Princess, and the Fragile Mother, and indirectly they give us lessons in how we should live our lives. Given all the possible stories, many containing at least one character of image status, how do certain stories get chosen as those which will be held up as the embodiments of cultural truth? There are certainly more stories than Cinderella, Snow White, and Sleeping Beauty with the power to capture our imagination. One only has to scan the shelves at the local library to see that there are literally thousands of folktales from many countries and civilizations.

Certainly not every story is a "big story"; not every story is worthy of capturing our imagination. We are especially susceptible to those stories that contain themes of triumph, rescue, or transformation. We love to see someone small and weak triumph over someone big and powerful, to watch someone who is trapped be rescued and saved, or to encounter someone who is despairing and lost and becomes transformed and remade. It is also true that not every story has a character with whom we can fall in love, a character with the power to enchant and mesmerize us.

Most of our popular folktales present us with only a narrow range of female possibilities. We have few if any stories of creative, feisty, and intelligent young women. Boys are often identified by their cleverness and, in fact, names like Clever Hans are not uncommon in fairy tales. Girls are described as beautiful, charming, dainty, and passive. In 1881, physician Sarah Stevenson wrote: "The whole status of the girl is made to depend not upon what she is or does, but how she looks. How do I look is the everlasting story from beginning to end of a

woman's life."[33] How do I look is certainly the defining charac-
teristic of the beautiful maidens who embody our idealized im-
ages of young folk heroines.

In contrast to young women who seem to abound in fairy
tales, midlife women are conspicuously absent. When midlife
women are good and kindly, they are invariably dead or die
young in the story.[34] The mothers of Bambi and Snow White,
seemingly wonderful women, are dead before the story gets
under way. The powerful queens and stepmothers are invari-
ably wicked and evil[35] and children find themselves hoping for
the destruction of these authoritative and strong women. Older
women in stories are usually witches; sometimes they are good
witches such as in the fairy godmother who helps Cinderella;
sometimes they are evil and nasty witches as in Hansel and
Gretel. Yet, they are always magical, otherworldly characters.

These stories have been made popular because they capture
the imagination of the men who popularize them.[36] Whether
the storyteller was Grimm, Andersen, or Disney, in each case
the teller of tales was a man who had a certain vision of ideal-
ized womanhood. There are certainly other stories that present
us with a very different picture, yet stories that no one has as
yet seen fit to make readily available.

In the story "East of the Sun and West of the Moon," the
protagonist is a girl whose task it is to go off and save a
prince.[37] The prince has been imprisoned in the palace of the
trolls and the girl must undergo several trials in order to rescue
the prince and win him as her husband. The story certainly
sounds familiar; it contains many of the elements of rescue and
suspense which make our stories compelling, yet the story con-
tains one critical difference from its more popular counterparts
—the hero is a girl rather than a boy.

Another story, the "Maid of the North" from the famous
Finnish epic poem the *Kalevala* tells the story of a feisty and
independent maiden who fends off a number of suitors.[38]
Eventually she chooses a magician-blacksmith to be her hus-
band, and she helps him to accomplish the tasks necessary in
order to win her hand.

Early in the story when she is fending off a suitor she finds
particularly unappealing, she says somewhat derisively: "Yes-

terday I heard a bird singing of marriage; I asked him if a woman was happier in her own house or in the home of a husband. Do you know what he answered? A maiden's lot is brighter than a day in summer, but a married woman's lot is colder than frost. A girl at home is as free as a berry in a garden, but a wife is like a house dog tied with a rope. Why should I be a servant and wait upon a husband."[39]

The Maid of the North is strong, competent, and clever. She is also, however, beautiful, and her story ends with her taking a husband, leaving her mother's home, and going off to start a new life in the land of her husband. In this sense the story contains many traditional elements. It also contains elements of adventure and mystery and magic; yet, it is a story which has not been popularized in American or much of Western culture. One has to wonder if the Maid of the North is just too independent and too clever to compete with the passive maidens who have been idealized in most of Western folklore.

Trapped by Images

It is impossible to live a life uninfluenced by cultural myths and idealized images. These images are all around us, telling us what it means to be a good and acceptable woman. They have been likened to pollution, an essential part of the air we breathe.[1] Although we may not be able to see them with the naked eye, we take them in with every breath, and like air pollution, these ubiquitous cultural images affect different women differently. Some women choke a bit but spit the image out relatively unaffected by its powerful irritant. Others become poisoned, unable to breathe freely, unable to think clearly. Still others become rigid and paralyzed, experiencing a living death in which they no longer act from personal desire or from indi-

vidual ambition, but rather follow a cultural script in robotlike fashion. It is these women who are trapped by the images of our imagination.

One woman who worked for a time as a prostitute said to me: "I became a whore because other people wanted that of me. Then I realized I could get things, now that's just who I am. I don't know how to be anything different. I feel trapped." For her, the image of the loose woman had become the defining model for her experience. Even though she now desired to behave differently and to think of herself differently, she was unable to do so; it was as if the image of the whore had taken on a life of its own, controlling her experience and determining not only the way she presented herself to the world, but also how she thought of herself as well.

What It Means to Be Trapped by an Image

When a woman is trapped by a cultural image, she feels as if she has lost control of her life. Science fiction stories of psychological horror often depict the trauma of an individual who has been invaded by alien forces that come to exert powerful and total control. In stories of this genre, the individual's entire being can be taken over by an outside force so that she becomes incapable of authentic action. An entrapping image can become such a controlling force for some women.

The relationship of an individual to an image can also resemble a macabre perversion of the connection between a ventriloquist and his wooden dummy. In these horrific accounts, the story begins with the ventriloquist clearly in charge; the dummy is merely a character of his imagination, an image perhaps of his other self kept safely under his control. As the horror of the story unfolds, the dummy, the image, gains increasing power and autonomy. No longer is the alive individual, the ventriloquist, in charge, but rather the dummy, who was originally only an image but now is more powerful and more real. When the story ends it is the dummy who pulls the strings. The ventriloquist is no longer autonomous and in control, instead

the figment of his imagination has become more powerful than he himself. This is exactly the psychological experience of women who feel trapped by an image. Instead of using an image of womanhood to *guide* them in their life experience, they feel *controlled* by that very image, as if they no longer have free choice in how they will live their lives.

A woman can become so attached to particular stories that she structures her entire life experience around the images from those stories. If, for example, the idea of a passive maiden waiting for rescue becomes the organizing principle of a woman's life, she might carry that image of herself through the various stages of her development; circumstance changes, time changes, but the image of herself as a particular embodiment of female possibility remains the same. As a young woman she will wait for her parents to tell her how to live; as a wife she will wait for her husband to save her from making decisions; and as a widow she will wait once again, this time for her children to rescue her from loneliness. The characters change, the time is different, but the plot remains the same. The woman's attachment to the image of a passive victim is stronger than any of the experiences of her actual life. The image becomes the controlling force in how she will understand and interpret the events of her life, and she may well feel that she has no choice other than to follow the dictates of that particular model, that story of female possibility.

In some cases, the images from a particular story are so strong that an individual may actually gravitate toward life experiences that validate the image from the story. It is as if one chooses one's life options and experience so that they will conform to the image. The image drives the experience in a very powerful and direct way; the story leads life, determining what constitutes allowable experience. For example, a woman who believes strongly in the myth of the Good and Loyal Wife might well choose for herself a husband who also believes this particular myth. Together they might live out the story of wife as companion and helpmate. The story influences the particular romantic experiences that the woman has. If the story is strong enough and if the image of the Good Wife is powerful enough, then only certain men will seem desirable and others

will seem quite unacceptable. It is as if the woman wears selective blinders; she can only see men who fit the image of the strong husband, the man with whom she can act out the possibilities of Good Wife.

When a woman is trapped by an image, the image remains constant despite contrary life experiences. It is not uncommon to find a woman attached to the myth of the Passive Maiden who waits patiently for Prince Charming, continuing her wait and her belief in the myth despite the fact that she has been repeatedly disappointed or abused in romantic relationships. In speaking with a number of women who were the survivors of sexual abuse and who had lived for a time as drug-addicted prostitutes, I routinely found them to be waiting and searching for Prince Charming. Their own life experiences had denied them any real contact with men who fit into the category of Prince, yet the image of that companion and the myth of the Maiden who would be rescued was so strong that it negated the real experiences these women had had with the men in their lives.

Another woman I interviewed, who also believed that her role in life was to wait passively for rescue, continued to believe in her fantasy despite the fact that by age forty she had not yet been rescued. When asked whether or not this image of passive waiting might be a dysfunctional one, she immediately countered with an accurate rendition of the Sleeping Beauty story. In the story, she told me, the Prince had to overcome bramble bushes in order to get to the Princess. Consequently, she was prepared to wait indefinitely, knowing that the trials of the Prince were great and many, but also continuing to believe that her Prince would triumph over his modern-day bramble bushes.

Yet another woman was so attached to the myth of passive waiting that she could not even allow herself to fantasize a more active role for herself. She imagined herself to be a sleeping Snow White, permanently immobilized in a glass coffin. When I asked her to close her eyes and imagine lifting the coffin lid herself, she became puzzled and frightened. Even in fantasy, she was incapable of assuming a more active role for herself. The image of the passive maiden had so totally seeped

into her consciousness that she could not imagine taking action that might disturb that image.

For most women, being trapped by a cultural image or a personal myth means attempting to approximate that perfect type regardless of their experience or their personal desires or motivations. For other women, being trapped manifests itself in a more paradoxical and less direct way. These women actively resist the pull of a particular image. They spend their lives trying *not* to be Wife, Mother, or Daughter, treating the image as a dreaded curse and feeling a mixture of rage and panic. The image has become so personally aversive because they have seen mothers, sisters, or grandmothers trapped by that image and have witnessed the personal despair or unhappiness of these women. As a result, they resolve never to be trapped in a similar way. Paradoxically, this denied image comes to exert powerful control over their lives. Like the fanatic prohibitionist, a woman at war with an image will see the offending picture in every interaction and around every corner. She will spend as much energy, as much focus, and as much time in trying *not* to be something as did her mother or sister in trying to be just like the ideal.

One woman who spent a good deal of her young adult life trying not to be a Wife and Mother, because she had seen her own mother destroyed by an attachment to those idealized images, realized that in her attempt to distance herself from those embodiments of female possibility, she was denying herself access to relationships and to activities that she in fact valued and desired. While she did not want to be the stereotypic Wife, the rigid and lifeless image which had made her mother unhappy and despairing, she did want the comforts of an intimate relationship. She did want to experience the joys of mothering a child, yet she did not want to be the Selfless Mother. She often found herself resisting certain nurturing and caretaking activities because these seemed reminiscent of stereotypic motherly and wifely behaviors. Her internal war would often take the following self-destructive form: she would enjoy preparing a nice dinner, and become lost in the process of mixing, measuring, and baking. Then she would realize that she was behaving like a Wife. She would get angry with herself and when her

husband came home she would scream at him, "Go feed your-self," having herself already eaten alone with a book. She was so afraid of falling into the trap of the Wife, that she denied herself activities which she actually enjoyed.

A woman may go along for some time in her life without being fully aware that she is trapped by an image. Often aware-ness comes at the time of some important transition. Transi-tions in a woman's life may come about as a result of a variety of different circumstances; biological changes move a woman from the time of girlhood into midlife; changes in role and status such as graduation and marriage bring with them chang-ing expectations and new experiences with which the woman must contend; necessary losses, such as the death of a spouse, result in a shift in relationships causing a woman to define her-self by different relationships and different interactions.[2] Dur-ing each of these transitions it is natural for a woman to experi-ence some disequilibrium, some sense of uncertainty as to which behaviors are still appropriate. She may wonder how to accommodate and adapt to new and changing circumstances. While some women find these transitional periods to be dis-turbing, others find them exciting and challenging. Some women go so far as to suggest that they are most truly alive at times of transition, for it is during those times that they become aware of who they are and how they understand reality.

For women who are trapped by cultural images, transitions are especially problematic. A transition demands that one be-have differently, that one adapt one's behavior to new circum-stances or to new times. Yet, to be trapped by an image is to be constant across space and time. A woman may come to know that she is truly trapped when all about her are changing yet she remains constant. One woman who had identified with the image of the Selfless Mother continued that identification de-spite the fact that her children were now adults themselves and lived far away from her in other cities. She occupied her time by baking cookies and sending little gifts to her sons and daughters. She would put the cookies into the freezer on the possible chance that one of her children might choose to visit. These activities of Selfless Motherhood were so much a part of who she was that she was unable to relinquish them despite the

fact that she no longer had young children to mother. Her friends had moved gracefully into retirement, having put their mothering years behind them; they were able to enjoy hobbies, to travel, and to engage in certain activities of self-exploration. Yet she remained wedded to the activities of active motherhood. She referred to her adult sons and daughters as the "boys and girls," keeping them frozen as children in her own mind so that she could maintain her imagined relationship to them as mother. This woman was equally trapped by the image of the idealized Mother during her active mothering years; yet during that time the fact that she was trapped went unnoticed because the nature of her activities was similar to that of other mothers. It was only when a transition occurred, when her children moved away from home, and when her friends began to take on other and different activities, that her being trapped by an image became apparent to others and painful to her.

A shift in context can reveal to a woman that she is trapped by a particular image. For example, it may be very appropriate to behave in certain ways when one is at home living with one's parents. When one goes to work, however, some of those same behaviors are no longer appropriate. One woman described herself as overly identified with the image of the Dutiful Daughter. She had learned well to be a good girl and to do what her parents asked of her and she believed that she would be rewarded for her compliant behavior. In fact, within the context of her family, she *was* rewarded for being a good daughter. However, when she went to work, she took with her the image of herself as a good girl. Initially she expected that she would receive praise and support from supervisors as well as promotions because of her good girl behavior. It became apparent to her that she was trapped by this image when she failed repeatedly in her endeavors at work and yet was unable to change her behavior. Her overpowering commitment to her image of herself as the good daughter was stronger than her desire to succeed and achieve on her job. Behaviors that were seemingly appropriate to one context, learned well within the confines of her family, were transferred automatically to the work environment where they were not only inappropriate, but they were, correctly, discouraged and disapproved.

Women who are trapped by idealized images do not change when the time and context changes, not because these women *will not* change, but because they *cannot* change. They are so confined within the bounds of a particular image that they do not have within their emotional and behavioral repertoire the new actions and behaviors that are demanded by the new circumstances. Many women, for example, who are identified with the image of Wife find widowhood or divorce almost intolerable. When they lose their important relationship, they not only lose someone whom they love, but they lose their identity in the world. For some women, an inability to function outside of the role of Wife results in despair and even illness. One woman languished and soon died after her husband's death; she was unable to imagine for herself any way of being in the world in which she was no longer defined as someone's wife. The behaviors necessary in order to transition into successful widowhood were beyond her ken.

Simone de Beauvoir has suggested that when a transition is especially traumatic, some women may cling even harder to an image that was constellated at an earlier time.[3] Paradoxically, while successful transition demands that one relinquish certain behaviors and roles from the past, the woman who is trapped, rather than letting go, holds on all the more tightly. The mother who does not know how to be anything other than a mother redoubles her nurturing and caretaking activities at the time that her children are moving away and separating from the home. Such children often feel strangled and suffocated by what feels like pernicious mother love. In fact, what they are experiencing is their mother's desperate attempt to hold on to an ideal image of womanhood that had worked well for her for many years.

Another woman with whom I spoke clung to the image of herself as a vibrant and aggressive Career Woman despite the fact that her most productive years had long passed. She saw me for our interview at 10 P.M. after what she described as another one of her hectic and busy days. In fact, she seemed to be busying herself with trivial make-work, but she could not change the way in which she understood herself in the world: she was the dynamic, busy, always bustling Career Woman, and

she could not alter that picture of herself despite the fact that her circumstances in the world had changed. Women who remain connected to the image of themselves as aggressive, professional women, are often said to "die in harness."[4] Unable to move to the last phase of their lives in which they might engage in more reflective and integrative process, they continue to "do their lives" the way they always have even when the circumstances have changed.

When we talk about aging with grace and wisdom, we are referring in part to the ability to let go of images and idealizations as transitions occur. When context and time change, one must accommodate to new behaviors and new ways of being in the world.

How It Feels to Be Trapped by an Image

When women become aware that they are in fact stuck, that a particular image of their own and the culture's imagination has trapped them, they experience psychological dis-ease. They feel uncomfortable with themselves, as if they know that they are living a role rather than being genuinely engaged in the actions of their lives. Some women have likened this disconcerting experience to that of minority members within a majority culture who must "pass" in order to survive.[5] Such individuals are aware that they are living out a persona, an image that does not fit them in an authentic and personal way, but an image which has become necessary for survival.

Some women become terribly angry when they become aware that their lives are not their own, that they are trapped by an image that has been imposed from outside. In her classic work *The Feminine Mystique*, Betty Friedan talked about middle-aged housewives who became aware of being trapped by the idealized images of Wife and Mother and who became angry and resentful when they saw the ways in which their lives were controlled by these externally imposed, but personally embraced, images.[6] One young woman described rather poignantly her anger and despair when she realized that she was

trapped by the image of the Dutiful Daughter. Throughout her adolescence, she had sacrificed her own interests and her own desires in order to take care of her dysfunctional parents. She had become a parentified child, managing the home, taking care of her younger siblings, and ensuring that both of her parents functioned moderately well. In her early twenties, she escaped from her parents' home and began to craft a life of her own, believing that she had left behind the stultifying image of the Dutiful and Good Daughter.

Well into her mid-twenties, when she herself was married and raising her own family, she received a call from her mother and father asking her to assume once again the mantle of the Good Daughter. Her parents were on the verge of divorce, near bankruptcy, and unable to control their younger children. They asked their oldest daughter to leave her husband temporarily and to return to the family home to take charge once again by performing her Good Daughter functions. This young woman found herself furious at her parents' request. For a time she was unable to control her rage at their suggestion that she abandon her own life in order to conform to an image of what they thought she should be. What angered her even more, however, was her own inability to resist their request. She seemed unable to stop being the Good Daughter, and she proceeded to make plans to sacrifice her own adult life in order to take care of her parents once again. Part of her pain came from the fact that she was aware that she was trapped. She complied, but not because she believed that she was doing the right thing or taking the appropriate action. Rather, like a prisoner being led to the gallows, she complied because she felt she had no choice. For her, the Dutiful Daughter was an entrapping image that gave her little room for free and autonomous action.

Some women actually feel surprised and even a little confused when they realize that they are trapped by an image. One woman who had worked hard to free herself from the demands of being a Wife was shocked and angered at herself when she realized that years after her divorce she was still being the Faithful and Loyal Wife, taking care of her ex-husband, making sure that his debts were paid, apologizing to his chil-

dren for his irresponsible behavior, and protecting his reputation within the community. Because she was divorced, she had assumed that she had left behind her the constricting demands of the role of Wife. It was only when a friend pointed out to her that this man was no longer her husband that she confronted her continued allegiance to the image of the Faithful Wife.

Other women become frightened when they realize that they are trapped by an image. They know how to live a certain way and they are satisfied with the lives they have built for themselves by identifying with a particular image of womanhood. They become fearful only when they imagine that they will be called upon to relinquish that image at some time. One woman, for example, who saw herself as the perfect Mother felt content raising her six children. She looked with dread, however, on the years between forty-five and sixty when her children would no longer be in the home but before she would have the privileges and joys of being a grandmother. She anticipated the fifteen-year hiatus between Mother and Grandmother with fear and alarm.

Still other women experience being trapped by an image with dissatisfaction. They know that they are living out a particular prescription for how a woman is supposed to live her life, yet they do not feel content with their chosen image of womanhood or with its particular rewards. Several women said to me with a note of surprise, "I'm doing it perfectly; I don't understand why I don't have what I want." One woman in particular felt especially baffled and resentful that her behavior as the perfect Wife had failed to produce a child for her and her husband. She had planned her marriage perfectly and behaved in every way as the supportive and loving companion. Part of being a Good Wife, however, meant producing children for her husband, yet she and her husband were unable to conceive a child. In addition to her sense of loss over not having a baby, she felt betrayed by the image of Wife to which she had accommodated herself for many years.

Anger, surprise, confusion, fear, and dissatisfaction are all part of what women experience when they realize that they have been trapped by an image, living out an idealization that

does not fit who they are or what they want. Why then do so many women find themselves trapped by the cultural images of what it means to be a good and valued woman? While the reasons are varied and many, they fall broadly into three categories: a desire to be loved, connected, and approved; a fear of what lies ahead and of one's ability to craft creative solutions; and a desire for power and responsibility.

Love, Approval, and Connection

While it might be more palatable to believe that most women are trapped by images of womanhood because someone forces them into those roles, the reality is that most women walk willingly into the cages of ideal images. When one accommodates to the expectations, desires, and needs of one's family, one's peers, and one's culture, one earns approval, love, and affection.

For many young women, the first seduction by ideal images occurs as a result of needing and seeking the approval of their parents. These women are convinced that approval will only be forthcoming if they conform to certain ideals held by their parents. One woman who was a lesbian had been raised by a mother whose allegiance to the Faithful Wife was absolute. For years this woman struggled with her sexual identity, believing that she would lose her mother's approval and love if she embraced her own homosexuality. Despite being in a committed and loving lesbian relationship, she continued to have dreams of a big church wedding in which she would walk down the aisle while her mother beamed approval, becoming at last the Wife her mother wanted her to be.

For other women, the pressure to conform to idealized and culturally sanctioned images came from peers rather than family members. Women schooled during the sixties, for example, experienced strong social pressure to be independent and to have a career, approximating, at least to some extent, the idealized image of the dynamic Professional Woman. One woman recounted actually going to graduate school just so her friends would still like her. She knew at the time that she had no interest in the professional discipline she selected and that her own

desires would be fulfilled by being a mother and raising a fam-
ily; yet her need to win approval from her friends was so strong
that she spent four years and several thousand dollars ob-
taining a professional degree.

For many women, this drama of love, approval, and connec-
tion is played out maximally in their relationships with men.
Women often believe that in order to be loved, they must ap-
proximate an idealized image of womanhood. For one woman,
this belief was shattered in her marriage when after seven years
of what she believed to be a successful relationship, her hus-
band announced that he was leaving her. His decision, he pro-
claimed, was based on his belief that she had not lived up to the
image of the Good Wife. When he had married her, he had
certain expectations which he assumed she would fulfill. She
was supposed to be a companion and lover, not a highly suc-
cessful woman in her own right—which she had become. To his
regret and sorrow, she had not been the Wife that he imag-
ined. While she was devastated over the loss of her primary
relationship, she also felt like a failure. Her inability to live up
to the idealized image of a Wife had resulted in her abandon-
ment. For some women, divorce leaves them not only alone but
confirmed in the belief that they must accommodate to certain
images and expectations if they are to remain chosen and
loved.

This ardent desire of a woman's to be approved and af-
firmed by others has been labeled "an addiction to love";[7] A
woman who desperately needs the approval and validation of
others in order to feel whole will sacrifice her own desires, in-
terests, and autonomy in order to win approval. Many women,
for example, worry that they may be "too much" for their hus-
bands. When a woman is "too much," her own ambitions and
desires disrupt the expectations her husband has of her wifely
behavior. A fear of upsetting her marriage can cause a woman
to deny her own needs and to cling tenaciously to the image of
the Good Wife, believing that only by playing that part can she
keep her marriage secure.

When women sacrifice their own identity and their own au-
tonomy in order to remain in a relationship, they commit what
has been called "woman sins."[8] A "woman sin" is a sin against

the self in which one's own beliefs and values are denied in order to accommodate someone else's image of how one should behave. While it is certainly true that relationships are important to both men and women and good relationships demand some compromise and sacrifice, it is not true that one needs to sacrifice one's entire self in order to stay connected. Yet many women believe that only by living out idealized images and denying the self will they be loved and remain connected.

When women feel that they have lost approval and love because they have failed to live up to idealized images, they may reaffirm their commitment to those images, almost saying to themselves and to the world, "Just give me one more chance; I'll do it right this time." One woman, who had become a mother when she was only seventeen, felt that she had been an inadequate mother. She resolved in her early forties to have another child in order "to do it right" this time and thus to prove to her family and to herself that she could live up to the ideal of the Good Mother and therefore deserve her family's love and approval. Another woman who felt that she had failed to be a good daughter to her parents when she was a young woman, resolved toward the end of her life to recommit herself to the image of the Dutiful Daughter. Her parents were now in their nineties and she herself was in her early sixties, yet she took on the role of Good Daughter, attempting to win their approval and love. By behaving in ways that she had been unable to do as a younger woman, she hoped to reclaim her rightful relationship with her parents.

Women have not just imagined that they will win love, approval, and connection by accommodating to idealized images. For most women this has been the reality of their experience; they are loved better, cared for better, and approved better when they do as they are told and behave within the confines of a narrowly circumscribed sphere.

One of the reasons that it is difficult for women to break free of confining images is that those images do indeed bring them love and approval. If one is rewarded for denying one's self or if one is loved because one lives out a script prescribed by someone else, then it may be difficult for one to walk away from those idealizations. We are not fools, we do not hold on to

images, however constricting they may be, that bring us no re-
ward. It is the very reward which we reap from stepping will-
ingly onto the pedestal of idealized images that keeps us there
and prevents us from acting freely.

<div align="right">Fear</div>

While some women may be seduced into accepting limited
roles for themselves in exchange for love, others go willingly
onto pedestals because they are afraid of the alternative. An
idealized image offers a woman a clearly articulated script for
how to live her life. She does not need to make autonomous
and independent decisions; she may not even need to assume
personal responsibility. She just has to learn the lines in her
part and she will be taken care of.

The living of an authentic and independent life can seem like
a frightening prospect. From the safety and security of our re-
lationships it is easy to talk glowingly about the options of being
one's own person, yet those options bring with them certain
fears and worries. When we think of the stories of male heroes,
for example, we remember that the young prince must leave
the security of his family's home and go off on a journey, often
without the road clearly marked and with little other than his
own resource to guide him on his way. While there is some-
thing exhilarating and adventuresome about such a journey,
there is also something frightening. If one stays behind and
remains the Good Girl, the Good Wife, or the Good Mother,
one knows how to live one's life. One is denied the adventure
but one is protected from the danger. It is out of fear that
many women cling to idealized images.

One woman recounted her experience of going off to college
and being frightened and intimidated by all the choices and
possibilities that lay before her. She experimented a little with
different courses and with different social relationships but
found that her experimentation, rather than opening new
doors for her, made her increasingly frightened and intimi-
dated. Her solution was to return home and marry her high
school boyfriend. Safely ensconced in the role of Wife, she
would not have to confront many of the open-ended options

that presented themselves to her during her brief stay at college.

While it is obvious that many women marry for reasons other than fear, some certainly find the clear guidelines of the Faithful Wife as a safe alternative to having to make more independent and dangerous choices. One woman, for example, who was very aware of her own fears about being on her own and being independent, used the role of Wife as a temporary bridge for herself. She knew that as long as she was in that role she would know how to behave. She temporarily allowed herself to be defined by the image of Wife while she considered her options for how to live her life. One might argue that this woman hid behind the role of Wife afraid of really testing herself. Yet, as she saw it, the pedestal of the Faithful Wife gave her a safe platform from which to explore other options. Several years later, she was still married to the same man; yet now she described her marriage as a relationship; she was no longer wedded to the image of Wife.

Another woman who had assumed that she would be a mother and that she would live her life nurturing and caretaking a large family found her plans disrupted when she learned that she was unable to have children. While she was clearly in mourning over the loss of a potential family, her biggest concern was about how she would define herself outside the image of Mother—"Now I will need to be responsible for my own life. When I thought I was going to be a mother I knew how to live; now I am not sure what I'll do. It just seems that there are so many choices."

For other women, the fear of living one's own life beyond the limitations set by idealized images causes them to "quit while they are ahead." If, for example, a woman knows how to be a Good Daughter, she may decide that she will spend her life safely nestled in the confines of that image, never exploring beyond what it means to be a Good Daughter and safely repeating the patterns that she has mastered well. One woman said to me quite candidly, "I know how to be a girl, I don't see why I should learn anything else."

Other women cling to their images out of fear of aging and what lies beyond those images as they grow into older wom-

anhood. Many of the women that I interviewed had had experiences with their mothers and grandmothers that were particularly traumatic and they could not imagine how to live the last part of their lives in any kind of harmony or peace. One woman said to me, "Old age is sitting on a beach in Miami, being lonely and isolated." Consequently she resolved that she would hold on to the image of Mother for as long as she could. The alternatives she envisioned were so bleak and frightening that she felt it would be madness to relinquish motherhood before she absolutely must. Another woman whose mother had grown bitter and resentful in a nursing home similarly resolved to stay active in her career forever. It seemed to her, as well, that old age was a frightening prospect, one that she wanted to avoid at all cost. Certainly our culture supports this fear of the last stage of life. We are continually exhorted that we are only as old as we feel and that if we just hang on tenaciously enough, the images of midlife will protect us from what lies ahead.

Power and Responsibility

Accommodating to idealized images of womanhood has always been a route to power and authority for women. By identifying with relational images, specifically the Selfless Mother and the Faithful Wife, women feel empowered.

As Mother, a woman can feel powerful in two ways. First she can feel a sense of accomplishment in having raised her children. She may feel proud that by mothering her children, she has guided and enriched their lives; she may even feel a sense of awe at having helped to "create" another individual. In this sense her power, akin to the creative energy of the Great Mother goddesses, is most legitimate. A mother also has the more coercive power to rule and dominate her children. For young children, no one is more powerful than Mother. Regrettably, some mothers become abusive in their exercise of parental authority and power.

It is also possible for a woman to feel powerful because she is associated with a powerful person. Her power exists by contagion. This is primarily the power of the woman who has identi-

fied herself as Wife. There are numerous examples of wives of powerful politicians or corporate executives who feel themselves to be powerful and important people as long as they maintain their relational connection to the identified object of power.

Consider in particular the "woman behind the throne," another image of acceptable womanhood. This is the good and strong wife who exists somewhere in the background. Part of our cultural lore is the belief that behind every successful man is a devoted woman. By nurturing and supporting the development and the success of her husband, the wife comes to experience power and importance herself. It may well be that women derive a sense of power and authority from identifying with idealized relational images because they feel they cannot—or should not—be powerful in their own right.[9]

Most women have an ambivalent relationship to power. They are able to be powerful in the context of giving and caring for others; however, they often believe that power in and of itself is selfish, unacceptable, and unwomanly. Although the idealized images of women may be revered, they are not images of authoritative women. Only in their authentic actions may women gain power that is truly their own. By identifying with idealized images women gain power through someone else. The Wife is not necessarily weak, but her power is derivative, coming from her association to her husband.

Throughout our history, women have been enjoined to use their energy to perfect the images of idealized womanhood. When colleges for women first opened in the United States, they were touted as places where women might learn to be better wives and mothers.[10] By educating themselves, women would strengthen the idealized roles that men found acceptable. To imagine that education might empower a woman for reasons other than being a better companion was unthinkable. We continue to be most comfortable with female power when it is limited to, and derived from, certain idealized roles.

The image of the powerful Career Woman is one that has received a great deal of public scorn, ridicule, and fear in recent years. The Career Woman, powerful in her own right, often seems demonic. Images of powerful women, both current

and mythological, are often images of diabolical and evil women.

Almost a hundred years ago, Charlotte Perkins-Gilman suggested that the economic reward women received for conforming to traditional images was one of the most damaging components of a woman's experience.[11] By conforming to societal expectations, women derive economic security and economic power; the Wife and Mother are housed, fed, and supported. The Eternal Girl and the Dutiful Daughter may even receive an allowance for remaining within role, and the Sexual Coquette, whether she is an ingenue or mistress, receives gifts and trinkets in exchange for remaining on her pedestal. If women did not derive economic power from keeping themselves confined within certain images, Gilman argued, they would be less inclined to do so.[12] The motivations that derive from love, approval, and fear may not be nearly as potent as those that derive from power and economic security.

Whether women allow themselves to be trapped by idealized images out of a desire for love, out of a fear of responsibility, or out of a striving for power, they deny aspects of their individuality and of their autonomy when they do so.

When discussing the phenomenology of being trapped by idealized images, it is important to note two caveats:

First, we must remember that women are willing participants in their own entrapment. It would be far easier for us to assert, as some feminist writers have in recent years, that we are trapped by the power of the patriarchy. While it is certainly true that many of the images which entrap us are the images of a male imagination, nonetheless we are willing participants in the process of becoming trapped. One could argue that if women felt more empowered, if they felt less in need of love, less frightened by responsibility, they would not so willingly enslave themselves. This may be true. However, if we are to change the way in which images control our lives, we must accept our own responsibility in embracing those images.

Second, just because a woman engages in behaviors that are similar to those of a woman who is trapped by an idealized image, does not necessarily mean that she herself is trapped. A woman can be married, engaged in a loving and committed

relationship, and in no way trapped by the image of Wife. Similarly, a woman can nurture and caretake her children and once again not be trapped by the image of Mother. She can enjoy her sexuality outside the confines of the Sexual Ingenue, and can be creative and ambitious without being identified as the Career Woman. Just participating in certain activities and certain relationships does not necessarily mean that one has given over one's autonomy and that one is no longer operating as a free agent. To be trapped is to be sleepwalking, to feel that somehow one's actions and one's behaviors are not in sync with one's deeply held values and beliefs. When a woman is trapped she may well feel that she has walked into the wrong story, that the life she is living is not her own.[13]

For each stage of a woman's life we are presented with images of womanhood. These Mythic Personalities sit securely on the pedestal, influencing the dreams, expectations, and fears of both men and women.

In young womanhood, we meet the Eternal Girl, the Dutiful Daughter, the Free Spirit, the Charmer, and the Lolita. All of these present us with portraits of child-women.

In midlife, the images which assume prominence all reflect a child's need for, or fear of losing, a nurturing protector—the Selfless Mother, the Faithful Wife, the Happy Homemaker, the Super Mom, and the Career Woman.

Older womanhood, because it is a less recognized and honored time in a woman's life, presents us with fewer robust images of women. Those images which do exist are either continuations of earlier images or images which reflect the older woman's status as "exile" in the larger culture. The pedestal is now occupied by the Grand Mother, the Sweet Old Lady, the Witch, the Spinster, and the Wise Woman.

While specific images originate in each chronological phase of a woman's life, the impact of those images is not limited only to women who are in that phase. Women are affected by *all* of the images of womanhood throughout their lives. The Eternal Girl continues to influence how older women think about themselves, just as the Witch influences the self-concept of younger women.

Images of
Young Womanhood

It has been suggested often that all of the images of womanhood which tempt and ultimately trap women are images of male fantasies and desires. While we might easily raise questions as to whether or not this is true for either the images of midlife or older womanhood, it certainly seems to be the case for images of young womanhood. The idealized images of the young woman emerge from the imagination of men. These images have evolved to reflect the way men prefer to see young women and perhaps all women, since the images of young womanhood are often synonymous with images of femininity itself.[1] These images present us with pictures of women who

charm, entertain, and occasionally seduce men; generally they are women who are easily controlled and rarely intimidating; infrequently, however, they do possess an aura of uneasy power combining sexuality, desire, and dangerousness.

Regardless of their specific form, all of the images of young womanhood present us with portraits of child-women. These are women who cannot, will not, or do not know how to grow up. They may have the bodies of women, but inside they remain girls.

In her most childlike and helpless embodiment, the young woman is the *Eternal Girl*. When she enters into a relational mode she becomes the *Dutiful Daughter,* behaving like Persephone, the Dutiful Daughter of Greek mythology, who only blooms forth during the eight months of the year when she is in her mother's presence. The Dutiful Daughter lives only in and through her relationships with real or symbolic parents. When she is independent and carefree, the child-woman is a *Free Spirit,* choosing not to accept constraints and responsibilities and as one woman said "following her bliss."

Each of these images, the Eternal Girl, the Dutiful Daughter, and the Free Spirit is childlike in part because each is asexual. The Eternal Girl is too naïve, the Dutiful Daughter too responsible, and the Free Spirit too self-absorbed to be swayed by passion or moved by sensual pleasures. Two other images of young womanhood combine sexuality with girlishness. The *Charmer* presents us with the image of a young woman who is flirting with her sexuality. In keeping with her young woman persona, however, her sexuality is more of a promise of things to come than it is an actual expression of passion and desire. She is coy, playful, and free to tease. Only in the image of *Lolita* do we meet the young woman who has become the sexual seductress, part love slave, part demonic mistress.

While the images of young womanhood are based on fantasies about young women, as images they have relevance for midlife and older women as well as for young women. Regardless of their actual ages, some women continue to be referred to as "girls" throughout their lives and as psychological "girls" are forever subject to the seductive power of the images of young womanhood and the rewards of love, care, and desir-

ability which are forthcoming to those who remain on this particular pedestal.

The Eternal Girl

Whether she is "Daddy's little girl" or "God's sweet angel," the Eternal Girl is the object of someone else's control. She belongs to God or to her father but certainly not to herself. First and foremost, the Eternal Girl is childlike. She is often portrayed as being thin, frail, and petite. Her voice is small, her style demure and naïve, her hair is long, usually blond, and she blushes when anything frightens or intimidates her.[2]

Not surprisingly, such an idealized young woman does not age or mature well. In fiction, writers often find it necessary to dispense with her by creating a premature and tragic death.[3] Of course it is not so easy for the real women who are identified with this image of the Eternal Girl. They cannot conveniently disappear after the first act, remaining forever young in our memory.

When a woman is identified with the Eternal Girl, we are inclined to favor her girlishness above any sign of intensity or engagement. Adrienne Rich gives as an example of this phenomenon the poetess Emily Dickinson.[4] Dickinson was referred to as a girl throughout her life and even after her death at age fifty-five. She was best known and immortalized for her sweet, gentle poetry, and for the fact that she would frequently send bouquets of white flowers to her friends. Rich says that this image of her as the girlish and enchanting writer was perpetuated at the expense of a very different view of the poetess as a woman who was impassioned, intense, angry, and sexual. As a young woman, Dickinson was self-possessed and determined to follow her own spirit; yet that aspect of her early development is often left out of biographical descriptions of the poetess in favor of portrayals which emphasize her childlike qualities.

In keeping with her girlish persona, the Eternal Girl is also passive. Many writers have highlighted depictions of young women in folklore and fairy tales which portray them as pas-

sively waiting for a hero or a prince either to rescue them or to bring meaning or engagement to their lives.[5] Sleeping Beauty, Cinderella, Snow White, and Rapunzel, all Eternal Girls, spend more than half their time waiting for something to happen. These young women sleep through much of the action of the story.

In addition to extolling this position of passive waiting, fairy tales often demonstrate for us that Eternal Girls who move beyond passivity get themselves into serious trouble. In the story of Sleeping Beauty, the heroine brings disaster on herself when she explores the locked rooms in the tower. When she allows her curiosity to lead her, she encounters the wicked godmother disguised as an old woman spinning yarn. When Sleeping Beauty takes some initiative, she is punished by lapsing into a long and passive sleep. The story's message is clear: passivity is the appropriate position for an Eternal Girl and if she chooses to venture beyond passivity, she will only bring disaster on herself.

It has been suggested that the course of action for young women in folklore is not merely to wait, but to wait for a particular end. The woman waits so that she will become the object of desire and the bride of some handsome and stalwart prince.[6] When her waiting ends, her independence, such as it was, ends as well. She now becomes an object, a prize in the drama whose principal actor is the prince.

Jung labeled this idealized Eternal Girl as a *femme à homme,* a woman who waited passively to be a receptacle for the projections, desires, and wishes of some man.[7] The wide-eyed receptivity of the Eternal Girl is essentially passive. Unlike young women in general who are free of entrapping images and who actively engage the world, taking in anything and everything, the Eternal Girl waits like an empty vessel to be filled by anyone who chooses.

Given that she is childlike and passive, it is not surprising that the idealized Eternal Girl is also helpless. In stories, she is frequently victimized by human, animal, or supernatural monsters.[8] In everyday life, she may feel that she needs assistance in handling even the most mundane of tasks. One woman in her early forties continued to feel overwhelmed and even panicky

whenever any mechanical device malfunctioned. She felt that she could not focus her thoughts in the direction of a solution and her only alternative was to call her father, who would come to her assistance. The image of the woman who becomes helpless and childlike in the face of an unbalanced checkbook or a flat tire has been the subject of numerous jokes and "humorous" characterizations.

Paradoxically, in the face of the derision she receives for being helpless, the Eternal Girl is often valued and cherished because of her very helplessness. Perhaps the most blatant and destructive idealization of the helpless maiden occurred in China where more than a million women had had their feet bound and crippled as young girls in the name of idealized femininity.[9] Foot-binding involved taking the girl's toes, curling them under her foot, and bandaging them tightly back so that her foot became like a small box, denying her a surefooted and forthright step. A woman walked like a toddler, feeling as if she might fall forward with each step. Rather than feeling like a competent adult, a woman felt as if she were perpetually just learning to walk, like a young child not yet sure of her own steps and dependent on others to support her. This frail, crippled, and childlike posture was considered a sign of beauty for Chinese women and in fact women became the object of erotic and sexual desire because they had very small and crippled feet. A woman, who for whatever reason, did not have bound feet was considered ugly and disgusting and was ostracized from the society of men and women. In this case an entire culture was captivated by and paid homage to the image of the Eternal Girl. It is a strange perversion of nature when being helpless and crippled is to be beautiful and desired and being strong and surefooted is to be ugly and denigrated; yet such is the power of idealized images.

Helplessness not only renders a woman vulnerable and dependent, but it also relieves her of any responsibility for taking care of herself. A woman, for example, who can barely walk is certainly unable to care for her own home or to fend for herself outside of the home. She is in no way a responsible agent and can be relieved of any sense of active agency for the events in her life. The Eternal Girl is thus also the irresponsible woman.

Women who consciously or otherwise accommodate to this image of the Eternal Girl guarantee for themselves, at least for a period of time, a position of love and adoration. They also insure, once again for a period of time, that they will be valued, cared for, and protected. However, like the young wife Nora in Ibsen's *A Doll's House,* the woman sacrifices her own autonomy and her personal development for love and security.[10] She becomes dehumanized, living in an artificial world, in a doll house, an object of desire but not an active agent in her own right.

Harmful psychological consequences befall women when they identify too closely with this image of the ideal maiden, the Eternal Girl. First, if one truly believes one's self to be childlike, helpless, and passive, then one must necessarily feel frightened and timid. The world seems powerful and threatening and the young woman does not experience herself as having the power or strength to protect and defend herself; consequently she often feels afraid of what she perceives as direct, external threats. As a consequence of being vulnerable in the world, the young woman also lives in fear of losing her much-needed protectors. Paradoxically, this fear serves to freeze her in her pathological identification with the idealized helpless maiden. Her unconscious reasoning goes something like this: "I am weak and helpless. He loves me because I am weak and helpless. I need him to protect me. I must remain weak and helpless so he will continue to love and protect me." Such a woman fears that if she strays from her position of passive helplessness, she will lose whatever respect, love, and protection she has in the world. It is certainly not uncommon for young women to feel that they have to deny themselves, to play dumb, to play helpless, to play victim in order to secure the love and safety they need. A woman wedded to helplessness must necessarily come to fear her own strength, since that strength poses a threat to the network of masculine protectors she feels she needs in order to survive. She thus condemns herself to remain weak in order to stay safe.

When she is not blatantly fearful, the childlike woman is often beset by feelings of general uneasiness and confusion. Since she does not experience herself as an active agent but

rather as a passive vessel, she often does not know her own desires and own wishes. She is cut off from whatever true self might have existed and feels that she must wait for others to tell her what she should do, what she wants to do, what she can do. Consequently, when faced with having to make an independent decision she feels panicky, indecisive, and unable to chart her own course, in part because she has been denied access to her own inner and true feelings. In a more extreme version, it has been suggested that some agoraphobic women may well be women who have so identified with the helpless and vulnerable maiden that they are truly afraid to go out and act in the world without some assistance.[11] Some women spend their days hiding inside their homes, having a friend or a male protector traffic for them with the world. For these women, the Eternal Girl has so dominated their sense of who they are that they cannot imagine an alternative way of being.

An even more life-threatening consequence of an identification with the idealized girl may be the development of certain pathological eating disorders.[12] The idealized body of the young girl is that of a twelve-year-old; one who is still slender, somewhat boylike in her appearance, and does not yet have the fullness or the roundness of a mature woman. Someone wedded to this image of the idealized girl cannot allow herself to attain the body of a mature woman. In some extreme cases, women will even subject themselves to starvation rather than relinquish this idealized body image.

Double jeopardy falls to women who are identified with the image of the ideal helpless maiden. They not only feel personally weak but they also become overly dependent on the generosity and good graces of the men who rescue them. Many women have waited passively for a Prince Charming who turns out to be a monster in disguise. When one has committed one's security and one's identity to another, one is vulnerable to the good intentions of that other person. There is a loss of self even when the rescuer is a kind and gentle man; when he is a demon or an abuser, one not only loses one's sense of psychological self, but one puts one's physical self in jeopardy as well.

A woman's attachment to the image of the Eternal Girl can be so powerful and so systematically reinforced by her impor-

tant relationships that she can maintain that attachment regardless of her real-life circumstances. Women of all ages—married women, women with children, as well as young single women—are all subject to the allure of the Eternal Girl.

Liza's Story

Despite the fact that she is the mother of two children, Liza finds herself still struggling with the image of herself as a girl. She does not yet know if she can allow herself to grow up and be a mature woman. Liza is the youngest of four children and has been told ever since she can remember that she will always be a child to her parents. On her wedding day her father said to her: "It doesn't matter what you do, you'll always be sixteen to me." The pressure for Liza not to grow up was very strong. Whenever she attempted any new or independent activity, her parents would commiserate with her, "Poor Liza, it's so difficult." Rather than encouraging her or nurturing her independence, they made it seem as if growing up was the hardest task in the world. Repeatedly they would encourage her to think in terms of a Prince Charming, some powerful man who would rescue her from the responsibilities of adult life and who would allow her to remain forever a child. It is not surprising that during her teenage years, Liza developed an eating disorder. She now believes that her anorexia was directly related to her trepidation about acquiring an adult body. She was certain that she needed to stay a girl in order to keep her parents' love and affection, consequently as her body started to develop she became frightened and anxious. She literally starved herself in order to preserve an image of herself that was pleasing to her parents.

When she went off to college, Liza made a conscious decision to separate herself from her family and from her parents' expectations. She enjoyed school, especially the social aspects, and in retrospect she believes that she took advantage of some of her freedom to act out in destructive ways—drinking and taking drugs beyond healthy limits. At the end of her freshman year, her parents insisted that she return home. They judged her to be an irresponsible young woman who could not live

independently away from them. When Liza asserted her desire to get a summer job and continue living away from her family, her parents declared that they would cut her off financially; if she wanted to be independent then she would have to be really independent. For a while Liza accepted the challenge and pursued her own activities separate from her parents' watchful eye. However, the pressure of being isolated and cut off was too great for her, and within a few months she began to experience symptoms of anxiety and depression. What she calls her "nervous breakdown" resulted in her returning home to the care of her parents and a psychiatrist.

Liza felt totally defeated by this experience. Her attempt to break away not only from her family but from the image of herself as an Eternal Girl had failed. She had gone back home humiliated and crestfallen, believing she would have to accept her parents' definition of who she was—a woman destined to remain forever a girl. Following the recovery from her nervous exhaustion, Liza returned to college. However, she was now subdued and less actively engaged than she had been before her struggle with her parents.

After college, she proceeded to get a series of temporary jobs at which she succeeded wonderfully until her employer offered her a permanent position. As soon as the temporary job turned into something permanent, Liza would panic, be unable to perform, and eventually be fired. If working symbolized being a competent adult, Liza could only allow herself to work successfully if the job were designated as temporary. She could be a "temporary" mature woman but not a permanent one, and if anyone demanded permanence of her, she would become agitated and unable to cope.

When she was in her mid-twenties, Liza met the man who was to become her husband. He was a stable and caring man who, interestingly, worked as a counselor in a crisis center when Liza met him. She now believes that his job was part of what attracted her to him. As a man who could solve other people's crises, he was a potential rescuer, and Liza initially looked to him to stabilize her life. Her parents were disapproving of her decision to marry, in part, she believes, because they would have disapproved of any movement into adult wom-

anhood. However, they specifically disapproved of her choice of a husband because the man was not of an educational background that they felt was suitable for their daughter. Again Liza received a message from her parents that when she tried to be an adult woman, to take responsibility for herself, and to make her own decisions, she was incompetent.

Perhaps more than in any other arena, Liza has experienced a conflict over being a girl versus being a midlife woman in relation to the birth of her two children. When her first child was born, Liza felt "completely out of control." She remembers during labor being unable to push the baby out and being screamed at by her obstetrician, "What's wrong with you? Push!" It is significant that Liza felt out of control during the experience of giving birth, an event which often symbolizes a woman's transition from girlhood to mature womanhood.

When Liza brought her baby home, she felt incompetent to be a mother. The child cried constantly and Liza had difficulty nursing. The midwife she consulted told Liza she was "doing it wrong," so once again Liza felt inadequate to the task of being a successful mother and a competent adult. When she brought her baby home, Liza became fixated on her need for a changing table. Specifically she wanted the table used by a friend of hers whom she deemed a successful and competent mother. She believed that if only she could get this changing table from her friend, she would then be able to do the tasks she needed to do. The table became a symbol of the change which Liza herself needed to make. In many ways, it was her own adolescent self that she needed to put on the changing table to initiate a miraculous transformation, changing herself from an Eternal Girl to a creative and nurturing mother.

In between the birth of her two children, Liza had a miscarriage. Once again she became panicked and out of control. As she started to bleed, the very femaleness of the experience frightened her. She says, "I had to be an adult and I just wanted to die at that point." The death imagery is not insignificant since many women do experience the transition from girlhood to womanhood as a type of death. Liza has experienced the death of her young self, the only self that has ever been valued or affirmed by her parents, as traumatic; she has strug-

gled over whether or not she wants to relinquish her adolescent identity and move fully into the role of a midlife woman.

Although Liza reports being somewhat more comfortable with the role of Mother since the birth of her second child, she continues to struggle with anorexia and issues of body image. It is very difficult for her to accept and embrace the image of a full-bodied woman. Despite the fact that she wants to nurture and care for her children, she is ambivalent about being a woman who has full breasts and large hips. To present herself physically in the world in such a way would be to make a statement that she is no longer a girl. For a woman whose only positive connection to her parents has been through the role of daughter and girl, such an affirmation is a frightening one. It risks abandonment and the loss of her relationship with her parents.

Because of her eating disorder, Liza has been in therapy off and on for the last several years. Recently she has chosen to leave individual therapy and to enter a couples therapy. Her choice stems in part from wanting to avoid the characteristic daughter/father relationship that develops in relation to her male therapist. In couples therapy, she must acknowledge herself as an adult woman; only *women,* not girls, are part of married couples. While she is certainly aware of her struggle, Liza remains stuck in the transition between young womanhood and midlife, unable to completely relinquish her allegiance to the Eternal Girl, an image which has defined her both to herself and to her family for many years.

The Dutiful Daughter

A kindred image to the Eternal Girl is the Dutiful Daughter, an image of a woman who is forever defined by her relationship to her parents. The Dutiful Daughter sacrifices her adult successes and her mature relationships in order to remain the good girl her parents need her to be. She is the woman who forgoes college in order to remain home and help her mother care for younger siblings; who breaks off her engagement to stay home and attend to the needs of her widowed father; who

neglects her own children to answer the demands of her over-bearing mother. She is often helpless and vulnerable in her dealings with the world, but for her parents she is the responsible little soldier, always there to do her duty regardless of the personal price she must pay.

In the story of Beauty and the Beast, we encounter an archetypal Dutiful Daughter. The story begins as Beauty's father, a merchant, falls on hard times when his trading ships are lost in a storm. The merchant must tell his three sons and three daughters that their fortune has been lost and that they will all need to work if the family is to survive. The three sons readily take up their tasks as workers, not because they are "good sons" but because they are men and their rightful response to a crisis is to take action. Of the daughters, only Beauty willingly works alongside her brothers. Her motivation is different from theirs, however. As a Dutiful Daughter, Beauty does what needs to be done in order to ease her father's guilt and his distress over the family's predicament. For Beauty "the look of pride in her father's eyes was reward enough for her."[13]

As the story progresses, the merchant takes a journey in hope of finding his lost cargo. He asks his daughters if they have any requests should he be successful. Beauty's sisters request fine dresses and beautiful shoes, but Beauty asks only for one red rose and her father's safe return. On his journey, the merchant encounters the castle of the Beast. After a night's rest, he prepares to return home, remembering Beauty's request for a single rose. When he steals the rose from the Beast's garden, the merchant rouses the monster who threatens to kill him unless Beauty loves her father enough to return to the palace in his place.

When the merchant returns home and tells his children of his encounter with the Beast, his sons are enraged. They want to return to the castle and kill the Beast. Beauty knows her role, however; she willingly agrees to sacrifice herself and save her father by returning to the castle. She is the flawless image of the Dutiful Daughter.

For many women, the power of the Dutiful Daughter is so great that they remain attached to this image well into midlife or beyond. For one woman, Esther, the image of the Dutiful

Daughter kept her trapped well into her fifties. It seemed natural to Esther to give up college in order to stay close to her widowed mother; it seemed reasonable to continue calling her mother nightly just before bed long after she was married and had children of her own. As Esther got older, however, she came to realize that her mother was a demanding and manipulative woman. During Esther's middle years, her mother experienced several medical illnesses. While these were legitimate illnesses, her mother used her medical condition to control her only daughter and to demand service and attention. Esther felt that since her mother was widowed, it was her responsibility to take care of her mother. She frequently dropped what she was doing at home and what she needed for herself in order to attend to the physical and emotional needs of her mother. Despite the physical and psychological stress, Esther never complained to her mother and only occasionally vented her frustrations to her husband. After all, she was only doing what was expected of her as a Dutiful Daughter.

During her forties, Esther suffered two stress-related hospitalizations and was advised by her physician to put her interpersonal house in order so that she might preserve her own medical health. This warning was not sufficient, however, for her to begin limiting her mother's often outrageous and demanding behavior. Only when her own husband suffered a heart attack did Esther realize that she would need to realign her priorities and attend both to her marriage and to herself. Such a shift was necessary if she was to be able to experience peace and happiness in the last phase of her own life. Esther spent many hours thinking of how to resolve the issues with her mother and at one point she considered seeking psychiatric help. She realized that she would not be able to change her mother's behavior and that she would have to take the risk of changing her own interactions, stepping off the pedestal as the Dutiful Daughter, and perhaps losing her mother's favor. Esther was driven not only by her desire to approximate the ideal of the good daughter but also by her need to win her mother's love.

On one particular occasion, Esther decided to go out of town

with her husband for a long holiday weekend. This decision followed her resolve to give more attention to her marriage and to take better care of herself. When she told her mother that she would not be available for the long weekend and that she had arranged for a visiting nurse to look in on her, her mother became outraged and accused Esther of being a selfish and ungrateful daughter. This attack was not only cruel and untrue, it undermined Esther's very sense of who she was. For years, she had allowed herself to be defined by the image of the Dutiful Daughter. Nothing is more damaging to that image than an accusation of selfishness. The good daughter's very essence is to be selfless in honoring her mother and father.

During her mother's attack, Esther remembers shaking inside but holding on to her resolve to stop catering to her mother's whims. When she told her mother that she was not going to change her plans despite her mother's upset and wish that she do so, Esther's mother actually calmed down and went along with Esther's realigned priorities. After this initial confrontation it became easier and easier for Esther to make decisions that placed herself, her children, and her marriage ahead of her obligations to her mother. When she looks back over her life, Esther is astounded that she had to wait until she herself was almost a grandmother to break out from the image of the Dutiful Daughter.

For another woman, Lana, her own experience of failure as a daughter has been a source of pain and self-doubt that has persisted into her eighties. Lana was the oldest of four children of a hypochondriacal and manipulative mother. From the time she can remember, Lana cared for her mother, took care of the home, and helped to raise her three younger siblings, presenting herself to the world as the embodiment of the Dutiful Daughter.

Her mother was always inventing an illness which made it impossible for her to attend to the tasks of nurturing and raising her family. Lana recalls frequently coming home from school and being afraid that the ambulance would be at her house taking her mother to yet another hospital for yet another series of tests for yet another imaginary illness. Lana says,

"I always had this ache. Walking home from school, I would wonder what is it going to be today. I was too young to be having that all the time."

Lana continued throughout her life to answer to her mother's calls and to be a responsible daughter, despite the fact that her mother was manipulative and controlling. Lana's feeling that she has failed as a daughter does not come from her failure to acquit her responsibilities or honor her obligations, but rather from her hidden resentment and anger. The Dutiful Daughter not only acts the part, she is supposed to feel it as well. Lana, however, frequently wished that she could escape from her mother's clutches and at one point, following her graduation from college, Lana almost decided to move to Oregon, far away from her mother and far away from the responsibilities of being an oldest daughter. Lana did not like her mother and felt a sense of relief when, at the age of ninety, her mother finally died. Her sense of disconnection from her mother and her lack of love for her mother caused Lana to feel guilty, as if she had failed in the task of being a truly good daughter. When she hears other women her age reminisce about their own mothers with a sense of warmth and love, she feels angry and left out. She is ashamed to tell the story of her own relationship with her mother and to admit to other people just how much she hated her mother and how much she failed at being a true Dutiful Daughter.

Perhaps the most tragic examples of a woman's attachment to the image of the Dutiful Daughter come from the stories of incest survivors. In a desire to protect their fathers and to preserve their families, some women deny the reality of their own experiences, even to the point of placing themselves in continued jeopardy. One woman waited until she was fifty years old to enter therapy and begin healing the scars left by years of abuse. She had not allowed herself to remember her own history until both her mother and father were dead. As a good daughter, she kept her secret, even from herself, until her parents were beyond being able to be held accountable for their actions. Another woman spent forty years in a mental hospital, allowing herself to speak of her abuse only after she had discredited herself as a crazy person. Only when she was sure she

would not be believed and that her parents would remain safe could she speak the truth. For many women, the belief that good daughters take care of their parents before they take care of themselves has allowed untold abuse and cruelty to go unchecked while the Dutiful Daughter sits securely on her pedestal.

The Free Spirit

While the Free Spirit is a child-woman like the Eternal Girl and the Dutiful Daughter, she appears, at first glance, to be far more independent than these other two. The Free Spirit does what she wants to do, unfettered by responsibilities and commitments. In a desire to be free, the woman trapped by the image of the Free Spirit may actually limit some of her options, since some opportunities are only open to those willing to make a commitment.

Belinda, who identifies with Diana, goddess of the hunt, a quintessential Free Spirit, has planned to study in Europe for a year. However, she has chosen not to go through her university and be part of a structured and defined program. Rather she is going to get on an airplane, arrive in a city that has a major university, and, just "see what happens." She has only the ticket in her hand. She has no place to live, no defined plans, nor is her program sanctioned or governed by her university. Belinda is concerned that if she follows the usual procedures for studying abroad, important possibilities for growth and exploration will be closed off to her. She is aware that her lack of an organized plan may well result in her not having certain experiences and perhaps in her not being able to study. But she is not especially troubled by her lack of plans because she can always spend the time wandering around Europe, allowing herself to have different experiences and returning home to resume her studies within the safe structure of her university. For Belinda, being true to her image of herself as free and easy is more important than any particular experience she might have.

When she first began college, Belinda allowed her room-

mates to christen her with a new name. She was intrigued by the idea that there would be all of these people who would only know her as the name that they had invented. They would not know anything about who or what she had been before and consequently they would assume nothing about her. She would be totally free to be herself and they would approach her free of preconceptions and prejudices. Belinda believed that their openness to seeing her in a new way was synchronous with her being a Free Spirit. Her friends would not constrict her. They would not force her to conform to a preconceived image, and in that sense she could be open to her own self and to her environment.

While the seeming freedom and openness of the Free Spirit is often exhilarating to young women, and indeed some version of this image has been touted as the archetype of the women's movement, midlife women who have felt trapped by the image of the Free Spirit often feel that they have missed out on important experiences. Her concern with being unfettered and perpetually available to new experiences may mean that a woman fails to make commitments and assume responsibilities. She may skim along the surface of experiences, participating only superficially in events, and never diving deeper into relationships or career options.

Lilly's Story

Lilly describes herself as a late bloomer, someone who has drifted through much of her life without a real focus or a plan. While she has not been unhappy, she has had the sense that she has never really made choices for herself. In her desire to be free, she has often found herself just going along with the life established for her by her parents and later her husband.

As a young girl, Lilly felt out of step with her peers. She considered herself an outsider who defined herself by rebelling against existing fads and trends. She came of age during the 1960s and felt very in sync with the antiestablishment values of her generation. Lilly recalls this as the only period in her life when she felt in the right place at the right time. Her own phase of untamed exploration and her attachment to the im-

age of the Flower Child, a 1960s Free Spirit, meshed well with the cultural premium on openness and gave Lilly a sense of belonging.

During college, Lilly was actively involved in the anti-Vietnam War movement and felt herself to be part of a committed group of young women and men. She became "a big fish in a little pond" and enjoyed exploring different options and different possibilities, trying out relationships, and thinking of herself as a woman who had many avenues open to her. When college ended, however, Lilly returned home and took a marginal job waiting for the next phase of her life to "just happen." She assumed she would meet someone, marry, and have children and a home in the suburbs. While she embraced the values of her generation, Lilly quickly returned to the traditional female life script once she resumed living in her parents' home. She felt like a cork bobbing on water, waiting for the next wave to push her along.

While she was living at home, Lilly met her husband. She recalls that he was surprised that she was still living with her parents. When he found out that she could not drive a car, he insisted that she obtain her driver's license before they marry. While she complied with this symbolic gesture of independence, she was well aware that she was moving from the home of her father to the home of her husband without ever having to survive on her own or assume responsibility for her life.

Shortly after she married, Lilly took a temporary job as a receptionist in a lawyer's office. Lilly says that she was probably "the most educated, sophisticated receptionist of all time." She stayed at that job until her husband died, almost fifteen years later.

Lilly's husband was a very dynamic and charismatic man who made it easy for Lilly to live in his shadow. Her career was obviously less important than his and while she was able to generate ideas, he had the energy and forcefulness to implement them. Her husband was "the mover and shaker" of the marriage and Lilly was quite content to go along.

She and her husband spent much of their time away from work, repairing and refinishing their home. Like two birds, they were feathering the nest, getting it ready for an eventual

brood. The children never came, however; Lilly never quite felt ready to take the next step in her midlife development. One senses that Lilly felt very comfortable in a prolonged phase of preparation. The main body of her life work had not yet begun and she continued the stage of young womanhood into her middle years, with her husband comfortably allowing her to drift into becoming a midlife woman.

Lilly might have comfortably maintained her attachment to her image of the free and breezy young woman if tragedy had not struck. Within the space of six weeks, her husband was diagnosed as having a terminal illness, received a trial of chemotherapy, and died. She was thirty-seven. Lilly was traumatized and shocked by her loss. She had had no time to get accustomed to the alien notion of widowhood. One minute she was feeling carefree and secure and the next she was alone, feeling abandoned by her husband and isolated from her peers. She did not know any other thirty-seven-year-old widows; after all, "You're not supposed to lose your husband until you're seventy."

Lilly felt that her trauma was outside of the normal experience of other women her age. It smashed her image of herself as a Free Spirit, causing her to confront realities that were both painful and unanticipated. She says: "It was like losing your life to a great extent. Everything that was familiar, how you defined yourself, it was all gone so it was like starting out again, almost like being born again, none of the rules were the same, none of the grounding was the same at all." Lilly felt both very young and very old at the same time. It seemed to her that all of a sudden her whole life lay ahead of her; choices and decisions that should have been made years ago when she was a teenager or woman in her twenties now faced her as a woman in her mid-thirties. The image of the Free Spirit, so comfortable while she was a young woman, had not provided the foundation to sustain her through the tragedy of early widowhood.

Although the Free Spirit prides herself on being independent and self-sufficient, a subplot of her story often has her being rescued by an older, wiser man. In Harlequin romance novels,

for example, a spunky ingenue is often rescued and mentored by a wise older man.[14] In these stories, the young woman, assertive, eager, and filled with youthful enthusiasm not yet modulated by experience, gets herself into trouble. She is rescued by an older man who is strong and capable and to whom she surrenders responsibility for solving the problems in her life. The Free Spirit is tamed, guided, and even remade by her experienced and powerful rescuer. In Shaw's *Pygmalion,* for example, a feisty working-class flower girl is transformed into a lady by Professor Higgins; the professor then falls in love with his own creation.

Kelly's Story

Kelly, a young woman who sees herself as a Free Spirit, fears she will succumb to the *Pygmalion* subplot and allow herself to be brought along by some powerful man. Kelly left her family home when she was eighteen years old to go off to a prestigious small college. She felt excited and enthusiastic about leaving for college and eager to explore all the new intellectual possibilities that were open to her. She was also aggressively competitive and quickly assessed the athletic, academic, and social competition. Kelly wanted to become a writer like one of her brothers, and so she joined the literary society at the college. Within a short time, she was elevated to a position of responsibility and remembers plotting her future and vying for status within the college community.

When she graduated from college, Kelly moved to a big city and began pursuing her literary career. She avoided asking any of her family members or colleagues for help, thinking to herself, I want to achieve on my own, not through anybody else's help. At times, she was so wary of being controlled by someone else that she turned down legitimate offers of assistance. From the examples of both her mother and sister, she felt at great risk for allowing herself to be transformed by someone else's agenda, in particular, a powerful man who might be helpful and supportive but might also rob her of her own sense of self. Eventually, Kelly did allow an ex-classmate to help her secure a job. Once in the organization, she rose

quickly on her own merits and worked hard, always, however, thinking about the next rung on the ladder and how she might succeed even further.

While her professional life has been quite successful, Kelly's personal life has been traumatic and problematic. She has just ended a three-year relationship with a man ten years her senior. This man was older than she and attempted to take her under his wing, remaking her in an image that suited his needs. When she first met this man, Kelly felt confident and independent. Over the course of their relationship, however, her self-esteem plummeted. She says, "I had a lot of self-worth wrapped up in him and allowed him to judge me." This man repeatedly questioned Kelly's values, her interests, and her activities and made her feel that she was immature and irresponsible for behaving in the ways that she did. Kelly now says that she invested this man with an inordinate amount of authority over her life. She ignored her friends and also surrendered much of her independent judgment. Many of her tastes changed as a result of the influence this man exerted; he made her feel that her experience and her background were inadequate.

Despite problems present even from the beginning of their relationship, Kelly and this man decided to be married after they had known each other for only a few months. Invitations were printed, and a wedding gown was selected. Kelly was preparing to get married when her fiancé decided that he was having doubts about their relationship. Consequently the wedding was postponed indefinitely, leaving Kelly feeling publicly humiliated and shamed. The relationship, however, did not end with the broken engagement; rather, Kelly and her boyfriend continued to live together for almost two and a half years during which time Kelly felt that she was on trial. It was her job to transform herself into a woman who would be acceptable to this man, allowing him to re-create her in an image he might find appropriate for his wife. This attempt at reconstruction failed miserably and through the help of therapy and counseling, Kelly was able to assert herself and to end the relationship.

This experience has left Kelly feeling disturbed by how much

she allowed herself to be controlled by another individual. She has often asked herself the question, "Why do women let their world get so small because of a man?" She feels that she can lose herself in a relationship and allow a man to remake her in his image.

Currently, Kelly feels in conflict about how she defines herself. Within her family, she has two competing models: the men in her family are competitive, successful, and aggressive; the women, while they may be successful, tend to look to important men for self-definition.

The Charmer

Whether as the flirt, the flapper, the Gibson girl, or as Miss America, the Charmer is wholesome and robust, just becoming aware of her sexuality and the power it might bring her. Eternal Girls, Dutiful Daughters, and Free Spirits are loved and adored because they are such "girls." They are naïve, somewhat helpless, playful, and kittenish. Charmers hint that they possess a sensual and sexual side as well. Yet, they are also essentially "good girls." Even the flappers of the Roaring Twenties eventually settled down and became wives and mothers. They were gay, spirited, and flirtatious, all the better to catch one of the eligible post–World War I bachelors.

Scarlett O'Hara, immortalized in *Gone With the Wind*, was a classic Charmer. She was beautiful, spunky, and spoiled, with just a hint of sexual mischief. In her character, we witness her girlish naïveté as she plans to change her life "tomorrow," as well as her fierce independence when she battles to save her father's plantation. She is coy and coquettish, using her sexuality to gain particular ends. We get no sense that she has strong sexual appetites, merely that she is aware of her sexuality and knows how to use it to her advantage.[15] In fact, when she is overtly sexual it is always within the confines of one of her many marriages.

Mona grew up with the image of the Charmer firmly rooted in the family mythology. The story was told that her grandfather ran off with a flapper when he was a young man, leaving

her grandmother alone to raise the children, have a nervous breakdown, and become obese. The message was clear: Charmers are winners; wives and mothers are losers. Although he remained faithful to her mother, Mona's father reinforced this message. He would repeatedly ogle young women on the street or on television, telling his young daughter that she would need to "be a beauty" if she wanted to keep a man.

Although she is in her forties and is now married with two children, Mona continues to be trapped by the image of the Charmer. She panics when she imagines growing older and fears she will become a "crazy old woman in a rocking chair" like her grandmother. For Mona, not being able to win a man's attention seems like death, and she fantasizes that she might have to become a lesbian when she is no longer attractive to men.

Despite the fact that she is a full-time mother, Mona refuses to let her children call her "Mom." She sees the role of mother as incompatible with the image of the Charmer, and when she meets new people she will often fail to mention that she has a husband and two children.

Her penchant for being coy and flirtatious has occasionally gotten Mona into serious trouble. She has been raped twice and frequently has to fend off advances from men who think she is available. Despite the dangers that being a Charmer have brought her, Mona clings desperately to the image fearing that the only alternative is an image she finds even more deadly, the crazy old Hag.

In many ways the image of the Charmer is a bridge between the three asexual images of girlhood and the more fully sexual image of Lolita. The Charmer plays with her sexuality like a child with a new toy, not yet aware of its full possibilities.

Lolita

The image of the sexualized young woman, sex slave, nymphomaniac, or dangerous seductress has been part of male mythology for eons. Images of powerful, demonic, and sexualized young women appear in the mythologies of diverse cultures.

These young women are seductive temptresses who use their sexuality, feigned sweetness, and vulnerability to lure men away from their homes, families, and responsibilities. There is a recurrent image of the beautiful Siren, a woman whose voice is so sweet and so enticing that once men hear it they are unable to resist her charms. The seductive voice, however, is merely an illusion; once men follow the sound of the voice they meet their death. The most famous of these Sirens appears in Homer's *Odyssey* and only Odysseus is believed to be strong enough to resist the voice of these young women.[16] The other men on his ship must plug their ears with wax because they cannot resist the tempting song. Even Odysseus must be bound with extra rope so that he does not leap from the ship and meet his death in the cold waters.

A less familiar version of this same demonized young woman is "the woman with the net."[17] She is an image from native Aztec mythology who lures warriors from their home path with her sweet voice. In this case, she imitates the voice of the man's wife or mother, enticing him to join her. As the man runs toward the familiar voice he finds that no one is there and he is actually running toward a cliff about to plummet to his death.

In addition to seductiveness, trickery is an important part of the power of the sexualized young woman. She is not open and direct in her desires, rather she uses subterfuge and manipulation to gain her ends. The Deer Woman from the Oglala tribe transforms her physical form in order to ensnare her victims.[18] She emits a poisonous and seductive perfume, creating an evil spell and causing any man who comes near her to fall in love with her. The man desires to make love to her even though she has transformed herself into the figure of a deer. When the man is in the height of ardor and passion, she runs away leaving him to go insane.

The demonic maiden may seduce her victim with a promise that she will merge totally with him. She seemingly denies her desire to be her own person and instead wishes to enter into a symbiotic union. In Sioux mythology, there is a young maiden who invites warriors to unite with her in a magical cloud.[19] Within this heavenly union, she entices her victim to believe that the two will be fused as one. When the cloud lifts, however,

only the maiden remains standing, the warrior has been trans-
formed into a pile of useless bones. The woman promises sym-
biosis—a giving of herself totally to the man and a denial of any
desire to be a woman who is unto herself. She promises to give
herself totally to the man who in reality becomes the victim of
her charms. Not only does she fail to deliver on her seductive
promise, but she destroys the man who falls for her enticement.

Death is only one of the outcomes that befalls the man who
enters into the trap of this deadly virgin. Alternatively, men
were believed to lose their essential essence or spirit at the
hands of these demonic women. The Succubi, demons in
women's form, would visit men at night, force them to have
sex, and suck or draw out of them their very souls.[20] The Suc-
cubus would use this soul essence to create a new spirit or be-
ing, perverting the normal process of biological creation by
robbing the man of his male seed and using it in her own inde-
pendent, creative activity.

In all of the mythologies of the demonic young woman, her
chastity, her purity, and her charm are merely ruses; they are
used to entrap or ensnare a man who is presented as an unwit-
ting victim, unable to withstand her powers, and doomed to
submit to whatever indignation she might impose.

There is also within the Lolita mythologies an image of the
sexualized young woman as a victim of her own passions. The
prostitute, for example, is depicted as being in sexual heat, a
lustful nymphomaniac who cannot get enough of her man, or
as a masochistic sex slave, so spineless and weak that she cannot
escape the degradation foisted upon her by either her pimp or
her customers. These images, while not idealized and romanti-
cized within the conscious public culture, are a part of under-
ground male mythology.

This image of the young woman as sex slave is perhaps no
more explicitly depicted than in the *Story of O*. Andrea Dworkin
in her book *Woman Hating* describes the theme of this porno-
graphic novel: "The thesis of O is simple. Woman is cunt, lust-
ful, wanton. She must be punished, tamed, debased. She gives
the gift of herself, her body, her well being, her life, to her
lover. It ends in her annihilation."[21] When a woman becomes
identified with the image of the sex slave, she ceases to have

any existence other than as a sexual object. Her body becomes her main means for gaining recognition and acceptance. While in its most distorted embodiment, this image appears primarily in pornographic literature, it has been sanitized somewhat in order to make an appearance in some modern advertising campaigns. Perfumes with names like Obsession and Eternity depict a woman lost in the intoxication of passion, willing to surrender her soul for her lover.

The image of woman as Love Goddess has antecedents in Greek mythology. Aphrodite, goddess of love, participated freely and wantonly in sexual relationships with gods and with men. Interestingly, Aphrodite was created from a mixture of sperm and sea foam, a product of male masturbation and sexual fantasy.

Vicki's Story

Vicki is a tall and statuesque young woman who presents herself as the physical embodiment of male sexual fantasy. She has carefully constructed a persona that concretizes the image of the sadomasochistic love slave, equally comfortable in the sadistic or the masochistic position. Vicki wears her costume with pride and seems comfortable with the attention she attracts just by walking down the street.

Vicki is from a successful, intellectual family and has received degrees from prestigious Ivy League universities. She is the middle of five children and for many years thought that she came from the perfect family. She believed that her mother and father had the perfect marriage and that she and her brothers and sister were the perfect children.

Despite her idealized image of family life, Vicki's actual experience presented her with contrary evidence going back as early as she can remember. Her father was very patriarchal and cruel and he physically abused his children, kicking them down the stairs when he was angry. He often criticized them for minor infractions, the nature of which was beyond the comprehension of small children. In particular, Saturday mornings brought an especially stressful ritual. One of the children was assigned to help her father with a task. He would then give the

instructions in a way almost incomprehensible to a young child. If the child failed to perform the task or asked an inappropriate question, screaming would quickly escalate into beating. Despite these examples of his cruelty, Vicki's father loomed larger than life and she remembers idealizing him from the time that she was a small child.

Early in their marriage, Vicki's mother and father moved several times in order to accommodate her father's graduate education and his career. Vicki's mother has subsequently told her that after each move she was promised that it would now be her time to pursue her own career. However, her time never came and her husband always asserted his right to primacy. Vicki recalls thinking that things in the family cycled so much around her father that she knew at a very early age that "if I had a family I wanted to be the father."

One of her most disturbing childhood memories involves a broken promise. Vicki was told that if she could learn her ABC's she would be awarded any present she wanted. Vicki decided that she would like a pink Easter bonnet, one with flowers and ribbons. Her parents agreed and Vicki quickly set to the job of learning the alphabet. After a successful recitation, her parents took her shopping for the bonnet, where they selected a practical sturdy little hat, nothing at all resembling the fanciful and charming bonnet she had imagined. She remembers her father telling her, "You'll take this hat or nothing at all," and she asserted herself, saying, "No, I don't want that." Her father then forced her to accept the more serviceable hat with her mother looking on and being powerless to do anything. Vicki recalls that she concluded from this that one can never tell a man exactly what one wants otherwise one is sure to be disappointed. This experience was Vicki's first indoctrination into the world of frustrated desire, betrayal, and humiliation.

Throughout high school, Vicki was extremely popular and had a series of boyfriends. She also pursued her academic studies with success. Her relationships, however, dominated her high school years. She says, "I am very relational. I have often considered this a problem and a fault of being a woman." Whenever one of her relationships ended, Vicki felt devastated.

She felt worthless. "I would feel that there was nothing to me and I should just kill myself." Indeed, Vicki remembers feeling suicidal on several occasions when a relationship with a high school boyfriend came to an end.

Although none of these breakups did in fact result in Vicki's attempting suicide, she made her first suicide attempt when she was a senior in college and her parents announced that they were divorcing. Vicki's mother confided in her at the time of the divorce that the marriage had been a sham. She had never been happy and had always felt that she had had to deny herself in order to be a satisfactory wife to her tyrannical husband. Vicki remembers feeling devastated by this news. Not only was the divorce itself difficult for her to accept, but her mother's revelation that this idea of the happy family had in fact been a fantasy was more than Vicki could assimilate. She became suicidal, feeling as if she was empty, worthless, as if nothing mattered. She felt identified with her mother, as if her own marriage were ending and she was being left bereft and alone. Following her suicide attempt, Vicki entered therapy and began to explore the nature of her relationships. However, she also turned her attention even more aggressively toward fulfilling the needs of the important men in her life.

Vicki likens her first job after college to prostitution. She was the executive secretary of a very successful man and a condition of her employment was that she be available for sex whenever he asked. Vicki not only enjoyed the sexual part of her job but felt that the frequent humiliation and betrayal she suffered from her employer helped her to feel aroused. She knew at the time that there was "something sick about it" but she enjoyed it nonetheless.

At the time that she was servicing her boss, Vicki was also having sexual relations with several other men, and she remembers feeling that her sexuality was out of control. At one point, she became completely obsessed with a man who reminded her very much of her father. This man introduced her to drugs, specifically cocaine, and she was quickly addicted. Vicki describes the time of her cocaine addiction as the most frightening period in her life. While she felt that her addiction to men and sexuality were within her control, her cocaine ad-

diction was more powerful than she could manage, and she eventually entered a drug treatment program in order to get help.

The years following her recovery from addiction read like a travel log of the men Vicki has known. She can barely talk about a time or event in her life without talking about the man of the hour. Her relationships are often primarily sexual ones in which she surrenders herself completely to the needs and desires of the man she is dating. Vicki believes that people are animals and what she wants with a man is an animal connection. For her, animals only "eat, fuck, or kill." Consequently her relationships are violent, passionate, and sexual. Even when she is with her women friends, Vicki is most compelled by discussions of sex and talks for hours with her friends about her sexual relations and theirs.

Vicki sounds like a true believer when she expounds on the virtues of losing yourself for love: "It is wonderful when a woman can sacrifice for a man and feel that the rewards of love are worth it." Vicki admires a friend of hers who has denied herself and sacrificed her own autonomy for the man with whom she lives. This friend spends most of her day waiting on her mate, tiptoeing around the house so as not to make any noise, and being ready should he ask her for any kind of service. Vicki feels that her friend's total self-abnegation is a reasonable trade for love and companionship.

Since her graduation from college, Vicki has worked at a series of menial jobs. She works to support herself, yet she has never been invested in pursuing a particular career. Most of the time, her jobs turn into a vehicle for meeting a new man and she frequently sexualizes the work environment, having an affair with a coworker or a boss. In the last several years, however, Vicki has attempted a number of artistic pursuits. In each case, her images are violent and sexual. She paints pictures of women who are violated and vessels waiting to be filled. Recently she has written plays that are explicitly pornographic and is currently involved in having her plays performed in nightclubs and small theaters. Vicki's drama is about submission and sexual slavery and some of the lines could clearly have been written by the character O.

Vicki feels that she has no personal worth unless she is reflected in the eye of her lover. She loves feeling that she only exists for him. When I suggested to Vicki that she was perhaps overly identified with the image of woman as sexual slave and that she was living out the shadow side of female possibility, she was somewhat disturbed. She did not like the idea that she might be the object of certain projected fantasies of both other women and the men with whom she interacted. Although the idea of being controlled and owned in a sexual relationship made her somewhat uncomfortable, Vicki was really at a loss for how to break her addiction to sexuality. It seemed to her that the only way in which she could feel alive was to be in a sexual and degrading relationship with a man, seeing herself as completely identified with the image of young woman as Lolita.

In all of the various embodiments of the young woman, elements of power, sexuality, and evil combine in ways quite different from how these elements intermingle in male mythology. The young woman is only powerful if she is sexual and evil. If she is sexual and good, she is able to be controlled. When she is asexual, she has no real power regardless of whether she is good or evil.

All of the images of young womanhood have the potential to trap women of all ages. While these images may have been crafted by men, they have been adopted, honored, and nurtured by women. Whether she is sexual, helpless, or naïve, the idealized young woman is childlike and as such she is the object of desire. "If you want to be loved and adored," she says, "be like me." Her attractiveness derives in part from her feigned or real powerlessness. She poses no threat to established authority, and is willing at times to trade her essential aliveness for security and love.

Chapter 4

Images of
Midlife Women

If the images of young womanhood originate from the imagi-
nation of men, then the images of midlife derive from the fan-
tasies of children. The images of midlife women—*Selfless
Mother, Faithful Wife, Happy Homemaker, Super Mom,* and *Career
Woman*—all reflect the wishes, fears, or needs of a young child
for care, support, and nurturance.

In the cases of the Selfless Mother, the Happy Homemaker,
and the Super Mom, a woman's caretaking functions are obvi
ous. She is named and defined by her relationships to children
and by her obvious investment in their world and in the home
in which they are raised. It is not surprising that three of the

predominant images of midlife depict a woman with a child in her arms. Not only does this image correspond to the inherent narcissism of children who imagine themselves to be the center of their mothers' universes, but it also reflects the primacy of childrearing in the lives of most women. All children grow up with the idea that it is reasonable and expected for a woman to define herself in terms of her mothering capacities and her mothering style. This expectation is even stronger for girls. Young girls, when asked what they want to be when they grow up, say, "I want to be a mommy."[1] "Mommy" is for them a way of life, a profession, an ideal image that has been identified as the primary way that a woman exists in the world.

Many of our religious organizations and churches support the notion that biological motherhood is the highest expression of womanhood.[2] The expectation exists within our society that women will be truly fulfilled only when they become pregnant and give birth.[3] In recent years, a favorite theme in the popular press is the tragedy of women who are unable to conceive a child. These articles usually chronicle the personal ordeal of an individual woman who must come to terms with the fact that she cannot bear a child, and in that way cannot be a true woman, a normal woman. While these articles generally conclude with some hopefulness or some resolution that the woman might be able to find other ways to be involved in nurturing activities, the message is clear: biological mothering is central to the images of midlife women.

As for the other two images of midlife women—Faithful Wife and Career Woman—one might think that these are not images created by a childish imagination, but rather that they originate from the mind of men in the first case and from the fantasies of a woman herself in the second. But such reasoning would be false. The Faithful Wife—steadfast, caretaking, and loyal—is merely the Selfless Mother with only one child, namely her husband. Her qualities are remarkably maternal; she is generally asexual and she is known for her unwavering devotion to her husband. It is not infrequently that we hear a woman complaining of her husband, "He doesn't want a wife; he wants a mother." In fact, a wife is just what he wants, an idealized image of the Faithful Wife who will love him and take

care of him just like his Selfless Mother did. It is important to remember that these images do not originate with adult men who might legitimately deny that they want a caretaker rather than a lover and a partner. These are the fantasies of our shared childhood where caretaking, love, and security are all that matter.

The Career Woman, as she has been depicted in this culture, is not an independent and successful woman; rather, she is a dressed-up version of the Diabolical Mother, a timeless image of negative mothering. The bloodthirsty Hindu goddess Kali and the monstrous Greek Gorgons foreshadow more modern fairy tales in which wicked stepmothers embody the evil, demonic mother. She is selfish, ambitious, and cunning. Rather than caring for others, she neglects their needs in her single-minded striving for power. She is to be feared—every child's nightmare of the Selfless Mother gone berserk.

The Selfless Mother

Unlike the mother of nursery-rhyme fame who "had so many children she didn't know what to do," the Selfless Mother is all-nurturing; she never has too many children. She is always able to nurture, feed, and succor those to whom she has given birth. In Mexico, the all-giving mother is known as "the woman with four hundred breasts."[4] There are enough breasts for all possible children. This woman never runs out of supplies; her milk never runs dry.

The fantasy of undiminishing supplies occurs throughout mythology and folk literature. A magical source of food appears that never seems to lessen in quantity no matter how much is eaten. These images suggest to us the nurturing quality of the idealized mother. It is not merely that she is nurturing or caretaking, but she is *all*-nurturing. She is abundantly, bountifully supplied, and never runs out of resources for her children.

The idealized mother is characteristically a selfless woman. She does not care for herself; she does not need anything for herself; her relationships are inherently nonreciprocal with all

the giving occurring in one direction. She gives; she does not ask to be nurtured in return. Interestingly, some of the early images of the all-giving goddess-mother depicted a woman who did not have a mouth.[5] The idealized mother did not need a mouth because she was not a taker; she was not someone who would need to be nurtured; it was her job merely to give. There is a somewhat satiric poem about ideal maternal love that has a young son killing his mother and cutting her heart out in order to satisfy the demands of a young woman whose attention and love he desires. As the young man is taking the heart of his mother to give to this young maiden, he trips and falls; the heart, lying on the ground, asks him if he has hurt himself. Here we have the ideal Selfless Mother. Regardless of the offense to her self, her thoughts are only for her child and whether or not he has been injured or hurt.

One woman, Ruby, was so proud of her selflessness that she eagerly recounted an event that had occurred forty years earlier. When she was a young mother, both of her daughters simultaneously developed high fevers and needed to be hospitalized. In addition to securing good medical care for her children, Ruby was especially concerned with protecting each girl from knowledge of the other's sickness. She did not want one child to be frightened or upset by hearing that her sister was also sick, consequently she watched her own responses carefully, being cautious not to cry or say anything that might add to the distress of a child who was already sick. Ruby contained her own panic and distress, focusing all of her energies on protecting her children from any further harm.

She recalls standing vigil for almost fourteen hours outside of the hospital room where one of her daughters was being cared for, in order to see the doctor who was attending the child and to obtain information about her status. The doctor did not arrive and Ruby continued to wait in the parking lot of the hospital until the doctor completed his nightly rounds. When she saw him, she ran over to him and pinned her body against his car, saying to him, "You can't pass until you tell me how my child is." For Ruby, her selfless devotion to her children's welfare was an indication of her worth as a person and her success as a mother.

For many women, this image of the Selfless Mother domi-
nates their concept of what it means to be a mother. Women
are often powerfully influenced and guided by the belief that
they must deny themselves and sacrifice themselves until their
children are raised.[6] When women accept this view of the ideal
mother as a selfless woman, they may well feel guilty, as if they
are violating their maternal duty, should they choose to leave
their children and go to work or direct their energy away from
children and home and toward interests that are more self-
focused and less relational.[7]

One woman who had suspended her own career to raise her
four children talked about the time when her children would
be older and she would be able to return to work. She talked
animatedly about "her time" when she would be able to put
herself first rather than tending selflessly to the needs of her
husband and children. Then she heard what she was saying
and stopped herself in mid-sentence. "Of course, Bill and the
kids will always be my top priority. No eight-to-five job for me.
I've worked too hard to turn my kids into latchkey kids now."
Even in conversation, speculating about her future, she could
not allow herself to tarnish the image of the Selfless Mother.

Even when women choose paths that put career or self ahead
of motherhood, they often feel guilty when they are less than
Selfless Mothers. Raina assumes that there must be something
wrong with her because she does not spend all her time raising
her children. She not only works, but enjoys a variety of activi-
ties outside her home. Yet recently she has felt so guilty about
her choices that she has questioned her family life to see if
there is some explanation for why she is choosing a path differ-
ent from that chosen, not only by her mother and sisters, but
by most of the women that she knows. She says: "I don't feel an
absence of mother love. I don't feel there is anything lacking. I
don't feel empty. And I think that I am a good mother."

Some of her sense that her lifestyle is not "correct" comes
from Raina's father, who is a conservative New England minis-
ter, and who believes that it is the job of men to care for women
and the job of women to care for children. He sees Raina's
choice as abnormal in and of itself and also as going against her

mother's life. In fact, he has gone so far as to tell Raina that her refusal to stay at home with her children is a slap in the face to the life that her mother has led. While intellectually Raina rejects her father's arguments, it is painful for her to hear his attacks on the life she has chosen and to admit that she has failed to live up to the image of the Selfless Mother.

In her ideal embodiment, the Selfless Mother is also all-forgiving. No matter how she is treated by her children, she forgives them. Whether she is exploited or victimized, it is her nature to forgive and to continue in her loving capacity.[8] Images of the Virgin Mary offer an ideal presentation of a woman who suffers in silence.[9] She watches her son crucified, but does not become angry or resentful. She suffers injustice stoically, knowing that it is her place to endure whatever comes.

If we think in terms of Mother Earth as the lifegiver of all, we can see the way in which modern men and women have treated our Mother Earth as an all-forgiving mother. Much of our environmental policy and our collective attitudes toward the earth seem influenced by the idea that we can exploit, rape, and victimize our mother and she will continue to repair herself, to love us, and to nurture us, never holding us accountable for our rapacious and violent behavior at her expense.

One woman whose son was a violent cocaine addict boasted about how she allowed him to come back home even after he had stolen from her and had broken two of her ribs. It was a sign of her superior mothering that she was willing to forgive her son regardless of his offense. In recent years some addictions specialists have urged mothers and fathers to practice "tough love," forgoing the image of the Selfless Mother and holding children accountable for their behavior. While this approach may make good clinical sense, it has been especially difficult for those who define good mothering as being selfless and all-forgiving.

Also characteristic of the Selfless Mother is that she is static and stable. It is not her province to grow, develop, or evolve; rather, she is to remain reliable and constant, always the mother that her child desires and needs. If we again consider the Virgin Mary to be an embodiment of the idealized mother,

one of her salient characteristics is that she does not age; she is always as her child wants her and needs her to be: a nurturing, energetic, and bountiful young mother.[10]

In ancient Egypt, the body of the goddess Isis formed the throne of the Egyptian kings.[11] Generations of kings reigned from the lap of the Great Mother, Isis. She sat there, a stable and unchanging being who cradled and protected her symbolic sons. This image of a woman as static and reliable is an idealization that derives from the needs of her children. It is to the child's advantage to see his or her mother as the embodiment of stability, security, and consistency. Such an image, however, does not allow for the evolution and development of a woman's own authentic self. As she remains stable for her child, she denies her own need to evolve and grow.

Many of the traits of the Selfless Mother reflect a dependent child's reliance on a caretaking mother who should give no matter how much the child needs. There is never a child too demanding for the ideal Selfless Mother. She should forgive any injustice and always be available regardless of how she is treated. She should remain constant, ever secure, always present exactly as her child needs and remembers her to be.

This idealized image presents us with a picture of a woman who is powerless to do anything on her own behalf. Her very essence denies her access to her own personal development. In this sense, she is both defined and controlled by her "giving trait," a quality which gratifies the needs of others even at her own expense.[12]

Because the Selfless Mother is an image which so completely denies a woman's autonomous needs, women who are aware of being trapped by this image may feel angry and resentful. One woman described herself as an "erupting volcano." She directed much of her anger at her husband, who seemed to "have it all." He was able to work and because of her efforts also enjoy the comforts of home and family. She, on the other hand, had devoted herself exclusively to raising her children.

Another woman, Kitty, grew up in the shadow of her mother's powerful resentment at being a Selfless Mother. Although she herself is not a mother, Kitty feels so angry at the

image of Mother that she is not sure she could have a child even if she wanted one.

Kitty's mother grew up in a working-class family where her own mother and father fought continuously. It was obvious to her from the time she was a young child that her mother and father were ill-suited to one another and that their marriage was an unhappy one. Kitty's mother married at twenty-one, and by the time she was thirty years old Kitty's mother had given birth to six children. Initially Kitty's mother seemed to enjoy raising her children, but with the resurgence of the women's movement in the 1960s, she became angry and resentful of her position as a wife and mother.

Growing up, Kitty not only saw the unfolding story of her mother's life, but she also observed the lives of the women in her community. Her family lived in a small industrial town which was uniformly working class. The options open to women within that society were, in Kitty's words, "horrible." Women grew up, got married, and had children, or as Kitty believed, "were dumped with children." It seemed to her that men got their wives pregnant in order to keep them in a subservient position. Kitty saw the women in her community as being trapped and abused and she could not bear the thought of settling down and having a life similar to theirs.

Because of the widespread influence of the image of the Selfless Mother, women who feel they have failed to honor this image sometimes feel they have failed as women in a more general sense. For one woman, Nettie, her sense of failure as a mother comes from the fact that two of her children have had serious problems. One of them has been an impaired alcoholic and the other has suffered from a major depressive illness. Both of these children have needed repeated treatment, have come to the attention of legal and social service authorities, and have caused Nettie and her husband to enter into years of counseling and therapy. The troubles of her children made Nettie feel ashamed and humiliated in her neighborhood. She remembers several times when neighbors had gathered for a picnic or a social event and the police came storming up the street looking for one of Nettie's children who had gotten into

trouble. For years, Nettie has berated herself with accusations that if only she had been a better mother her children would not have had problems.

Nettie's sense of failure as a mother is compounded by the fact that her two healthy daughters have chosen to live lives very different from her own. Neither has opted for mother-hood. Both are married but have high-powered careers and are very clear that they have no interest in the life that their mother led. While Nettie is able to affirm the choices made by her daughters, she clearly feels devalued by their decision, as she sees it, to reject her life.

It has been especially difficult for Nettie to compare herself to her husband. They have had a fairly traditional marriage. It has been Nettie's task to raise the children and to keep the family together; her husband had the role of breadwinner, and he has been a very successful entrepreneur. In Nettie's own eyes, she judges herself to be even more inadequate when she compares herself to her husband. He was able to keep his part of the bargain successfully; he kept the family well cared for financially. She, on the other hand, failed at the only task to which she was assigned; she was unable to produce four healthy children.

The Faithful Wife

The Faithful Wife is loyal, subservient, and caretaking. She is completely defined by her relationship to the powerful man in her life, her husband. The old dictum "Husband and wife are one and that one is the husband" defines the role of a wife.[13] The Faithful Wife lives her life through her husband. His ca-reer, his interests, and his concerns are her main agenda. She must remember not to assert her own wishes or to be too com-petitive lest she overshadow her husband. Rather, her role is to support her husband with a kindly "yes, dear." Anything that takes her energy away from her man is problematic; she cannot invest too much energy either in her own growth and develop-ment or even in the development of her children. As one woman said: "I wanted to be married to him, so I never took

the time to do anything for me. All of our decisions have been made to suit his career—where we live, how we live, who we socialize with—I just kind of go with the flow."

In a good middle-class marriage, a woman finds a man better than she and gains status and livelihood through him. By becoming his wife, she becomes a more important and valued person. A wife should be less than her husband in age, in height, in judgment, in earning capacity, and public status. It has been suggested that "less than" is an important characteristic of wife across all areas.[14] As one woman said, "My husband is my best side." For women who are trapped by the image of woman as wife, to be somebody is to be *Mrs. Somebody;* women who are bound by this idealized image feel a pressing desire to be married.[15]

In the United States, the role of First Lady is effectively that of First Wife since it is clearly her function to stand by her husband's side, to support him, and to look adoringly on as he makes decisions. When she was First Lady, Nancy Reagan epitomized woman as Wife; she said quite directly that her most important priority was being Ronald Reagan's wife. She attributed all of her own vitality to having met this very wonderful man and said that she would have no purpose or direction in her life without her husband. He was "my reason for being happy."[16] This total abnegation of self, whether it was accurate or not, was Nancy Reagan's public persona. As a society, we are clear that we want our First Ladies to remember that they are wives first. They only have status because they are married to competent and powerful men, not because they are skilled in their own right. When successful women like Rosalyn Carter or Hillary Clinton attempt to speak for themselves, they are met by a swift public outcry reminding them of their proper role as Faithful Wives.

Maureen's Story

For some women, their socialization to the role of wife and to the image of the Faithful Wife begins when they are still girls. From as early as she can remember, Maureen was told that it was important for her to grow up and to marry well. When she

was a young child, her three older brothers teased her by telling her that she would be a spinster. If she did not get prettier, she would end up as an old maid librarian and they threatened to sell her to the ugliest, creepiest boy in town. Repeatedly, in "good fun," these boys would tell her, "You're too big, too awkward, too ugly. You'll never get a husband." While some of this teasing is certainly common among brothers and sisters, it is significant that the worst threat her brothers could issue was that she would be an old maid.

These brothers had grown up with a mother whose life centered around her husband, and Maureen's mother felt that her life began when she married her husband. He was, according to her, the catch of the century and the best thing that had ever happened to her. Maureen watched her mother be a helpmate and companion to her father. By three o'clock in the afternoon, her mother would have finished the day's chores and would change into a dress and sit quietly, composing herself for her husband's arrival. Once her husband came in the door she was, says Maureen, "his." She would prepare snacks and a cocktail and would sit attentively as her husband shared the events of his day. It was her job to listen, to nod her head, and to offer support. Throughout her growing years, Maureen observed her mother fulfilling this role with enthusiasm and joy.

Maureen wanted to please her parents so she set about attempting to make herself a suitable match for a good husband. In high school, she was very popular and was a cheerleader and a class officer. These activities improved her currency as a prospective mate and her parents were pleased with her performance. She believed that she would go to college in order to find someone to marry, and she says, "I would be successful because I would be married to someone successful."

In helping her select a college, Maureen's parents were primarily concerned with finding a university where there might be an abundance of suitable marriage candidates. They had no concern for Maureen's academic success or interests or for her eventual career. In fact, they referred to her possible profession with an offhand comment, "Well, maybe you'll teach or something." It was quite clear that Maureen's agenda should

be to find a husband. She enrolled in a large university where her parents believed she might be able to find a suitable man.

At the end of her freshman year, Maureen returned home dejected. She had no boyfriend, no dating prospects, and was feeling distressed. The image of the old maid haunted her and she was almost panicked as she went back for her sophomore year. At that point, she met the man with the right credentials. He was smart, handsome, personable, and headed for a financially successful career. Her parents were delighted and whenever she called home they would inquire about this new boyfriend. He became much more the focus of their interest and attention than Maureen herself.

She and this young man became engaged and the storybook romance was about to reach its conclusion when Maureen became pregnant. Maureen was devastated and frightened to tell her parents, believing that she might have failed in some way. Her parents, however, were not upset and she remembers her mother saying, "Well, dry your tears, pull up your socks, let's plan a wedding." Her parents were clearly pleased that she had found a suitable husband and that she was about to be married. There was no upset about the pregnancy because, as she later discovered, her parents never had any expectations that she would be a virgin when she married. In fact, they assumed that she had been promiscuous throughout high school. Since sex and pregnancy have often been a way in which women have snagged husbands, Maureen's parents were not disappointed by her unplanned pregnancy. Instead, they saw it as an additional guarantee that Maureen would marry "Mr. Right."

Maureen, however, felt terribly ashamed by her pregnancy and wore a girdle into her seventh month trying to hide the baby she was carrying. For her, the image of Wife was not yet an integrated one and she felt more like the fallen woman. It was also clear to her that her life changed dramatically once she became pregnant. She felt different from her classmates, alienated, and somewhat exiled. Throughout her pregnancy, she prayed for a son, believing that if she could deliver a boy to her parents that she would in some way redeem her irresponsible act.

After her child, a boy, was born, she and her husband moved to a different part of the country so that he could attend a prestigious graduate school. It was assumed that Maureen would support her husband throughout graduate school and she took a series of menial jobs in order to do so. These jobs often took her away from her young child and initially she was concerned that her family might be disapproving because she was leaving her son in the care of others. From her mother and father's perspective, however, it was more important that she was putting her husband through school. For them, the image of Wife continued to be a more powerful one than the image of Mother. Maureen was fulfilling her function as a Good Wife: she was supporting her husband.

During the years in which she was working, Maureen began to experience herself as a competent woman and felt proud of her ability to support her family and to function assertively in the world. This experience nurtured her growing sense of an existence separate from her role as someone's wife.

When her husband finished graduate school, Maureen announced her desire to go on for additional training herself. Her husband was nonchalant toward her interest and proclaimed that he did not care if she went to graduate school as long as she continued to take care of their child and their home and so long as her plans could be accommodated to his own more important career agenda. Maureen accepted his rather begrudging approval and began graduate studies. Her academic career and the job which followed strengthened Maureen's sense of a life separate from "Wife."

Six years after her marriage began, it ended in divorce. Although she initiated the separation, Maureen felt sad and upset over the failure of her marriage. She was especially wary of her parents' reaction. Surprisingly, they expressed some sadness but were not overly critical of her for divorcing her husband, who had become increasingly estranged from both her and their son. They made their position clear, however, when Maureen approached them about reassuming her maiden name. She was to keep the name of her ex-husband. When she found a new husband, she could take a new name.

Maureen felt strongly that she had failed. It was certainly not

in the plan to divorce her perfect husband and she began to feel somewhat anxious without the role of Wife to define her. Maureen says, "I became independent and the minute I was independent I got very scared and I was on the track of finding somebody again."

When she began dating, Maureen was initially concerned that she might not be able to make a good match because of her child. The right man might not want a woman who was already encumbered with another man's child. After almost two years of dating, Maureen met a man with credentials similar to those of her first husband, a man her parents would deem an acceptable mate. After a few months of dating, she and this man decided to marry. Once married again and successfully in a familiar role, Maureen felt back on track and described herself as feeling secure and safe once again.

Despite some external similarities to her first husband, Maureen's second husband was quite different in his support for her independent growth and development. During her second marriage, Maureen has become increasingly involved in her career and in her life outside the home. Maureen is clear, however, that she has allowed herself to have an independent existence outside the roles of Wife and Mother only because she has adequately paid homage to these idealized images. She has sufficiently sacrificed in both the past and the present at the altars of Wife and Mother to give herself the freedom to move somewhat beyond the confines of these roles. It is unclear whether Maureen would feel as confident or comfortable as she now does if she did not feel that she had sufficiently paid her dues.

Despite her own shift in perspective, Maureen's parents continue to see her importance only in terms of the man she has married. They have expressed little if any interest in her own career and when they visit or call they continue to ask about her husband, his progress, and his successes. When sending her letters, Maureen's mother continues to address the letters to Mrs. *John Doe.* Despite the fact that Maureen is almost fifty years old, her mother still sees her only as the wife of some man.

While she feels that she has begun to separate herself from

the powerful image of Wife, Maureen still struggles to define who she is. Because for so many years it has been an externally imposed sense of womanhood that has guided her, it is now hard for Maureen to know how to behave without some outside structure to direct her. More recently, she has looked for alternative models, searching for something to compete with the image of Wife. She has considered the life of her paternal grandmother, a feisty and aggressive woman who dominated her own home, as an example of an independent woman not in the least subservient to a man. She has also looked to several of her friends who define themselves in terms of their own interests and careers rather than their relationships, at times trying on the persona of these other women.

A short while ago Maureen was shocked to discover that the image of the Faithful Wife still lurks in her consciousness waiting for the opportunity to assert itself. During her son's graduation from law school, Maureen found herself making plane reservations for her ex-husband, helping him to select a graduation gift, and covering for him when he failed to attend a pregraduation brunch. Maureen was still playing the Faithful Wife to a man from whom she had been divorced for over twenty years.

A cardinal characteristic of the Faithful Wife is her loyalty and steadfastness. She "stands by her man" regardless of how he behaves. In recent years, we have been treated to public displays of wifely loyalty by the spouses of several powerful business, religious, and political leaders accused of being sexually unfaithful. After an announcement of the husband's indiscretion, the public relations handlers stage a media event in which the accused politician declares his innocence or occasionally begs forgiveness, but all with his Faithful Wife steadfastly by his side. Her presence conveys several messages. If she forgives her husband, should not the general public be able to do so as well? She also reasserts the moral superiority of women in general and wives in particular. Whether through the Women's Christian Temperance Union or the Moral Reform Society of the previous century or through their individual efforts, wives

have been traditionally seen as the moral backbone of their families. Finally, the public behavior of the political wife reaffirms the image of the Faithful Wife whose loyalty is unbending and whose forgiveness is unbounded.

When a husband is more obviously abusive, beating or demeaning his wife, the Faithful Wife becomes the battered wife. She continues to return to her husband regardless of what he does to her or their children, believing that it is her place to stand by him or perhaps that it is her fault that she has been abused. If she were a better wife, he would not treat her cruelly. When a woman is trapped by the image of the Faithful Wife, she does not even consider that leaving an abusive husband might be an option.

Leslie's Story

Leslie's mother felt that it was a woman's lot to endure. She saw women who asserted themselves or attempted to gain power within their homes as uppity and arrogant. Leslie's father was verbally and physically abusive toward his wife and children. Leslie's mother was put down and devalued throughout her married life and was treated, in Leslie's words, "like a doormat." Despite being verbally and psychologically abused, however, Leslie's mother continued to defend her husband and made her children give him respect.

Leslie's mother had three daughters and one son, and despite having resented the special attention that had been given to her own brother while they were children, she gave the same special attention to her only son, treating him like a little prince. Her daughters were irrelevant. She believed that girls were powerless and unimportant and managed to convey that feeling to her daughters. Leslie's mother felt inadequate to equip her daughters to live in the world and she gave them the message that their only hope was to attach themselves to a man who would take care of them financially and emotionally. Only by becoming Faithful Wives could they survive in the world.

Leslie was a shy and quiet child who never felt that she was very smart, very pretty, or very creative. It seemed to her that

her best strategy for survival was to be quiet and to draw as little attention to herself as possible.

When Leslie was thirteen years old, she met a man who was ten years her senior who began to make sexual and romantic advances toward her. Rather than being appalled at the attention an older man was paying to her daughter, Leslie's mother was delighted. It seemed to her that Leslie might have a chance to marry early, to escape from the family home, and to secure for herself a reasonable life. Leslie remembers her mother telling her that she knew what was best for Leslie and she thus laid out this plan: Leslie would continue to date this man until she was old enough to marry. Leslie remembers being told to be a good little girl and not to say no to her man's requests. Her career as Wife was already under way.

It is rather remarkable that a mother would subject her daughter to this kind of relationship at such a young age. While she was not raped or sexually abused in an explicit way, Leslie remembers being introduced to sex before she was old enough to understand what was happening. It seemed to her, however, that she had no choice but to comply with this man's wishes. It became obvious to her early on that it was her assignment to replicate her mother's life; she would be married to a man she did not love; she would be abused and belittled, and she would, like her mother, endure. One Faithful Wife following the footsteps of another. Despite the fact that the prospects for her future seemed bleak, Leslie remembers complying because, as she said, "I adored my mother and I would have done anything to make her happy."

Throughout her childhood, Leslie's mother interpreted reality for her. Unfortunately the story which her mother told her was a false story. Sara Ruddick, in her book *Maternal Thinking*, has suggested that these overedited, falsely cheerful stories about what life is like can result in the production of a false sense of self if taken too literally by a child.[17] When a child loves her mother dearly, she is unlikely to question the truthfulness of her mother as a storyteller. Despite her own eyes showing her that life is hard and that her mother's marriage is unsatisfactory, the daughter may be willing to accept her mother's narration, her distorted view of reality, rather than

calling into question her mother's view of the world. This is especially true when the mother puts forth a culturally idealized image of womanhood. This was certainly the case with Leslie. Despite her own instincts telling her that the match with this man was a mistake, she followed her mother's dictates rather than question her mother's authority.

Because Leslie had never been encouraged to succeed at any endeavor, she did not feel that she was very smart or able to accomplish anything on her own. Consequently she assumed that she had no alternative but to accept her fate as a child bride and to go along with the plan as it was described to her. On two occasions, Leslie attempted to break the relationship with this man and at one point she actually separated from him for almost a year. However, her mother encouraged her to go back, and said to her, "What's wrong with this man? He seems to like you, and after all he doesn't beat you." At this point it felt to Leslie as if it was her fate to go along with this loveless marriage. When she finally married him, Leslie withdrew emotionally and stopped eating and sleeping for several months. It now seems to her that she was clinically depressed at the time of her marriage, filled with hopelessness and despair. Leslie felt like a condemned prisoner as she walked into the trap laid by the image of the Faithful Wife.

Leslie's husband was an insecure man who was threatened by any independent relationship Leslie tried to have, so during the first several years of her marriage Leslie remained isolated from other people. However, her husband allowed her to take courses at a community college. For some reason, he felt that knowledge and learning were not threatening to him, and Leslie found a world within literature and fiction that allowed her some escape and comfort.

The only thing that Leslie ever recalls truly wanting in her life was a baby. Her husband manipulated this desire whenever Leslie talked with him about separating. If she raised her intent to leave him he would tell her that she could have a baby. Since she could not imagine how she might have a child on her own, she felt that the only way in which she could actualize this dream was to stay with her husband. It seemed to her that she could have her heart's desire only if she sacrificed herself.

Over the course of ten years, Leslie had three children with her husband. She recalls truly enjoying mothering these sons and it was significant for her that she had three boys. It seemed that in giving birth to sons she might break this chain of abused women within her family. Boys were valued and valuable, and a son of hers would never have to feel humiliated and defeated the way in which she and her mother had felt. Despite the comfort and enjoyment which she got from raising her sons, life with her husband was a living death for Leslie. At one point she contemplated suicide because she could not bear staying with him, yet she could not imagine how she might cope in the world without a man. So convinced was she by her mother's injunctions that women were useless and valueless unless they were attached to men that Leslie could not imagine a life on her own.

Once when Leslie was particularly depressed, a friend of hers suggested that she seek out a therapist. Leslie did so and began her therapy by telling the therapist, "Let me just tell you that I'm not going to leave my husband." The image of the Faithful Wife was off limits. The therapist, who was intuitive and feminist in her politics, worked with Leslie within the limitations that Leslie imposed on the therapy. However, the therapist was funny, spunky, and broke all the rules that Leslie had learned of how one is supposed to be a woman. When Leslie would describe events within her home, the therapist would casually say to her, "I'd throw the bum out." Leslie remembers at first being rather shocked by the therapist's unabashed assertiveness but secretly enjoying the therapist's different perspective. This therapist was clearly not a Faithful Wife. Leslie's therapist taught her that it was okay for a woman to enjoy herself, to enjoy life, to be assertive, and most importantly, to take care of herself. After two years of therapy, Leslie finally felt strong enough to end her unhappy marriage. When she first told her husband that she was moving out, he laughed at her. He could not believe that she was serious. He was so convinced that she was indeed the passive victim that she had been for the twenty years of their marriage that he could not consider that she might be different.

For the first two years of her separation, Leslie just managed

to cope: she took care of her home, she raised her children, she did things she never believed she could do. At first Leslie's mother was frightened by Leslie's decision to stop being a wife. After all, she had remained with her own abusive husband for almost fifty years. Shortly after Leslie's separation, however, Leslie's mother suffered a serious illness and as she was in the hospital with doctors telling her that she might die, she decided that she could endure her own marriage no longer. Once she made the decision to leave her husband, she refused ever to see him again, feeling as if she could not communicate with him or interact with him for one more minute. The image of the Faithful Wife was shattered and she had no interest in putting the pieces back together. At age seventy-five, with very little money, she went out on her own and for the remaining seven years of her life experienced what she called "the only happy times I have ever known." She began to do volunteer work, to socialize, to feel less afraid of interacting with other people. She reached out to her daughters, hugging them, loving them, and allowing herself to tell them that she cared for them.

It is significant that Leslie's separation from her husband predated her mother's decision to end her own unhappy marriage. Leslie believes, and her sisters have confirmed, that her example allowed her mother to finally free herself of fifty years of abuse. It was as if her mother needed to see the broken image of the Faithful Wife before she could risk changing her own behavior.

Chung Mi Kim, the poet, wrote in a dialogue to her mother in 1980, "Mirror to mirror, through myself I see you, you see me."[18] The mother and daughter in this poem reflect one another back to each other. Similarly Leslie and her mother reflected reality back to each other. Initially Leslie could see only her mother's life in herself. When she looked at herself, she saw her mother and felt unable to break the pattern of abuse that her mother had experienced. Leslie remembers that when she took her husband's name, she felt traumatized; she did not want to change her identity, yet she could not imagine what other name she might take. The name of her father was the name of an abuser; the name of her grandfather was the name of an abuser; she could not look back in the genealogy of the

women in her family and find a single woman who bore a name that she might want to have.

Conversely, Leslie's mother saw her life reflected in the face of her daughter. When she saw her daughter being strong and independent and breaking the chain of abuse, Leslie's mother was able to incorporate that strength and make changes in her own life. Leslie's mother became strong for the first time in response to her daughter's strength.

After several years of being on her own, Leslie is now once again exploring the possibility of a relationship. However, she is doing so with a newfound sense of who she is, no longer believing that it is her fate to be abused. She is also now part of an active, feminist community where the rules for a woman's life are different. Being a nice girl, denying one's self, and acquiescing to the needs of another are not valued by her feminist family. The Faithful Wife is a persona non grata. In order to be part of this new community, Leslie must remain true to herself.

The Happy Homemaker

The image of a woman devoted to home and family has been embodied in a variety of forms in different cultures and at different times. Virginia Woolf called her "the angel in the house."[19] The angel's job was to ensure that everything in the home ran smoothly even if it meant sacrificing her own needs to accomplish the task. She tended to others like the perfect concierge, unobtrusively but efficiently providing them with the necessary material and emotional supports.

During the Victorian era, the word "motherhood" came to represent the image of a woman who was defined by her commitment to home and family. The family prospered in "the warm sun of motherhood."[20] Later, during the German Socialist Republic of the 1930s, the phrase *Kinder, Küche, Kirche* (children, kitchen, church) defined the tasks for this idealized image of the homemaker.[21] A woman's job was to uphold traditional values and to support and nurture her family. In recent years, television has presented us with several images of

this idealized version of family life with the mother as the stabilizing anchor who ensures that family functions are performed in a loving and thoughtful manner.

In the 1950s, advertising campaigns showed the Happy Homemaker dancing around her all-electric kitchen, desiring nothing more than to use her various appliances in the service of her family. These portrayals harken back to the arguments of the last century regarding a "woman's sphere."[22] A woman's proper place was considered to be her home, in which she might govern with a firm but loving hand. The home under a woman's rule provided a warm and restful antidote to the rigors and competitions of the working world. By making home-life her main mission, the Happy Homemaker could contribute to the smooth functioning of her community and her country.

Cynthia's Story

Cynthia grew up in a small town, the youngest daughter of a large extended family. Her parents each had six siblings and the families lived within close proximity of one another. For most of her childhood, Cynthia associated only with people related to her by blood, and her family enjoyed a sense of harmony and security. The women in her family were competent homemakers who made life pleasant and easy for their working husbands.

Her parents were quite explicit about their desires for Cynthia and her two older sisters, telling them, "Get married, be happy, have a family—raise children; children are so important." Cynthia never questioned these parental values nor did she doubt she would eventually accomplish these goals. When she graduated from high school, however, Cynthia decided to go to college, the first member of her family to attend a four-year program, thereby distinguishing herself from her mother, who had never graduated from high school. Cynthia chose a college far away from her family's home. When she left her parents' house at the age of eighteen, she separated from her close-knit and supportive family for the first time.

Upon completing college, Cynthia initially returned to her parents' home. Within a short time, she moved to a rented

apartment but remained in the same town where her entire extended family resided. While living independently and working, Cynthia discovered a part of herself that she had not previously known. She loved working, earning her own money, and providing a valuable service to other people. In fact, she says, "Work is who I am. I love being out in the world."

By the time she was twenty-five years old, Cynthia had met the man she was going to marry. She did not, however, rush into marriage and motherhood. Instead, she and her husband moved to a neighboring state where they both attended graduate school. They were both actively involved in pursuing their careers and Cynthia felt open to intellectual challenge and exploration, worlds that had been unknown within her family.

Following completion of their graduate studies, Cynthia and her husband chose to live in an exciting cosmopolitan city, far from the provincial towns in which they had been raised. Cynthia in particular felt that her family was a bit too close and constricting. If she once again lived near her sisters and cousins, Cynthia feared that she would be unable to hold on to this new and exciting part of herself.

Cynthia remembers this time in her life as being expansive and exhilarating. She felt that her "life was great." She enjoyed her marriage, enjoyed her career, and did not want to have a child just yet. She remembers thinking, I will eventually have a baby, but then I'll stay home for three months and return to work full time. The plan was clear to her. A child would accommodate to her life as a career woman. She thought, This is a whole new life, I don't want to go back to where I came from. In several of her choices, Cynthia had moved far away from the idealized image of the "angel in the house," the good woman who was to stay near her parents and siblings and raise children in a supportive and self-sacrificing way. She had decided to pursue an intellectual professional life and had allowed herself to explore her own femininity and sexuality, enjoying her freedom as a single woman and her marriage to a man very different from her father and her uncles. Cynthia had all but abandoned the idealized image of womanhood at whose altar she had been taught to worship.

When she was in her early thirties, Cynthia decided that it

was time to proceed with having her own family and within the first month of trying to get pregnant she conceived a child. Cynthia was delighted with how very easy it was to get pregnant and she looked forward to adding this new experience to her already full and exciting life. Within ten weeks, however, her world changed as she miscarried the baby. This trauma initiated four years of self-doubt and agonizing tension between Cynthia's new self and her old family values.

Cynthia was terribly distressed by the miscarriage of this baby with whom she had already begun to bond. She had even named this unborn child in her own mind. As part of the process of recovering from the miscarriage, Cynthia planned an extended visit back to her family. Her return to the family marked Cynthia's first attempt to appease the image of traditional womanhood, the Happy Homemaker. She felt as if she had strayed too far from the traditions in which she had been raised, and she needed to return both literally and psychologically to the "way of the family."

After a year of trying to get pregnant again, Cynthia began to think that something must be wrong with her not only in a biological sense, but in a moral sense as well. She had committed some sin and now she was being punished. Despite her fears, Cynthia did conceive a child the second time, but once again she miscarried. Her second miscarriage occurred on Christmas Eve and Cynthia found the symbolism unmistakable. Christmas was a time of birth, a time when family values are affirmed, and she, rather than giving birth to a child, was losing a child.

After her second miscarriage, Cynthia's doctor told her quite clearly that she would never be able to get pregnant on her own. This diagnosis felt like a curse to her. Cynthia felt cast out from the community of women as if she had committed a terrible sin. For several months after receiving the diagnosis, Cynthia felt unable to see friends who were pregnant or had small babies. She believed that her body did not work, that something was not right with her, that she was defective in a profound sense.

For several years, Cynthia and her husband enlisted all the new technologies designed to help couples conceive children.

The procedures were painful, expensive, and often humiliating. Cynthia remembers having to test herself at work and sneaking into the bathroom several times a day, guilty and ashamed, as if she had some secret that she could not share with other people. At this point Cynthia began to conceptualize the meaning of her infertility: "I should not have been having intercourse before I got married. I should not have been using birth control. God is punishing me. I must be a very bad person."

In her rational moments, Cynthia knows that this explanation is inaccurate; yet, she is pulled to believe that her infertility is the result of her own doing. While she views her sexuality as her main sin, she may be speaking of a more general crime she has committed: her digression from the mission of being a Happy Homemaker that was laid out for her. At times Cynthia believes her infertility is retribution for her choosing to be a free and modern woman, unbridled by traditional images.

Cynthia was so distraught over her infertility that she gave her husband the option of leaving her, feeling that it was her fault that they could not have a child. She offered him his freedom so he could find a younger and perhaps less tainted woman with whom to have a family.

Eventually Cynthia and her husband worked through some of their distress and made a decision to adopt a child, a decision with which they are both very happy. However, becoming an adoptive mother has not been an easy road for Cynthia. Initially she wondered if she would be able to love and nurture an adopted child. Within Cynthia's own family, connectedness is defined by blood relations; it was hard for her to imagine being a mother to a child to whom she was not biologically related. The difficulty which Cynthia experienced in becoming a parent was in marked contrast to the carefree and easy mood of the Happy Homemaker.

When her new baby came home from the hospital, Cynthia was relieved, at last, to be part of the world of mothers. However, she quickly began to have doubts about herself as a mother. She had expected that she would be euphoric to bring her new child home and was distressed that she felt tense, uneasy, and ambivalent about having this new person in her life.

She longed for work and the people who knew her as a competent professional.

When her daughter was only a few months old, Cynthia was offered a part-time job at her old firm. While she was tempted to take this position, she turned it down believing that it was now her responsibility to be the very best mother that she could since she had waited so long to have this baby. She must make amends and be the "angel in the house," no longer participating in a life outside the home. In her attempt to return to the images with which she had been raised, Cynthia devoted herself to being "super mom," "super wife," and "super homemaker." Because initially she was under close scrutiny from the adoption agency, Cynthia felt additional pressure to be the ideal, absolutely perfect mother. She experienced a great deal of anxiety whenever her daughter manifested any of the usual childhood illnesses. Her worry was that she might be accused of neglect or abuse when she took her child to the doctor with the sniffles or an ordinary diaper rash.

Once again, while Cynthia is able to see some of her fears as irrational, she is plagued by them nonetheless, and she seems obsessed by the need to prove her credentials as a good mother, demonstrating that she can be the woman she was raised to be. Her repair does not end with her mothering activities. Cynthia is also concerned with being a supportive wife, a wife, as she says, "like the fifties," who has to earn her keep and provide her husband with support and encouragement as he goes off to work. Sometimes Cynthia feels resentful at having to attend to all of her husband's needs. When she confronts him with her distress, she is reminded that he has never asked her to be the perfect wife; this agenda originates with her.

It has also been important for Cynthia to keep a perfect home and she spends much of her day cleaning, cooking, and attending to the little amenities that make life in the home more pleasurable. Often when she completes a particularly arduous cleaning task, Cynthia will ask her husband to come and inspect, almost as if she needs his "Good Housekeeping Seal of Approval" to make her feel that she is performing her job adequately.

Cynthia's allegiance to this traditional image is not without

conflict. She needs to make amends and repair the damage that she did by wanting to be a more independent and autonomous woman. Cynthia continues to feel occasionally bored and anxious at home and realizes that she is not fully satisfied with the role of homemaker. She occasionally berates herself for not being satisfied baking cookies, making curtains, and changing diapers. She feels eager to have a paycheck once again and to control her own money. She finds herself chafing under these restrictions which she has placed upon herself, yet Cynthia is afraid to return to the life that she had before she began trying to get pregnant. Cynthia finds the world closing in on her almost as if the image of the angel constricts her in a very literal way. She finds herself dreaming about returning to her hometown so that she can live near her mother and sisters. While realistically she knows that this would not be a healthy plan, she is tempted by the security that she knows would come from her total and complete return to the image of the Happy Homemaker.

The Super Mom

The Super Mom is in many ways a composite image. A woman identified with this image "has it all," or more importantly, does it all. She is a wife, a mother, a worker, and an independent woman. More than anything, this image assures us that when women take on responsibilities outside the home they need not compromise their obligations within the home. The stories of Super Moms are replete with accounts of baking cookies at 4 A.M., driving miles every week to take children to various activities, and at the same time never missing a day at work or an aerobics class. In recent years, the discussions of life as a Super Mom have spawned a new vocabulary to describe the experiences of women trapped by this image. Super Moms must "juggle" multiple responsibilities, a task which they sometimes manage by "sequencing" their commitments to careers and family life. Sociological studies of the impact of juggling and sequencing have been reported in the popular press, only serving to reify and validate the image of the Super Mom.

Women trapped by the image of the Super Mom wear their busyness like a badge of honor. As the introduction to a book on juggling (the primary mode of Super Moms) says, "The juggler [who] collapses into bed at the end of the day happy and exhausted—or just exhausted—and wonders why her 'to do' list is no shorter than it was when she had arisen in the morning."[23] One woman recounted how when she and her friends get together they engage in a playful competition as to who has done more and who has a busier schedule. With five children and a private consulting business, this woman proudly announced that she usually wins.

It has been suggested that composite images like the Super Mom only appear at particular times in the life of a culture, times of flux when the images of one generation are giving way to the images of the next. During this period of "crossover" we find women who have broken with the traditions of their mothers but who do not yet have viable mentors or role models for how to live a woman's life.[24] Whenever cultural roles and expectations change, a transitional generation gets caught between the expectations of the past and the aspirations of the future. Women caught in this crossover phenomenon often experience a combination of guilt and confusion. They are confused because the guidelines for how to live are absent; they also feel guilty because they have broken away from the patterns of living set by their mothers.[25] For many women in a crossover generation, the experience of adulthood is one of trying to live two lives: the woman actively engages in the activities of her mother's generation and at the same time engages in a new set of activities particular to her own breakaway generation. The Super Mom, combining the qualities of the Wife and Mother with more independence and self-directedness thus becomes a perfect transitional image. Sociologists speculate that the daughters of women in a crossover generation will not have similar problems with confusion and guilt.[26] They will be able to follow easily the paths of their mothers who have already broken new ground.

It also seems likely that the Super Mom will be a relatively short-lived image because once the headiness of doing it all wears off, women identified with this image will be unable to

sustain their health much less their cheerfulness in the face of twenty-hour days. The very existence of this image, however, speaks to the potency of the traditional triad: Selfless Mother, Faithful Wife, and Happy Homemaker. Just as the first women collegians needed to reassure their families that by going to college they would not betray the domestic agenda of the nineteenth century, so too do modern-day women, by ascending the unstable pedestal of the Super Mom, feel that they need to give assurance that their having a life outside the home will not compromise their obligations to their husbands and their children.

The Career Woman

The Career Woman is not to be confused with the working woman. As an imaged presence, the Career Woman is really the diabolic mother in a business suit. She is cold, cruel, and unloving. She cares only for herself and will devour anyone who gets in her way. Her attributes have little to do with the reality of careers and professionalism in women's lives. To understand this image fully, we must first understand the mythology of the demonic mother.

When she is demonized, the midlife woman is powerful and fierce. She diabolically reverses the action patterns of her healthy self. Rather than creating, she destroys; rather than preserving, she brings about dissolution. She does not nurture, she neglects. It is not her inclination to bring balance to the universe but rather to incite and cause chaos.

Folklore and literature are replete with examples of the destructive, demonic mother. In many tales, she destroys her own creations by cannibalizing them. She is a voracious, unsatisfied woman who can do nothing but eat her own children. The Hindu goddess Kali, often portrayed as a young woman who devours her own baby, is a most gruesome example.[27] Within Western folklore, there are numerous examples of the wicked stepmother whose desire it is to cannibalize and devour tender young children.

The diabolical mother draws life back into herself. She does

not transform by infusing others with energy or life; rather, she is a vulture or vampire desirous of the energy of others.[28] She sucks the lifeblood from others, either quite literally in her embodiment as vampire or as the seemingly good mother whose real desire it is to ensnare and entrap her children, emotionally crippling them, and keeping them dependent and infantilized. This mother sucks the psychological life out of her child, denying that child his or her own independent development. In talking to the employees of a woman identified with the image of the Career Woman, one might well find accusations that the boss drains the creative ideas of her employees, stealing their ideas for herself, and never giving her subordinates a chance to get out from under her stifling control.

It is characteristic of the diabolical mother that rather than nurture her children, she either poisons them, gives them bad or evil food, or neglects them. Once again, there are countless examples within fairy tales and folklore of mothers who concoct evil potions and tamper with good food. Consider the wicked stepmother in Snow White who gives the poison apple to the young girl.

Scores of biographies have been written by the distressed and angry children of famous mothers who depict their mothers as vampiric women, unable to give and desirous of draining the good energy from others. Diabolical mothers are most likely to destroy their own creations. It is as if they say to their children, whether the children be literal or symbolic, "It is I who made you. Your life is mine and I can do with it what I will."

Typically, the negative or demonic mother is embodied as a stepmother. She is one step removed from a natural mother because it is so difficult for us to allow these demonic aspects in the identified biological mother. It is these impostor mothers we can allow to carry for us the demonic aspects of a woman in her middle life.

The demonic mother neglects her creations. In the Russian folktale of the Baba Yaga, a young girl is sent by her stepmother to the evil Baba Yaga whose intention it is to eat the young girl.[29] In order to save herself, the girl gains the instruction of a more benign mother figure who tells her how to nurture and care for the animals, the servants, and the plants at

the Baba Yaga's mansion. Because she maintains a nurturing attitude, the young girl is eventually saved and able to defeat the monster. When the Baba Yaga turns to these various creatures within her domain and asks them why they have betrayed her, they condemn her as a neglectful mother. Each in turn passes judgment: "I've served you for years yet you never even gave me a bone. She gave me some ham." The dogs respond to her: "We've served you for years, yet you've never even thrown us a crust of bread. She gave us fresh rolls." Even the tree says, "I've served you for years but you never even tied me up with a thread, but she tied me up with a ribbon."[30] All of the creatures within her domain chastise her for her years of neglect. The Baba Yaga is the antithesis of the nurturing mother; each of the beings in her domain gives allegiance to the young girl because she shows them attention and concern. The complaints of the Baba Yaga's disgruntled servants sound similar to what we might hear from the employees of the Career Woman.

In her demonic form, the mother brings chaos to the world. She is not concerned with balance and harmony, rather her own sense of having been treated unjustly causes her to unleash rage and venom on the world. She is vindictive and angry, bringing famine, drought, and infertility, and taking life away.[31] In the Greek myth of Demeter and Persephone, Demeter is angered that her daughter has been taken away from her, and acts out her rage in a vindictive and spiteful way, punishing the entire earth for her own loss by bringing desolation and famine. When natural disasters such as hurricanes, tornadoes, and storms destroy populations and kill people, we often think in terms of an enraged Mother Nature taking her retribution against the earth by wreaking havoc.

Within the Grimm's tale of Hansel and Gretel are several examples of this demonic and ungiving mother.[32] The story begins with the natural mother of Hansel and Gretel deciding to abandon them. There is not enough food within the family and the mother chooses herself over her children. She would rather see them starve in the woods than see the whole family experience poverty. This image of a mother who is both selfish and rejecting is an exemplar of the demonic bad mother. Once in the woods, the children meet their second embodiment of

the diabolical mother, the wicked woman who entices them into her power with the gingerbread house. She knows that these are hungry children and she manipulates their need and dependency for her own ends. Once they are seduced into her house, she imprisons them with the goal of cannibalizing them. It is only at the end of the story that she is defeated, just as she is about to cook the young brother and sister for her dinner. Both the woman in the woods and Hansel and Gretel's natural mother are examples of diabolical and selfish mothers. These mothers are powerful women; they control life and death, yet they do so to destructive, selfish, and self-aggrandizing ends.

It is easy to see how our twentieth-century imagination has transformed the demonic mother into the Career Woman. The Career Woman as she is imaged in the movies and in the media is a devouring monster who puts her success above all else. If she is married, she neglects her husband, perhaps having affairs either to further her career or satisfy her voracious sexual appetites. If she has children, she either uses them as live-in servants or foists them off on a more maternal caretaker. In most cases, however, she is single because she is single-minded, her career and her advancement are all she cares about.

This image of the focused maniacal Career Woman has become so powerful, in part, because it is the *only* characterization we have of working women, especially professional women. We do not have a "softer, gentler" image of the woman who becomes a lawyer, a business executive, or a "careerist." Consequently professional women sometimes feel compelled to describe themselves as conforming to the image of the Career Woman even when their behavior is otherwise. One woman who said she "had blinders on" for everything except her career actually took several vacations a year, was in a long-term committed relationship, and took piano lessons on the weekend. Her life seemed much more balanced than her own caricature of herself as Career Woman.

As a boss, the Career Woman has been called the "boss from hell."[33] She has no compassion or concern for her employees. She will use anyone she can to get ahead and will destroy anyone who gets in her way. One woman who ran a small consulting firm described herself as a "bitch in the office." In fact her

employees found her to be generous and supportive. Yet in her own mind she believed that if she was successful, she must necessarily be scheming and cutthroat.

The Career Woman is different from other women. It has been suggested that she secretly wants to be a man[34] or that her confidence and success are merely covers for her underlying sense of failure as a woman.[35] She is at times not even human, being called an Iron Lady, an Ice Queen, or a Steel Magnolia. She is "hard as nails" or "cold as ice." These labels are not only not feminine, they are not even human, hearkening back to the images of the diabolical mother.

Finally, the image of the Career Woman is that of a woman so out of balance that she is crazy and destructive. Recent film portraits of the Career Woman depict her as a homicidal maniac who goes berserk when her long-suppressed need for love is denied.[36] While this portrait is clearly misguided, some women do fear that they do damage to themselves if they focus too heavily on their careers. Researchers Dana and Rand Jack tell the story of Jane, who finally gives up her career as a successful lawyer because her needs for connection and relationship are being thwarted.[37] So pervasive is the myth that working women will have to choose between career and family and that they will be destroyed if they choose wrong that I have seen some women enter therapy as a protective measure to ensure that the image of the Career Woman does not "get them."

Just as the Selfless Mother does not reflect what the mother-child relationship is really like, and the Faithful Wife does not adequately describe marital relationships, the Career Woman does not capture the experience of being a working woman. These images, like the Super Mom and the Happy Homemaker, reflect what we as children wanted and feared from our own mothers. In part, the power of these images lies in the fact that we created them. Each of us, male and female, wanted an all-giving, loving caretaker who would live only for us; each of us hated anything or anyone that threatened that fantasy. Because we formed these images from the longings of our childish imaginations, they continue not only to feel powerful, but also to feel right. For that reason they pose the most seductive traps for midlife women.

Images of Older Women

When we look at the last stage of a woman's life, we find few images of the older woman. In contrast to the robust and vivid images of young womanhood and of midlife, the images of older women are less attractive and more obscure. This dearth of seductive and appealing images may be fortuitous. The empty pedestal of older womanhood may mean that if a woman arrives at the last stage of her life free of entrapping images, she might well remain that way. There are few images waiting to tempt her. Given that the pedestal is relatively crowded during young womanhood and midlife, why this lack of images for older women?

Neither our mythologies nor our fictions present us with many depictions of a woman in the last stage of her life. Carolyn Heilbrun in her book *Writing a Woman's Life* says that biographers do not celebrate the late years of a woman's life. Furthermore, we have no categories to define the life tasks and the events of a person's experience past a particular age. Our failure to think critically about what goes on during the last stage of a woman's life has resulted in a paucity of images of the older woman.

The poet Meridel Le Seuer comments that when you are old you are seen as a nonperson.[1] As she got older she had to contend with the experience of being ignored, of not being seen by others. It is difficult when one is devalued and rendered a nonperson in this way not to identify with the devaluation and to feel that one is indeed barren and empty. In fact, the dreams of some older women contain themes of barrenness and emptiness.[2] These may well be the internalized representations of the culture's belief that these women are dried up and useless.

There is a telling story about a young man who goes off to seek Truth which illustrates the pervasive devaluation of the older woman. When he decides to dedicate himself to the pursuit of Truth, his wife suggests that he go on a journey and seek Truth high in the mountains where Truth lives. The man gives up all of his worldly goods and takes to the road journeying to try to find Truth. High in a mountain in a small cave he finds a wise and old woman who identifies herself as Truth. She has only one tooth in her mouth and her skin is dry and brown like parchment; her hands are gnarled and she is somewhat deformed; but she is a wise woman and she teaches this man all that she knows. He stays with her for a year and a day before he is ready to venture back into the world. When he leaves he is grateful to the woman who has taught him what is true and asks her what he can do for her in return. The woman responds, "When you return to the world and they ask you what I am like tell them that I am young and beautiful."[3] Even Truth must lie about her age, even Truth knows that only youth and beauty are valued.

Images of womanhood reflect either what the culture wants or fears of a woman. Young women are valued for being child-

like and compliant; midlife women are cherished for being nurturing and steadfast. Older women, by contrast, are no longer seen to be of value for the men or the children in their lives. They are not seen as sexual beings; they are not defined as beautiful; they are not capable of reproducing; they are not involved in nurturing their families.[4] From a male's perspective or from a child's perspective, the older woman is invisible. It is thus no wonder that our culture possesses few idealized images of the older woman.

It has also been suggested that our culture's failure to take note of the older woman comes in part from the fact that older age, whether it is in men or women, is associated with death.[5] Within Western culture, there has been an inability to experience death as a part of the natural rhythm of life and existence. Consequently anyone linked to the end of biological life is viewed negatively or not seen at all. There is a great desire to deny the very existence of older people; they remind us all too clearly that life is finite, carrying within its many possibilities the inevitability of death.

I had an experience recently of being asked to participate in the croning ceremony of a friend. The woman was turning fifty and wanted to mark her entry into older womanhood with a symbolic and a joyous ceremony. When I began to speak and used the word "crone" to describe the woman in her later years, several people winced at the sound of the word. This word, whose derivation comes from the word "crown," was once a designation of honor and respect.[6] It is now difficult for us to think of the word "crone" without thinking of "old crone," a term which connotes a decrepit, useless, and somewhat suspicious older person, a woman who already has one foot in the grave.

While it is true that there are fewer images of older women than of young and midlife women, it is not true that there are no images. The images which do exist fit into one of two categories. Either they are aged versions of earlier images, or they derive from the older woman's status as exile. The *Sweet Old Lady* and the *Grand Mother* are merely the Eternal Girl and the Selfless Mother with gray hair and wrinkles. The *Witch*, the *Spinster*, and the *Wise Woman* represent some version of the

older woman as outcast, a woman living outside of normal society. Each of these images depicts the older woman as the quintessential other, that person who both younger men and women deny as part of themselves.[7]

In folklore, whether she is the Witch or the Wise Woman, the older woman lives in exile outside of the human community.[8] One must seek her either deep in the forest, under the sea, or on the side of a far-off mountain. She no longer participates in the community of other humans; something about her renders her unacceptable. When she is found, she is often surrounded by desolation. The vegetation around her house is burned or destroyed, and there are skulls and bones that mark her garden. We make the older woman a nonperson when we segregate her from the rest of the community. Whether we place her in our myths on the side of a mountain or literally in a nursing home, we are deciding that she is no longer a part of the human community. Many of the women who were executed at the Salem witch trials were single women, women who were living alone and without the support of family or community.[9] Perhaps it was easier to single out these women as demons because they were already social outcasts, already excluded from the main body of society.

The devalued older woman may well represent the exile or outcast in all of us. When we feel uncomfortable about the part of ourselves that feels isolated, lonely, and unacceptable, we project it out and make it the particular province of the older woman who becomes the isolated, lonely, and unacceptable one. If we can further push her away, then we do not have to deal with our own essential aloneness and our own experience of being outcasts. Such a strategy, however, does not serve to heal our own inner sense of loneliness; it merely distances us temporarily from those feelings. In so doing, we do a disservice to older women who carry that unacceptable projection, but we also do a disservice to ourselves because in a fundamental and human way that old woman is also us.

The Sweet Old Lady

The Sweet Old Lady is the aged and trivialized Eternal Girl. Without the girl's charm to make her helplessness appealing, the Sweet Old Lady is merely ineffectual. Media portrayals depict her as somewhat silly and laughable and often not even worth noticing. A recent promotion for a fast-food restaurant has two elderly sisters, one a little deaf, the other a little daffy, planning their birthday dinner. The restaurant offers a free meal and like two little girls, the two sisters eagerly anticipate their treat.

Occasionally the Sweet Old Lady, like Agatha Christie's Miss Marple, is really a Wise Woman in disguise. Her bumbling allows her to be discounted and thus to go unnoticed while she seeks the truth. At other times she really is oblivious and just stumbles good-naturedly onto the solution. In the latter case, her naïveté is what allows her to be successful. Like the Eternal Girl, she succeeds through weakness rather than cleverness and strength.

The Sweet Old Lady is sweet primarily because she is benign and harmless. She offends no one and attends to her own business, working in her garden, and going about the dailiness of her life. She has none of the wisdom that comes from integrating and making sense of experiences. She has none of the complexity that follows from knowing her darker side and from having tasted of the range of life's possibilities. Her sweetness is born out of a desire to please and a willingness to ignore anything which might be upsetting to her or anyone else.

It has been suggested that women who identify with the image of the Sweet Old Lady collude in their own devaluation; that they allow themselves to be made invisible.[10] Barbara Walker, a feminist mythologist, has suggested that it is often safer for women to adopt an invisible, self-effacing, and undemanding posture, especially if they experience themselves as being in jeopardy.[11] It is far safer for them to deny their own existence, to be humble, and to disappear into the interpersonal woodwork. Regrettably, although women may initially assume this strategy of invisibility in order to protect themselves from real legal, economic, and religious dangers, once such a

posture is adopted, it seeps into one's being and causes the older woman to feel her devaluation in a very real and personal way.[12] This is similar to what happens to any oppressed minority. One may adopt a self-effacing strategy as a means of survival, but after many years what was once a strategy becomes a way of life and one comes to feel insignificant and invisible.

I recall entering a group of older women who were talking with one another; when I peered into the room in which they were gathered, one of them met my gaze with the comment, "There is no one here but us chickens." Everyone laughed and I walked out of the room not really thinking much about the comment. In retrospect I think that this woman was really making a comment about how many older women feel: they are in fact nothing very significant and do not need to be paid much mind.

Blanche's Story

One woman, Blanche, adopted the image of the Sweet Old Lady after years of being the Faithful Wife. For almost forty years Blanche was a devoted companion and helpmate to her husband, whose career in the foreign service took them to live in several different countries. As the wife of a diplomat, Blanche learned to be a gracious hostess and worked closely with her husband in his professional duties. Although they had two children, Blanche always felt more connected to and allied with her husband than with either her son or daughter. As their diplomatic career began to wind down, Blanche had every expectation that she and her husband would retire together, continuing their lives as a devoted twosome.

Shortly before their last assignment was to terminate, Blanche's husband informed her that he would not be returning home with her. He announced that for several years he had been having an affair with one of his subordinates. He now planned to divorce Blanche and marry this woman. After this rather blunt pronouncement, Blanche's husband never spoke to her again. Since he believed their marriage had always been

more of a business arrangement than a love match, he felt justified in filtering all future communications through his lawyer.

Blanche returned home alone and in shock. She had lost her primary relationship as well as her identity as a Faithful Wife. Even more devastating was the challenge to Blanche's sense of reality. For years she had believed that she had a good marriage, that she was a supportive wife, and that she would enjoy her status into old age. Her husband's decision to end their relationship challenged Blanche's understanding of who she was and how her life had gone.

While she would have mourned her husband had he died prematurely, Blanche would have more easily adjusted to widowhood than she did to a divorce. As a widow, Blanche might have continued her identification with the image of the Faithful Wife. She could have maintained her allegiance to her husband and his memory, reminisced about her married life, and surrounded herself with mementos of her years with her husband. As a sixty-year-old divorcee, Blanche felt rejected and ashamed. The circumstances of her divorce caused Blanche to feel like a failed wife. Her husband's decision to remarry seemed like a public declaration that Blanche was inadequate.

At first Blanche responded to her situation with confusion. She seemed lost without the identity of Faithful Wife that she knew so well. She was forgetful and somewhat disorganized despite the fact that as a wife she had been a highly organized and competent hostess often planning parties for a hundred or more people. Initially Blanche's friends attributed her disorganization to depression and hurt over her divorce. Eventually, however, a consistent pattern of behavior began to emerge. Blanche would frequently interrupt a conversation with an irrelevant or silly comment. When her companion would look at her quizzically, Blanche would blush, put her fingers to her lips, and say, "Oops, did I say something wrong?" She would consistently apologize for her behavior and tell people, "Don't mind me."

Her sense of humor, once sharp and wry, became silly and girlish. While some of her friends worried that Blanche might be developing Alzheimer's disease or be suffering from severe

depression, it soon became clear that Blanche had found an image to replace the Faithful Wife. She had transformed herself into the Sweet Old Lady. She was ineffectual, somewhat daffy, and completely harmless. Perhaps because she had so surrendered herself to the image of the Faithful Wife, Blanche had failed to develop any sense of herself as an independent person. When her identity was snatched away from her precipitously, Blanche felt not only panicked but empty as well. She felt as if she was nobody when she was no longer a Wife. In her need for a defining image, Blanche found the Sweet Old Lady. While it was not an image with as much status and public approval as was the image of Wife, at least it put an end to Blanche's sense of emptiness.

The Grand Mother

The image of the Grand Mother is a derivative of the Selfless Mother, only the Grand Mother is more wrinkled, more gray, and somewhat softer both physically and psychologically. One woman who was identified with the image of the Selfless Mother looked forward to her years as a grandmother: "When I'm sixty I'll know just what to do; there will be babies to take care of and a house full of people." For her, the role of Grand Mother would repeat the activities she had performed for so many years as a Selfless Mother.

The lore about grandmothers suggests that they are supposed to best the efforts of the ideal mother, indulging and spoiling their grandchildren beyond anything expected.[13] Some women talk with great pride about all the special things they do for their grandchildren. In that sense, grandmothers are grand indeed because they nurture even the most outlandish impulses and desires of their grandchildren.

So accepted is the idea that grandmothers are Grand Mothers that some women actually feel hurt and betrayed when their mothers fail to conform to the image of the selfless and nurturing older woman. One woman in her thirties with three children could not understand why her own mother did not

want to stay home Saturday nights and baby-sit. Another young mother felt confused and abandoned when her mother chose to retire to Florida, far away from her two grandsons. The Grand Mother, like the Selfless Mother before her, should have no needs or desires of her own and should be quite content to sacrifice herself for the needs of her children and grandchildren. One woman, for example, received only agreement from her friends when she decided to quit her job, sell her house, and become a live-in baby-sitter for her daughter's three small children.

When women are identified with the image of the Grand Mother, much of their status and self-worth derive from being nurturing and supportive. Several of the older women whom I interviewed felt the need to tell me at least one story about a grandchild. Usually the story followed a set pattern: the older woman denied her own power and authority, acted somewhat helpless and needy, and allowed her grandchild to come to her rescue. This scenario was consciously constructed to empower the young child, and each woman told me her version of the story with pride—pride in her grandchild's resourcefulness and pride in her own self-sacrifice and willingness to "play dumb" in order to help her grandchild feel competent. One woman was so concerned with boasting about her grandchildren that she could not even sit still to tell her own story. She kept getting up to bring me a picture of one of her grandchildren or to find a trophy won by one of her sons. At one point she even said, "I don't know why you want to talk to me, I'm only a mother."

Significantly, the image of the Grand Mother is not limited to women who have biological grandchildren. One woman in her seventies who founded a prominent literary school identifies herself as a Grand Mother. Arlene is a nationally recognized scholar who educates, lectures, and writes. Her world is filled with symbolic children who feel indebted to her for her intellectual nurturing. When she talks about her students, Arlene refers to them as children: "I think of them as my children and they think of me as a mother. I'm seen in the world as a very motherly figure and to me it's like a continuation of life. It's

like a multigenerational thing. In one way or another I will have influenced the next generation and the generation after." Arlene relishes the day-to-day contact with her students and feels valued when she is able to nurture them. When she thinks about no longer nurturing and teaching her students directly, Arlene feels isolated and lonely. Arlene recounts that when she leads a literary workshop, she is treated like the Queen mother: "I am recognized for my motherhood." Despite her nationally acclaimed professional accomplishments, Arlene identifies herself primarily as a mother with special powers and with many children, a Grand Mother indeed.

Some of the fairy godmothers or good witches of folklore are embodiments of the Grand Mother. The fairy godmother is able to interfere in the course of events to alter them in a more propitious way for the hero (or heroine).[14] She concentrates all of her energy toward magical ends, bringing about events that would not ordinarily occur. Her magical activities serve to assist, heal, or improve the condition of some person who is dependent on her. The good witch is often presented as someone who has access to knowledge that others do not have. In the story of the young woman in "East of the Sun and West of the Moon," a girl sets off in search of a prince who has been locked away in a castle.[15] On her travels she meets three old women; each of the hags gives her a magical golden object, whose purpose seems vague and elusive. The young girl accepts the gifts, not really knowing how she will use them. Eventually these three objects become the means by which she rescues the prince and completes her journey. These Grand Mothers have access to magical objects and to knowledge that the young girl does not possess. These fictional Grand Mothers are special, however, not because of their magical powers, but because they are so nurturing and kind. Cinderella's fairy godmother is not known for being a powerful magician, rather she is remembered as a good mother who helps Cinderella go to the ball. I am reminded of a story in my own family about my Grand Mother who sold her wedding ring so one of her daughters could go to college, an act of self-sacrifice and love but not a demonstration of power.

The Witch

In her diabolical form, the older woman is the Wicked Witch. The Witch is the embodiment of all that is evil and wicked in the world; she appears repeatedly in folklore, mythology, and in the dreams of children. The image of the Witch has been associated with some of the worst examples of woman-hating in our history. As many as nine million women in Europe and the United States were killed as heretics and witches during the early Middle Ages through the seventeenth century.[16] Seen as representatives of evil and deviltry on earth, these women were destroyed so that evil and wickedness might cease to exist.

The Witch is always portrayed as an ugly woman; she is the opposite of everything valued, beautiful, and clean.[17] She is often deformed and crippled, her hair is stringy and unattractive, her hands are clawlike, and she has a foul and inhuman smell. Descriptions of the evil Witch remind us of the images and depictions of homeless women, who are also often described as ugly, unclean, and foul smelling. The image of the Witch has archetypal power. It is always present within our consciousness and we project it out onto appropriate people when they cross our paths. Regrettably, many homeless women have come to identify themselves with the image of the Witch. One woman described how she now purposely did not bathe or change her clothing, hoping to scare people away with an occasional shriek or a well-timed cackle. For her, the woman she had been before she began her life on the streets was well obscured behind the image of the Witch.[18]

In addition to her loathsome physical appearance, the Witch has an ugly spirit. Rather than rising above petty concerns and putting herself and her experience in a larger perspective, the Witch is always involved in petty rivalries and competitions. She is plotting devious and cruel ways to foil her competitors, never seeming to know what really matters.

Historically, the Witch has been associated with Satanic cults and deviltry. It was believed during the time of the Salem witch trials that witches had made a pact with the devil.[19] Because they were bitter and resentful with their lot in life, these

women were supposedly willing to sell their souls for worldly power. Evil-tempered, older women were easy targets for the devil who "walked in a dry place,"[20] since they had little access to legitimate power and were willing to bargain for evil authority.

In Greek mythology, the crone goddess Hecate was associated with evil and death. Hecate was the mother of the witches and it was her province to rule over demons and ghosts.[21] She walked on the earth late at night, accompanied by baying hounds from Hell. Since it was Hecate's task to teach humankind that without death there could be no life, her very presence invoked notions of death and mortality as necessary and integral parts of the life cycle.

Just as integration and wholeness are the central themes of the healthy older woman, fragmentation and chaos form the core of the diabolical older woman. She turns things upside down, disrupting the natural order, rather than integrating and bringing things together. During the Salem witch trials, the women who were accused of Satanic acts were specifically condemned for performing malefice, the act of causing harm to others by using supernatural powers to create illness, injury, or death.[22] Supposedly, the witch could not only transform her own shape but could also interfere with natural processes and rhythms. When animals or humans failed to give birth, when children were born deformed, when there was a miscarriage, the witch was blamed for disrupting natural rhythm. She was seen as the cause of such accidents of nature.

Three of the most famous fictional witches appear in Shakespeare's play *Macbeth*. These witches entice Macbeth to believe that he can have power which is beyond his capability; in so doing, they overturn the order of things. They not only confuse Macbeth but they also disrupt the order of the kingdom, chanting, "Fair is foul and foul is fair." Things are reversed; they are not like they seem; good is made evil; evil is made good.

The Witch is usually depicted as a mad woman. Her voice is often cackling; her reasoning is questionable; and her demeanor seems crazed.[23] Rather than being wise, she is demonic. She speaks in riddles that are chaotic and confused.

Rather than being able to access what is genuine and real in a situation, she is a woman who has lost touch with reality. These mad Witches not only have nothing to teach us, they are women that we should shun; their messages are crazy and they are telling us things we should avoid. In her landmark study *Women and Madness,* Phyllis Chesler comments on the disproportionate number of older women who were institutionalized prior to the deinstitutionalization movement at the end of the 1960s. It has not been uncommon for us to view the older woman as a crazy woman and to lock her up and put her far away from the rest of us. What is more significant for this discussion, however, is that it is not uncommon for institutionalized, mentally ill older women to identify with the image of the Witch, believing themselves to be diabolical, evil creatures.

Several years ago, I attempted to involve a group of institutionalized women of all ages in a volunteer project. Instead of being the recipients of services, these women would deliver charitable services. As we discussed going to a nursing home or to an orphanage, several of the potential volunteers became visibly nervous. Believing themselves to be like Witches, some of these women were fearful of what they might do to vulnerable children or geriatric patients. This fear existed in the absence of any history of violence. They just worried that their essential evil might manifest itself. When women are identified with the image of the Witch, they believe themselves to be demonic independent of any evidence to support that belief.

Heather's Story

For one young woman, Heather, the image of the Witch has haunted both her interpersonal and her intrapsychic worlds. Heather grew up with a mother she believed to be a living embodiment of the Witch; and as significantly, Heather fears that the Witch will emerge as a powerful and controlling element in her own personality.

Heather can never remember a time when she and her four siblings were not abused by their alcoholic parents. She remembers being beaten by her father until her back was bloody and raw. The family lived in Maine and it was a favorite tor-

ment of her parents to lock their children outside of the house in the middle of winter. The children would stand there crying and shivering trying to get back in and the parents would either ignore their cries or laugh contemptuously. Heather remembers a time when she disobeyed her mother and her mother decided to punish her by making Heather wear oversized clothing to school. She dragged along the street in a dress twice her size, being laughed at by the other children. Her mother devised this humiliation as a punishment for one of Heather's many imperfections.

Heather's mother was an outwardly religious woman who frequently asked her children to kneel and beg for forgiveness for some sin they had committed. Because her mother was mentally unstable and acted, in Heather's words, "like a Dr. Jekyll and Mr. Hyde character," the children never quite knew what behavior would be labeled a sin. Consequently, they were always fearful of being accused of an offense that only the day before had passed unnoticed. When they were caught at a behavior that Heather's mother deemed sinful, they would be sent into the darkened basement and made to kneel on hard, uncooked peas, saying the rosary and begging their mother for forgiveness. Heather's mother built a shrine in the basement to her own private god and would ask her children to worship at the altar, behaving like the master of a private and sadistic cult.

Heather considered telling teachers or neighbors about the bizarre and frightening activities that went on within her home, but she did not, fearing that no one would believe her and that her parents, on finding out about her betrayal, would only increase their abusive behavior.

While she was growing up, Heather was depressed and suicidal much of the time. She would often go down to a river near her house and fantasize jumping off the bridge, knowing that she could end her own pain by ending her life. She also had fantasies of murdering both of her parents. She would construct elaborate plots, down to the very smallest detail, of how she would do away with her tormentors. She firmly believed that she would never be prosecuted for killing her parents because after the deed was done the story of their cruelty would come out and no one would punish her. She, like Doro-

thy in the *Wizard of Oz*, could sing joyfully, "The Witch is dead."

In many ways, Heather was asked to contend with harsh and brutal adult realities when she was still a fragile and impressionable child. Instead of enjoying carefree play, she was plotting to kill her parents or contemplating her own death. Like Gretel in the fairy tale, Heather's only concern was surviving the torments of the Witch. She was not only fearful of daily beatings and humiliations, but also concerned that her mother had the power to inflict some sadistic curse that would haunt Heather forever. Most of us never have to contemplate the horrors which Heather faced daily, or if we do, it is in times of war or in our worst nightmares when acceptable social norms are temporarily suspended. However, increasingly stories are being reported of the ritual abuse of children by families who belong to Satanic cults. These stories reveal the level of terror, self-blame, and distorted reality testing that formed the core of Heather's childhood experience.[24]

When she looks back on her childhood, Heather is astounded that she survived the extent of abuse that she and her siblings experienced. In retrospect, it seems to her that she found comfort only in a dog her parents allowed her to have and in the solitary activities of dancing and drawing. These more artistic activities allowed Heather to center herself, finding a place where she might be quiet, away from other people, and where she was able to define the world for herself.

Because of the profound trauma which she sustained, Heather's entire development was derailed. She skipped secure, carefree childhood almost completely and moved prematurely into a distorted young womanhood. When trauma and abuse are extreme, it may be naïve to speak of anything resembling normal development.

The expansive and free exploration of young womanhood was completely curtailed for Heather. She had none of the support that young women need in order to test out their possibilities. Unable to receive the affection and care that parents give children, Heather got love in the only way she knew how, by becoming a young woman very quickly. Like many children who are victims of sexual abuse, Heather skipped adolescence

completely and became a sexual being when she was only thirteen years old.[25] By acting like a woman and being sexual, Heather was able to receive the only love and affection that she had known. She was so happy that her boyfriend seemed to love her that she would have done anything he asked.

Heather's behavior, like the actions of so many women who are forced to survive outside of normal developmental sequence, is a child's interpretation of what it means to be a woman. Since she had barely experienced childhood and had no viable model of healthy adult behavior, Heather constructed her womanly persona from the media and her older brothers' lewd imagination—she became a sexual object. Anything seemed preferable to becoming the Witch she felt her mother to be.

When she was just barely fifteen, Heather became pregnant. She was terrified, knowing that her parents would beat her when they found out the news. Heather's mother, however, did not live to find out about her daughter's pregnancy. Within weeks of when Heather became pregnant, her mother died of complications of alcohol abuse. Heather was then even more frightened because now she would have to deal with her tyrannical father alone. Although she had prayed for the death of her Witch-like mother, Heather, like many captives held by sadistic tormentors, felt frightened when her mother actually died.[26] Heather considered killing herself or aborting her baby. She felt distraught, as if a solution to her problem was beyond her ability to conceive or even imagine. She eventually told a counselor at school of her dilemma and received some support; the counselor, however, was obliged to inform her father. Heather's father was asked to come to school so he could be told the news. While her father conducted himself reasonably at the school, when he and Heather left the counselor's presence, he began to scream at her, telling her that he was disowning her and wishing that she and her baby would die during childbirth.

At this time, Heather was placed in foster care and continued her pregnancy estranged from her family, but at least somewhat secure and safe from further beatings. Heather did not have the money she needed to receive adequate medical care.

In desperation, she and her boyfriend robbed a convenience store so that she would have enough money for a physician. Heather felt as if not only her life, but the world as well, was totally absurd and out of control.

After she gave birth to the child, Heather decided that she wanted to keep her baby, believing that she would find in her relationship with her child the loving relationship for which she longed. However, because she was underage, she needed her father's permission in order to keep the baby. Her father vowed that under no circumstance would she be allowed to keep her child. When her baby was taken away from her and put up for adoption, Heather felt "the greatest pain" that she has ever known. She herself was still a child. She had never received love and support from parents and she was losing the only other living person to whom she felt a connection and a bond. Later in her life, Heather consoled herself over the loss of her baby by telling herself that at least her child did not have to experience the despair and lack of love that she herself had known as a young girl.

After the birth, Heather was sent away from the family home to live with relatives in another state. She was told by her father that everyone would know that she was a tarnished woman and that she would be taken advantage of by boys and men who would see her as an easy target. Heather was barely sixteen years old and she already felt like a fallen woman, someone who was useless, worthless, and unlovable. Not surprisingly, she engaged in wild and reckless behavior, taking drugs, acting out sexually, and allowing herself to be abused and mistreated. For a period of time, she was passed from one man to the next.

When she was nineteen years old, Heather was hospitalized for three weeks for severe depression and suicidal intent. This hospitalization and subsequent psychotherapy marked the beginning of her attempt to repair and recover "the inner child" that she had lost as a result of parental abuse and neglect. Heather says: "It took me a long time to start to grow. Now I feel like I'm getting to the point where my life is becoming simplified and I'm getting back to the basics that made me happy when I was a child—my dog, doing my artwork, and dancing."

The self needs interpersonal nourishment in order to grow and flourish. For much of her childhood, Heather's psyche subsisted on starvation rations. As she now attempts to nourish herself and to make use of the sustenance provided by therapy, Heather has returned to activities that fortified her when she was younger.

Today Heather lives independently and supports herself as a commercial artist. She is committed to doing her own paintings and consciously creates herself with each new work of art. Although her work is abstract, her paintings feel as if they are self-portraits; the rough surface mirrors the scars of her abuse. As she has gotten older, Heather has felt increasingly entitled to have a life of her own. She says: "The past few years I've realized that I've been alive longer without a mother than I was with a mother, and it gives me a sense of freedom, like I have escaped." Occasionally, however, Heather still has nightmares in which her mother appears to her, cackling and ridiculing Heather for believing she could really have a life of her own.

Although she survived the abuse and has begun to nurture herself and to grow once again, Heather still bears some of the scars of her childhood. Heather has been unable to enter into a healthy relationship with either a man or another woman. While she has friends about whom she cares and who care about her, she has had difficulty establishing true intimacy. She continues to feel she only has value to another person as a sexual object and she involves herself in relationships that are mainly sexual and often sadistic.

As she enters the time of midlife, Heather is involved in creative activities, engaged not only in producing paintings, but in actively creating herself, making herself the woman that she would like to be. It has been her task over the last twenty years to transform herself from the injured and crippled child that she was into a woman who is able to survive in the world. Heather has been especially concerned with being able to protect herself, to protect the child that remains locked within her. She is an expert in martial arts and feels proud, knowing that she now has the skills to protect herself if she is ever attacked. These are skills she needed when she was a child and was unable to fend off the abuse of her parents.

Heather acknowledges that she has no model for how to be an adult woman; midlife is perplexing to her. The only woman she has known who was a midlife woman was her mother; yet her mother perverted and distorted midlife possibilities. She became the Wicked Witch who devours her own children and destroys herself in the process. Heather is fearful that this destructive streak will emerge in her own life and she works hard to control herself. By simplifying her life, Heather manages to contain some of the destructive impulses that run within her. Heather seeks to manage the activities of a midlife woman with a sense of moderation and control. Yet she continues to fear that the Witch inside her will one day emerge and she will be as diabolical as her mother was. Consequently, Heather makes sure that she never has power over anyone who might be vulnerable enough to be hurt by her.

Telling her story was part of the healing process for Heather. She felt not only that she wanted to share this story with others who might be experiencing what she experienced, but also that she needed to give a voice to the experiences that she had had. She finally needed to speak for the child that she was, so that her inner child could move beyond the trauma of abuse and so that she could break the curse of the Witch.

The Spinster

If the big winner in the romantic drama is the young woman who is chosen by the prince, then the big loser is the Spinster. She is "old unwanted goods."[27] When a woman is chosen by a man, her passive waiting ends. She can now assume her place in the community of other women as some man's wife. For some women, not to be chosen is a source of great pain and shame. One woman described being unwilling to go to the ballet or out to dinner alone not only because she wanted company but because she feared being seen by some acquaintance who would realize that she was a Spinster. Another woman described her family's collective relief when at the age of twenty-nine she finally married. For years she had been warned that if she did not socialize more she would be doomed to repeat the

fate of an unmarried aunt whose life was mythologized as a tragic story of female failure. Just as the heads of traitors were placed on a spike outside the town to warn townspeople against acts of treachery, this unmarried aunt was held up as a negative example of female possibility. The child's card game Old Maid illustrates the dread and revulsion with which our culture views the Spinster. In this game, children learn to avoid the card that pictures the old woman because the player left with this card at the end of the game is the big loser.

Because of her failure to be chosen by some man, the Spinster is filled with "ressentiment," the powerful spitefulness and negativity borne of impotence.[28] Her failure to marry does not come from a choice to be single, instead she is unmarried by default: no one wants her. Moreover, she lacks the essential female attribute of beauty; she is ugly, and to be ugly is to run the race of a woman's life with one's legs tied together. All of the chosen ones are pretty, or so the stories tell us.[29] Consequently, the Spinster is alone through no fault of her own. She was born unlucky and ugly. Her status as victim is the source of her envy and her vindictiveness.[30]

Since she cannot have love and companionship, the Spinster is critical and prudish. She is the woman who tells her neighbors to make the music softer or who condemns another woman who has a child out of wedlock. If she cannot be happy, then no one should be. Devaluing, criticizing, and detracting are her primary modes of interacting; she is the master of the snide innuendo and the piece of destructive gossip.

In fairy tales, the Spinster is often relegated to the role of ugly sister of the heroine. Cinderella's sisters are classic Spinsters. They gossip between themselves, both envious and dismissing of Cinderella's beauty and charm.[31] Because they will never have the prince themselves, they desire to spoil Cinderella's chances as well. When the story begins, the sisters are busy mocking and tearing down Cinderella. She is ridiculed for wanting to go to the ball. Her Spinster sisters have no choice but to diminish Cinderella; they are too envious of her to grant her any praise. The sisters do not want the prince to find Cinderella; they keep her hidden in the kitchen when the messenger comes with the glass slipper. Spite and revenge are the only

victories for the Spinster, who is unable to gain satisfaction in a more positive way.

This highly negative view of the Spinster as touchy, temperamental, and mean-spirited derives in part from her position as an outsider. She lives on the periphery of traditional heterosexual society and in that sense seems both alien and dangerous. Historically she has not only been shunned but also punished for her separateness. Women who were living alone, without the protection and legitimacy of a man, were overrepresented among those accused, convicted, and executed for witchcraft in colonial New England.[32] Although they were accused of being mean-spirited, quarrelsome, and spiteful, they were also "guilty" of living outside of the norms of colonial society.[33] The seeming failure to conform to the images of Faithful Wife and Selfless Mother may have been the real crime committed by these unmarried women.

Yet regardless of how our antipathy for the unmarried woman began, the Spinster continues to occupy a place on the pedestal of female possibility. Men often ridicule and avoid her for she has little to offer them; women genuinely fear her image. Whether she is the desiccated and bitter Miss Havisham from Dickens's *Great Expectations* or the homicidal Lizzie Borden, the Spinster is an image of what happens to a woman who is not chosen by anyone.

Valerie's Story

Although she is only in her mid-thirties, Valerie has struggled with the image of the Spinster since she was a young girl. Valerie was raised by her paternal grandmother, a woman Valerie describes as mean-spirited and chronically unhappy. Although she had married and had had one child, Valerie's grandmother felt that she had been cheated of the pleasures that come easily to other women. She imagined that her neighbors all had easy lives and that she was destined unfairly for a hard life. Valerie's grandmother did nothing to improve the quality of her life, rather she spent her days complaining. Every evening she would sit on her large front porch sharing with

her young granddaughter her critical comments about every-
one who went by.

Valerie was the oldest of four children, yet her two brothers
and younger sister lived with her parents in a nearby town.
Only Valerie stayed with and was raised by her grandmother.
When she would ask her grandmother why she had been cho-
sen for this questionable honor, her grandmother would tell
her that it was because "you're just like me; we're two peas in a
pod." Valerie felt that her grandmother must be right and that
she had no choice but to become an unhappy, lonely "old spin-
ster mouse."

When she was in grade school, Valerie wrote a story which
was to become the blueprint for her adult life. In the story, a
small flower grew neglected at the back of a large yard. All the
other flowers were noticed and cared for save this one who
grew alone. Following a big storm, only the lone flower, who
had grown strong on her own, survived. She grew in total isola-
tion for several more years, watching while other flowers were
chosen to decorate homes and to be part of bouquets. One day
some children discovered the lone flower and, recognizing its
beauty and grace, used it to adorn the church altar.

As a young girl, Valerie already felt trapped by the image of
the Spinster. Throughout her adolescence, Valerie learned
from her grandmother how to be bitter and critical. Whenever
a classmate would make overtures toward Valerie, she and her
grandmother would find fault with the potential friend and
Valerie quickly gained a reputation for being a "sour puss."
After a while, no one called and Valerie became even more
convinced that she was fated for a life alone.

Believing she would never marry, Valerie prepared herself
well for a successful career. She became an architect, and al-
though she was admired for her good work, she gained a repu-
tation for being unduly critical of her colleagues, openly find-
ing fault with their ideas and their plans. Once again Valerie
found herself isolated and alone. Each time she was shunned
or left out by colleagues or friends, Valerie felt bitter and re-
sentful; yet each of these incidents only confirmed her belief
that she was a Spinster to the core.

When Valerie was twenty-eight, her grandmother died. Vale-

rie remembers returning to her hometown to attend the funeral and being surprised at how few mourners there were. Even the priest had few personal or kind words to say about her grandmother. When she returned to her own home after the wake, Valerie was haunted by recurring nightmares of a dried-up old woman with vacant eyes beckoning to her. Valerie began to feel that she was in a struggle for her very Self with the image of the Spinster. If she could not break the hold the image had on her, she would cease to be anything but a caricature of her grandmother.

In the past several years, Valerie has consciously tried to break free of the behaviors she learned from her grandmother. When she finds herself responding to any new situation with an automatic criticism, she stops herself. She tries to do positive things for herself so that she will not feel envious of what others have, and she has worked to control the rage she feels toward her grandmother for seducing her into such an undesirable image of womanhood. Valerie has also stopped thinking of herself as a woman who must live her life alone. She is active in a bicycle racing club where members also share pot-luck suppers and other social activities. Despite the progress that she has made in descending the pedestal of the Spinster, Valerie remains wary. At times she refuses to voice even legitimate criticism, fearing that by expressing any negativity she might open the door for the Spinster to take control once again.

The Wise Woman

The image of the Wise Woman has recently gained the attention of the women's spirituality movement. It is a venerable image whose most potent embodiments are found in certain ancient or non-Western cultures. In ancient Greece, the Sybils were older women who comprehended the mysteries of the universe and whose task it was to interpret divine will on earth.[34] These women had oracular powers and were in touch with the rhythms of the universe; they could see things unavailable to others. Moreover, it was believed that all women contained within themselves the wisdom of the menstrual blood.[35]

The magical wise blood which flowed out of a woman each month was contained inside of herself only when she was participating in the mysterious transformation of life or when she had reached a certain privileged age. Her wise blood was believed to give her special insight and knowledge.

Themes of death, resurrection, and healing are central to the image of the Wise Woman. The goddess Medea, for example, possessed the blessing of immortality, having the power to restore the dead to life in her cauldron.[36]

In some non-Western cultures, we find images of idealized older women that share some of the characteristics of these ancient mythologies. Within Native American tribes, the Oglala respect the knowledge and wisdom of older women. White Buffalo Woman, patron goddess of the tribe, endows the old women with the task of remembering what is important.[37] They help the tribe to evaluate what is meaningful and what is trivial, bringing to all a sense of perspective. The older woman is the ancestress of the tribe because she is next in line to become a literal ancestor, that is, she is the next in line to die.[38] Her age, rather than rendering her fearsome, grants her a position of honor and respect. She is in greater communion with her ancestors and once again participates in knowledge that is unavailable to others.

In some South American countries such as Chile, the older woman is also honored by her family. When a woman reaches a certain age, if she is widowed, she returns to her family to participate in a literal linking of generations.[39] This is a time for her to be tranquil and reflective and to think about her life. It is also an opportunity for her to bask in the love and warmth of a large family. She is connected in a vital way with other generations and occupies a position of living ancestor within the family. Within African-American literature, we also find the idealized image of the wise and instructive older woman. It is her task to protect her family and to share with them the wisdom that comes from a lifetime of experience.[40]

The character of Old Spider Woman, a Native American goddess, possesses many of the aspects of the Wise Woman. It is Grandmother Spider who prepares the members of the tribe for their ascent to the upper world. She teaches them what

they need to know in a practical sense, but she also provides spiritual guidance, telling them, "Only those who forget why they came to this world will lose their way.[41] Her wise counsel instructs men and women to stay focused and centered, remembering who they are and what is important. It is also her role to provide guidance and mentoring to travelers, whether their journeys are literal or psychological. Her wisdom comes from her years of living and she is available to guide and share with those who seek her.

While the image of the Wise Woman is awe-inspiring and magical, we must remember that it, like the other embodiments of older womanhood, is an image. When women are trapped by thinking of themselves as super-human goddesses they may well miss out on some of the pleasures of being real women.

Gina's Story

Even as a young girl, Gina knew that she would one day take her place as part of the sisterhood of spiritual women within her family. Her mother's family had a long history of initiating daughters into feminine mysteries that were not unlike the transformation mysteries practiced by priestesses of old.

When she was a young girl, Gina listened to her mother talk about the power and majesty of nature. The two would stand on their midwestern farm and watch as a thunderstorm approached. Gina's mother would hug the young girl to her body and together they would experience the power and wonder of the storm.

Because she was raised on a farm, Gina was exposed early to the cycles of living things. She learned as a child that death was a natural part of life as she observed the yearly deaths among the farm animals. She also participated in the rituals of death that took place whenever a relative died. Her very religious, rural family always attended to the care and burial of the dead person themselves. The body was brought into the family home where it could be attended by members of the spiritual sisterhood. Gina keenly watched the ritual and felt comfortable with the bodies of her dead relatives, believing that this final stage of life was as much a part of human experience as birthing and

living were. When she was a young girl, Gina knew that one day she would take her place as part of this sisterhood. However, she imagined that her time would come when she was a woman well advanced in years. She had seen other women initiated into this society when they were in their fifties and sixties. Gina assumed that her life would take the course of most of the women in her family: she would eventually marry, have children, and be a support and a help to her husband, then she would become a spiritual, ancestress woman.

Although she was a feisty and opinionated young woman, when it came to choosing a husband Gina deferred to the opinions of her peers and her family. She chose a young man who was considered a suitable match by others, a young man, however, with whom she felt no special rapport or connection. She married immediately upon graduating from college and as a young woman of twenty-one, she and her husband set out on a European adventure. When they were traveling for a short time, Gina had an experience which changed her life, causing her to assume the role of a Wise Woman long before her time. As they were traveling, Gina and her husband were involved in a serious train accident. The train was going too fast, rounded a bend, and spun off of a mountain side. All of the people who were seated on the right side of the train were killed; those who were on the left side, far from the window, managed to fall against the bodies of those who were killed and thus cushioned, survived. Gina remembers her horror at realizing that her own fall was softened by the crushed bodies of other people. For a year after the train accident, Gina experienced what might best be described as a post-traumatic stress disorder. She had frequent flashbacks of the event, terrifying nightmares, and often found herself crying for no apparent or obvious reason. On one occasion in particular, she was making the bed in her apartment and as the sheet brushed up against her face, she was overwhelmed by a memory of the shirt of the man whose body cushioned her fall, and she burst into tears.

As Gina was attempting to make sense of this disaster, her mother encouraged Gina to believe that the accident might have a purpose in the overall scheme of Gina's life; God had saved her and had chosen her in order to do his special work.

The religious tradition in which Gina had been raised allowed her to accept her mother's explanation and from that time forward she began to think of her life in terms of a special mission. She needed to prepare herself for a kind of work and a type of activity to which she was uniquely suited, an activity which God needed done in the world. As she comforted herself, Gina remembered her experiences with death and the ease with which she had attended dying animals on her parents' farm. It seemed to her that perhaps her special calling was to aid people in the last activity of their lives, namely to help people to die: a classic activity for a Wise Woman.

Gina refers to herself as the ultimate ticket taker, the person who stands at the entrance to the next world and helps people to make the passage from one state of being to the next. In describing herself, Gina says: "I have been absolutely drawn to the transitions in life, yet I don't know spit about birthing. I know nothing about that, but the transition of death, that is what I understand. My experiences of it are that it's absolutely profound. It is an extraordinary privilege to witness it and be part of it, and if one can even most remotely assist it, it's a life-changing sort of thing."

When Gina and her husband returned from their European travels, she began to prepare herself for what she believed would be her life's work. She refers to her work with a capital "W," her special calling to assist people in the task of dying. Gina received medical training and began to work with people who were seriously ill and in the last phase of their lives. For a time, Gina worked in an organ donor program and she was assigned to work with donor recipients and their families, preparing them for the surgical procedure and its aftermath. Quickly Gina found that she had a greater affinity for working with the families of the actual donors. In fact, it seemed to her that in handling the donated organ she was assisting the person who had been killed in the final act of his or her life. It became very important to Gina that the act of donating an organ make sense in terms of the individual's total life experience. Even though the donation of an organ occurred after the person had died, Gina believed that this final act must be integrated into the donor's life; it must have meaning within the context of

that life. Consequently, Gina spent time trying to understand who the donor was and how he or she had died. Gina became totally involved in her career and saw her work as a spiritual calling.

During this time, Gina made decisions not to have children and to end her marriage. In both cases, Gina believed that these more traditional, female roles interfered with her calling; she could not fully devote herself to the process of transitioning people from one life to the next if she were involved in a serious relationship or if she were engaged in mothering children. The decision not to have children was an especially important one for Gina because she has such a close relationship with her mother and with the sisterhood of women within her extended family. Yet it seemed to her that if she were to actualize her gift to the fullest and develop her powers as a Wise Woman then she would need to skip the stage of biological motherhood.

Interestingly, in the last couple of years Gina has found a niece to whom she is beginning to impart some of her wisdom as a spiritual woman. As with the priestesses of old, it is important that the initiate be a member of one's family, but the new acolyte does not need to be one's biological daughter. By transmitting spiritual wisdom, one can establish a relationship and make the new learner a spiritual daughter.

When news of the AIDS epidemic began to occupy more of the public's attention, Gina became aware that the time for her to fully consolidate her Wise Woman identity had arrived. AIDS, which presented society not only with a medical crisis but also with a spiritual dilemma, was the arena in which Gina would express her talents. She was initially involved in the establishment of an AIDS unit at a large metropolitan hospital directly providing care to the sick men and women on the unit. It quickly became obvious to the other clinicians, however, that Gina had a special gift for helping people in the last moments of their lives, facilitating their passing. It became almost a joke on the unit that patients seemed to wait for Gina in order to die. They would survive through the change of shift, knowing that with Gina they would be in the hands of a skilled practitioner who would guide them through their final good-bye to this world and into the next. Gina says that it initially startled some

of her colleagues when she would continue to talk to one of her patients after the monitor clearly indicated that the individual was dead. Gina felt that she was still in communication with the essence of the other person even as he or she passed away.

While she was engaged in her work with AIDS patients, Gina had a personal experience which once again seemed to further consolidate her role of Wise Woman. Her sister-in-law was diagnosed with a terminal illness and Gina's brother asked Gina to attend her in the last months of her life. Gina spent time with her sister-in-law as she slowly said good-bye to the important people and places in her life and prepared herself to die. Gina was with her sister-in-law on the evening of her death, and she sat vigil as "the woman's essence took flight and left her body." Although it is often the case that the staff in intensive care units make themselves scarce at the time of a death, for this particular death, doctors and nurses were lined up three deep watching Gina perform her gift. Gina guided her sister-in-law out of her body and she herself trembled as the young woman died.

For several weeks after this event, Gina felt drained and exhausted; she questioned whether or not she was in fact ready to take on the calling of a woman who performed the mysteries. At this time, Gina sought out a spiritualist who was herself many years older than Gina and quite skilled in the art of helping people die. As soon as she saw Gina she said to her, "My girl you took that woman as far as you could physically go. One step further and you would have been dead yourself." From this experience Gina learned that one must respect one's own limitations in doing the work of a Wise Woman; while one can lead an individual to the final stages of mortal life, one cannot take the final step with that person; one needs a spiritual accomplice on the other side in order to preserve one's own strength and one's life.

For the last several years, Gina has been in training with this spiritualist. Her initiation began in a formal and studied way after she sought out this woman's advice. The woman took her on as a fledgling apprentice, realizing that Gina had the talent and skill to be a Wise Woman.

Gina saw that her life experience up to this point had been a

long series of preparations and initiations into this work which now defines her life. At times she has some regret for having skipped over the usual midlife functions. As she herself said, birthing and the act of creation are things about which she knows very little. Yet for Gina, being a Wise Woman feels right, she feels as if now that she is entering her fifties, she is becoming the woman she was always intended to be. Gina describes a sense of longing or emptiness that had filled her life for years, a longing which she was unable to articulate or identify fully. For years, she attempted to fill it with accomplishments or with relationships; her first marriage blended into a second unsuccessful marriage. She eventually concluded, however, that it would not be in midlife activities that she would fill the longing inside her. Since her own near-death experience many years ago, she has in many ways been waiting to blossom fully into the life of a Wise Woman. Now that she is chronologically as well as psychologically a Wise Woman, Gina feels content; she feels full, describing herself as "having fully walked into selfhood."

All of the images of older women serve to distance us from the real experience of women in the last stage of their lives. The Sweet Old Lady and the Grand Mother are merely aged versions of images from a woman's youth and her middle years. These carryover images deny that old age is really any different from what has gone before. Women may get older, but they really stay the same.

With the images of the Witch, the Spinster, and Wise Woman we see the culture's real desire to gain distance from the older woman. Whether she is seen as demonic, bitter, or magical, the images of older women portray her as outside of the human community. She is not like us, and we only need confront her if we stray far from traditional roles. It is no wonder that these outsider images have special power to trap women who feel themselves already to be on the margin of society.

PART Two

Chapter 6

Themes of Living

Many of the women with whom I spoke who felt trapped by particular images said to me, "My time will come; I won't be a mother forever, I won't be a wife forever. It's my family's turn now, but my time will come later." By this reference to some future time, they were reminding themselves that while they felt stuck and trapped now, they held out hope that when a transition occurred or when circumstances changed, they would be able to step down from the pedestal on which they currently stood. While such naïve promises might be temporarily reassuring, they are somewhat like the promises of an alcoholic to stop drinking tomorrow. The intentions may be honorable, but without an alternative way to live our lives, we may

have no choice but to remain on the pedestal. What we need is not new images or more images, rather we need a strategy for how to live outside of images. This chapter offers an alternative way of thinking about a woman's life—themes.

One way to think about a woman's life is as a story. Stories, like lives, have parts: there is a beginning, a middle, and an end. Stories have characters, which roughly correspond to the images of a life. They have plots that might be seen as being analogous to the actions of a life. Under the surface, connecting the events of the story to one another in some relational order, stories also have themes. A theme gives coherence to the action and imbues the story with meaning.

Continuing with the analogy, the theme of a story corresponds to the life theme of a person, or more precisely, the life themes, because most people are living out more than one theme at any one time, and the themes change and evolve as a person passes through the different phases of life. Life themes are broad categories that describe how we "are" in the world. Understanding our lives in terms of the important life themes gives meaning and structure to our experience. It gives us an alternative way to think about who we are. The image of the Dutiful Daughter or the Sweet Old Lady no longer rules us. The themes provide a framework for our actions.

Different life themes are appropriate at different phases of one's life. The themes of young womanhood are in general different from the themes of midlife women which are in turn different from the life themes of older women. Consider the experiences of a young woman who finds herself trying out new relationships, going away to college, and living apart from her friends and family for the first time. The life theme which connects her different experiences is one of exploration. This continuous thread of "exploring" runs through and connects all the different experiences of a young woman's life. In midlife, a woman may find herself caring for her children, supervising and counseling her employees, and ensuring that her parents are looked after. The theme that connects all of these different experiences is nurturance, one of the themes of midlife women. In the last phase of her life, a woman may spend

time trying to understand and make sense of her many experiences. She may give new weight and importance to an interest put aside when she had less available time; she may let lapse a relationship that no longer seems significant. The life theme which connects these activities is one of integration.

The first part of this book has been a discussion of how idealized images seduce women by promising them a formula for how to live their lives. In this part of the book we will develop the concept of life themes as being structuring categories which help us to make meaning of our lives.

Instead of themes as an alternative to images, we might have been tempted to turn to actions. What, after all, could be freer than actions? Yet, therein lies the second great trap for women. A life defined by activity alone has no more inherent meaning than a life limited by the dictates of an image. One only has to hear the feelings of emptiness in the complaints of women who describe their lives as: "I get up; I fix breakfast, dress the children for school; I go to work, pick up the girls, fix dinner. And that's my day." The mere "doing" of a life can feel meaningless. When we reduce our lives to nothing more than a collection of everyday experiences, we trivialize what it means to be human.

Some of the frustration which women felt in the 1950s and 1960s occurred because running a home had become nothing more than a set of daily activities. Women saw their lives as consisting only of caring for children, keeping the house, and cooking meals. The thematic coherence that might have made these everyday events seem meaningful was not appreciated. In fact, the activities of a homemaker do reflect the midlife themes of nurturance, balance, and transformation. While we should not elevate meaningless activity to a level of importance and significance it does not have, we would be equally remiss if we failed to appreciate the thematic coherence which makes a life more than a set of disconnected activities.

Many of the action movies that have been popular in recent years seem empty because the action has no thematic integrity. A murder gives way to a chase which leads to an escape and yet another murder. Sometimes these actions, intended to excite

and engage us, merely bore us; they bore us because they have no meaning, there is no underlying order, no thematic coherence to the action. It is merely action for action's sake.

In recent years, leaders of the men's movement have suggested that too much emphasis on action may be one of the causes for the emptiness and disconnection that many men experience. When action is not grounded by thematic integrity, it seems meaningless. By giving meaning to events, or by discovering the meaning inherent in certain activities, men have the potential of making their modern experience more full and more rich.

Life themes unite and give coherence to the seemingly disconnected events in an individual life. Thematic coherence is one of the things which is uniquely human and which distinguishes us from all other living creatures. In addition, life themes also connect the lives of people who seem, on the surface at least, to be leading very different lives.

Must a woman consciously choose specific life themes, or does thematic coherence work at an unconscious level? The answer is different for different women. Although the lives of all women are organized thematically, some women are aware of those themes around which their lives are organized; others are not. Some women not only understand but in fact consciously choose the themes that articulate how they "are" in the world. Other women live their lives equally thematically, but they seem to do it with blinders on. If asked, they could not articulate the themes that describe how they are in the world. Yet I believe that the lives of all women can be described in terms of life themes, that it is better to know what those themes are, and that it is still better to choose consciously the themes of one's life. Because there are only a small number of themes that women live by, and because there is even a smaller number that are usually operative at a given stage of a woman's life, many women share similar life themes, even when they seem to be leading very different lives.

While the focus of the present discussion is on themes, not actions, it is impossible to discuss one without the other. Themes give meaning to actions; actions are the raw material which themes organize. All of us remember the coloring book

game "connect the dots" which amused us as children. Consider the analogy in which the dots represent separate actions, while the connecting lines stand for the unifying theme. Unconnected, the dots appear to be a meaningless jumble on the page. Without dots to connect, the lines would fail to make a recognizable picture. One needs both dots and lines, actions and themes, to complete a meaningful picture.

The relationship between theme and action is also captured quite poetically by the traditionally female metaphor of weaving cloth. As every beginning weaver quickly learns, there are two basic kinds of threads in each cloth: the warp and the weft. The warp threads are the long continuous threads that run the length of the cloth. In some heavy cloth, like tapestry, the warp threads are barely visible, yet they provide the essential structure of the material, giving it form and substance. Many pieces of cloth which actually look very different have similar underlying warps. The coloration and individuality unique to each cloth is supplied by the weft. Horizontally laid weft threads provide the texture, color, and often the pattern of the material.

The themes of a woman's life are represented by the warp threads. Her specific and unique personal actions are analogous to the weft. We all share similar themes—our warps are similar—but our lives look different because we weave our lives with the weft of unique actions and personal choices. In my own life, I express the theme of nurturance by supervising and guiding a large staff of young therapists. Another woman weaves the warp of nurturance by staying at home and raising biological children; she creates a different cloth. Yet both our lives are expressions of the theme of nurturance, although they express the theme very differently.

On the surface, our lives seem to be worlds apart; however, both express a central theme of midlife women and at a thematic level are quite similar. The metaphor of weaving is a rich one for capturing the essential task of each individual, the creation of a life. The weaver creates the cloth, taking the threads of the warp and embellishing them with the weft to form particular and unique patterns that reflect the weaver's own sensibility and talents.

In recent years, the phrase "get a life" has been made popular. Aimed at one who seems passive and disengaged, the injunction urges the person to whom it is directed to get involved in living. However, "getting a life" is like selecting a cloth from the ready-made rack. One does not do the weaving one's self, one merely picks out a life that has not only been structured, but embellished by another. When a woman chooses to pattern herself after a preconstructed image of womanhood, she is quite literally "getting a life"; she is selecting an image from the ready-made rack and forcing herself to fit into it. When a woman weaves her own life, taking the standard warp of womanhood and altering and embellishing it to reflect her unique perspective, her particular life experiences, and her personal values, she is not "getting a life" but is "creating a life" in the truest sense.

Themes for All Seasons

Psychoanalyst Carl Jung believed that each stage of one's life was just as full of meaning as the next, but that the specific meaning and theme at each stage was different.[1] We engage in different activities at different times in our lives, and we employ different strategies for understanding those activities at different stages in our development. Each stage of life has its own characteristic set of life themes that integrate and order our experience.

In the book of Ecclesiastes, the stages of life are defined by thematic actions.[2] The biblical verse tells us that everything has its own season and its own time. The seasons of a person's life are defined in terms of enduring ways of being. There is a time for planting, a time for sowing, a time for weeping, and a time for laughing.

Certain aspects of recently resurrected goddess mythology emphasize the themes specific to each phase of a woman's life. The symbol of the moon has been used to describe how a woman will be at different stages of her life.[3] The young woman is the waxing moon: it grows; it is full of promise; it

cradles the future. The mature woman is represented by the full moon: she is ripe and completely present. There is no longer just potential and promise, the waiting for actualization of possibility; rather the full moon shines forth in all its being. The waning moon represents the older woman: it is fading, slipping away, about to pass into nonexistence, a mere sliver or shadow of itself. The movement of the moon has been a powerful image of feminine development because one phase of the moon passes naturally into the next. Rather than being jarring, discrete, and absolute, the movement from one phase to the next is gradual and organic.

Temporal sequences divide easily into past, present, and future.[4] When we think about the totality of a woman's life, it makes sense to use a similar three-part division and to speak of her young womanhood, her midlife, and her older womanhood. Each of these phases has different properties, different activities, and different themes that are appropriate to it, yet these three fit together into one consciousness, one life story. To understand the story, we must ask what life themes order a woman's experiences at each particular stage of her development.

The central theme that underlies much of the activity of the young woman is *preparing*. She is a woman about to embark on the full journey of her life and preparation is one of her main tasks. She is an explorer. Her curiosity is at its peak because she does not yet know who she is going to become and thus she *explores* many possibilities. She *anticipates*. She is a woman who is in a state of active anticipation, engaged with the world and with herself but not yet fully the woman that she is going to become. The woman at this stage is receptive, so that she *receives* that which the world has to offer, taking from many places the raw materials which she will use to create herself.

The central life theme for a woman in her middle years is *creativity*. She is a vibrant and full woman whose job is to bring forth, to *generate,* but not merely to *actualize* potential and then to leave that which she has created, but also to *nurture,* to *protect,* to *caretake.* She is a woman who brings forth life, ideas, possibilities, new ventures, and then nurtures those until they

grow into their own full development. She also *balances* multiple competing demands, establishing priorities and instituting harmony.

The older woman is engaged in *reflecting*. She is the woman who has perspective, who has not only her own life to use as a yardstick in *measuring* and *judging* things, but also the lives of those who have gone before her. Her central theme is *integration;* she brings things together, taking the fragmented experiences of her life and making them one unique and resonant whole. It is her task to *contemplate*. She is a woman who is able to reflect, to think, to bring to bear rich and deep personal experience in offering judgments.

Though the life themes of each phase are different from each other, the themes of one phase should not be judged better or worse than the themes of the others. It is not better to reflect than it is to explore, nor is it preferable to create than it is to prepare. Each phase has its unique themes, different but equally valued as those of the other phases.

Framing a woman's life in terms of a limited set of life themes still leaves completely open the particular actions in which she might engage. She can explore, for example, in a variety of different ways; she can be creative in a variety of different ways. One woman's exploration may take her on a journey to a new place; another's may lead her to the library with books and historical data. One woman's creativity may result in painting a picture, another's in birthing a baby. By focusing our discussion of a woman's life on thematic coherence, we say nothing about the form in which those themes might be actualized.

Barring some personal, familial, or social disaster, a woman can expect that she will live a life long enough to allow her to experience, at least to some extent, all of the themes of feminine possibility. We expect that our lives will last seventy to eighty years. In our late teens and twenties, we are at the beginning of our journey; as we move through our thirties, forties, and fifties, we are in the middle; and in our sixties and seventies, we are nearing the end of our lives. While accident, personal biology, and family history may alter the course of an individual life, almost all of us begin with the assumption that we will reach old age.

When a woman is denied or thinks she will be denied the normative seventy or eighty years, she experiences her life differently. One woman with whom I spoke had always assumed that she would die before the age of thirty. She believed that she would really never enter the middle phase of her life. Consequently, as a young woman she saw fit to explore but not to anticipate or prepare. Since for her there was no future, preparation and anticipation were meaningless. When she passed her thirtieth birthday, she needed to reorient her sense of herself in time, and she proceeded to assess her situation and figure out what she needed to do to get herself ready for midlife. By the time she was thirty-eight she was married with two children and actively pursuing a career. She managed to condense into just a few years some of the preparation and anticipation which other women spread out over ten or fifteen years. The realization that she was quite possibly going to live seventy or eighty years instead of thirty caused her to shift from the themes of young womanhood to those of midlife.

Another woman who died while this book was in progress had a very different experience. She assumed that she would have a normal life expectancy and would grow, as she said, "into a crotchety old woman." When she found out that she suffered from a terminal illness and that she would probably not live past the age of thirty-five, she had to integrate the themes of older womanhood into the last few months of her life. Almost overnight she went from being a woman who was in the middle of her life to a woman who was at the end of her life. With this new sense of time, she engaged in activities that were appropriate to a woman who was closing out her life. She remembered some of the people and events that had been important to her; she left behind messages and words of wisdom and support to her children; she attempted to make sense of the life that she had had and to give meaning and importance to her experience. She worked with a spiritual counselor, trying to find resolution and peace. Her thematic focus was now appropriate to a woman who was at the end of her life. Because of the reality of her illness, she needed to make this shift while she was still chronologically a woman in midlife.

Another woman whose family boasts rather remarkable lon-

gevity assumes that her life will endure well past the seventy-year mark into her nineties or even beyond. Consequently, she envisions the middle of her life as spanning almost fifty years. For her, midlife, the time of heightened activity, performance, creativity, and nurturance, seems almost burdensomely long. She feels as if her mothering years will endure forever, and by mothering she means not only literal mothering but also her caretaking and nurturing in general. She is exhausted as she contemplates the prospect of this extended period of midlife. She envisions that the time of winding down will not begin until she is in her mid-seventies and she laments that she may not have all the energy she would like when she engages in this final part of her life journey.

Each stage of one's life makes sense in the context of the stage that has gone before and the stage that will follow. It is reasonable, for example, to engage in a prolonged period of exploration and anticipation if one assumes that a time of development, fruition, and blossoming will follow. It would be pointless to tend a garden that never bloomed, to plant seeds that never grew. One only engages in these anticipatory, pre-paratory activities if one assumes that what will follow will be a period of fertile activity. It makes sense to wind down, integrate, and bring together the different pieces of one's life only if in fact one has had a life. When one dies in childhood or in adolescence, there is no time and no model for the integration and winding down that would ordinarily take place at the end of a life. One can only integrate experiences if one has had experiences to integrate.

Unlike a cross-country journey in which there are specific mile markers to tell us just how far we have gone and geographic landmarks to indicate the middle and end of the trip, the journey of life has no exact points of time demarcation. We have only a subjective sense that we are in the middle and no longer in the beginning; we may be unable to say exactly where that transition occurred, when it was that the beginning turned into middle. As an individual lives his or her life, the point of transition where one phase of experience ends and the next begins is often unclear. However, several women with whom I spoke were able to identify the middle of their lives by a very

clear sense of awe that they were in fact "living their lives." Women said, "I know this is my life; this is the life I'm going to have." They felt committed and connected to their experience, no longer anticipating, no longer open to a number of different possibilities; the route was chosen and they were aware of being in the middle of the journey.

Themes are all about connection. Thematic coherence connects the seemingly separate behaviors in which a woman engages during a given phase of her life. The flow from one theme to the next, thematic continuity, unifies the separate phases of a woman's life. Thirdly, the universality of age-specific life themes connects women who are in the same stage of life to one another.

Thematic Coherence

One woman with whom I spoke initially described her life as that of a traditional homemaker; she recounted a hodgepodge of various things that she did to sustain her family. She liked to cook; she liked to decorate her home; she spent time devising a computerized system to organize the files in her office. When she began to talk to me, these activities seemed connected only because they were all performed by her in her role of efficient homemaker and businesswoman. Yet each of these activities was connected by the theme of transformation. Regardless of where she did her work, this woman liked to transform things from one state to another. She liked to take disorganized files and develop a system for ordering them; she liked to take unusual ingredients and bring them together into an interesting stew or soup. While none of these activities may seem very glamorous on the surface, each of them is a way to transform the world, to make the space around herself uniquely and truly her own. When this woman thought of her life as being held together by the theme of transformation, the various disparate activities in which she engaged all seemed connected and more meaningful.

Throughout her life, writer Isak Dinesen created herself several times. She used several pseudonyms in her writing, including her most well-known, Isak Dinesen. She wrote and rewrote

in both English and Danish and she was twice exiled, once to Africa from her native Denmark and then away from the Africa which had become her home.[5] Yet, all of her activities are connected by a single theme—creativity. Dinesen spent her life stretching the limits of her creativity both in her writing and in her experiences.

I am not suggesting that everything in a woman's life must necessarily fit into one pattern. However, there is a great advantage to becoming aware of what the underlying life themes are. One woman with whom I spoke had been a mathematics teacher. In her mid-forties she decided that she no longer enjoyed the rigid and formalistic content of mathematics. She decided, after much thought, to abandon her career of twenty years. For a time, while she was searching for a new profession, she found herself organizing political seminars in her community, teaching Sunday school, and writing a cookbook for ecology-minded cooks. When she and I began to talk, she was confused about how all these different things fit together. It seemed to her that she really did not know what to do and was reaching out in several competing directions at the same time. When she began to realize that these were not disconnected activities but rather that they all meshed around the theme of transformation and education, all of a sudden her choices seemed clearer: she was an educator, a transformer, and the content to which she applied her particular skills was less important than the underlying theme which guided and connected the events of her life.

Thematic Continuity

Life themes are both continuous throughout a woman's life and specific to certain phases of her life. This seeming paradox is explained when we consider that certain ever-present themes come to the foreground for a period of time then recede so that others might take their place. The theme of creativity, for example, is present throughout a woman's life; for most women, however, it is only a predominant theme during midlife. Similarly, the theme of integration, in the background dur-

ing young womanhood and midlife, becomes foreground during a woman's later years.

Continuity among life themes occurs because the movement of themes between foreground and background occurs quite naturally. Anticipation and exploration blend easily into creativity. In the creative act which follows, we can see the threads of the theme of preparation. We can see the traces of the theme of nurturance in the integration which assumes primacy in later life. Many of the themes of our lives form continuous threads with one another making the transition from one phase of life to the next far easier than it might be if we looked at events as being only discrete and disconnected.

Transitions are more difficult when we define ourselves in terms of ideal images and when we move from one discrete image to the next. In the world of idealized images, transitions have often been likened to death.[6] Daughter must die for Wife to be born. It is no wonder that we hold on to certain idealizations for too long.

As a woman moves on to the next phase of her life, one part of the self dies. One woman with whom I spoke decided to change from her maiden name to her husband's name after the birth of her first child. She felt so fundamentally changed by the shift in her role that she sensed that the woman she had been, identified by her maiden name, no longer really existed.

Connection Among Women

A thematic analysis of women's lives illuminates the commonality among women who are living seemingly very different existences.

A thirty-five-year-old artist living in New York City, a welfare mother raising three children in Baltimore, and a suburban homemaker and attorney living near Boston seem to have very little in common. They play different roles, honor different images and do different things. Yet as midlife women, the same connecting themes appear in each of their lives. Each woman is engaged in creating, nurturing, and ultimately preserving her creations. One woman actualizes these themes by raising children, another by making paintings, and a third by balancing a

law practice and a home. When we strip away the personal actions and individual choices, we find the same unifying themes in the lives of each of these women.

Several years ago, Sara Ruddick suggested that all women would benefit from the conceptual shift of viewing "mothering" as an activity rather than as a role.[7] The label "mother" applies to a woman and her baby. "Mothering," by contrast, specifies a set of behaviors that might be applied to a variety of circumstances—from raising a child to working in a soup kitchen. A narrow interpretation of Ruddick's work merely provides us with the list of behaviors that make up mothering. When we interpret her work broadly, however, we can begin to see mothering or, more generically, nurturing, as one of the big themes of midlife. As a theme, mothering applies to women who are engaged in a range of activities in addition to raising children. If we realize that life themes are the same for all women who are at the same stage of development, we may be able to transcend the debate about who is being a better woman or a "true woman." The theme of exploration is not expressed better by a woman who goes to college than by one who takes an apprenticeship in an office, nor is it better to apply one's creative energy to running a business or to writing a book than it is to raising a family. The thematic infrastructure of our experience is the same. In that sense, we are all "true women" and we can dispense with the judgments that tend to set one of us as better or more womanly than the other.

A life theme approach to women's lives does not necessarily result in women acting differently. It is not a call for new images to replace the Dutiful Daughter or the Faithful Wife, nor is it a mandate to stop doing what we have been doing and to live differently. Rather it is a shift in perspective, an alteration in emphasis. The thematic threads that connect our actions are now brought to the foreground so that we might become aware of that which gives structure to our lives.

Too often we only become aware of infrastructure when it starts to crumble. As a society, we ignore our bridges and roads until they begin to fall apart. As individuals, we only struggle to understand thematic infrastructure when we are faced with a crisis of meaning. When our actions do not make sense, when

we do not know why we do certain things, or when we are
faced with something for which we are not prepared, we ask
ourselves where the meaning in our life lies. We start to search
for the connecting themes that ground us in our experience
and give a sense of purpose and continuity to our lives. When
we move those themes to the foreground, when we come to
know that the cloth of life has an underlying warp as well as a
more surface weft, we enhance our efforts to lead an authentic
and conscious life.

Themes of Young Womanhood

During young womanhood, themes of preparation, explora-
tion, anticipation, and receptivity predominate. Young wom-
anhood is first and foremost a time of preparation. The young
woman is busy *making herself ready* for life. She is the researcher
who *explores, tests out* different options, and gains the data that
she will need to embark on the task of creating herself. The
young woman also *anticipates* the future; yet her anticipation is
quite different from the passive waiting of the Eternal Girl. The
young woman's anticipation is an active process of imagining
herself into the future. She *dreams* herself forward hundreds of

times, fantasizing her many possibilities before she actually takes on the mantle of midlife.

The exploration of the young woman takes a variety of forms; she wants to know about the world, about relationships, and most importantly about herself. Significantly, there are few if any limits set on her exploration—if something is there she wants to know about it. One young woman, Midge, has acted on her belief that one can learn from any encounter—by designing a course that she would like to see offered by her university. She has entitled this course "A Random Walk Through Life" and, as she envisions it, the seminar would consist of a small group of highly motivated students, excited by learning, who would come to class prepared to talk about something that interested them and engaged them in a passionate way. Each student would be responsible for researching an area of personal interest and then bringing that into class and making it available to the other students. In such a course, students learn from one another but they also learn information that is not connected in the usual way. The only reason that particular content comes into the course is because it happens to be of interest to someone who is participating in the seminar. This open eclecticism typifies the young woman's belief that she can and should explore far-reaching aspects of human consciousness and possibility.

Paradoxically, her very openness often brings her into conflict with her parents, who want to know what the relevance of a course in Hindu Symbolism has to being a wife, a lawyer, or a social worker. The young woman is appalled by her parents' crass practicality. At this stage in her life, data does not need to "lead somewhere" in order to be valid; it merely has to be interesting. It may be that in the service of practicality, parents attempt to curb some of the expansive exploration which they themselves have had to leave behind and which they now find threatening.

All of the young women with whom I spoke felt a strong desire to explore what it meant to be a woman. For some this took the form of watching their own mothers; for others, it meant questioning older women about issues of motherhood

and career. For still others who were estranged from family members, the exploration led them to read about the lives of both famous and ordinary women. Many felt the need to take at least one Woman's Studies course more for personal than academic reasons. One woman, Sally, steeped herself in goddess mythology and joined a witches' coven in her exploration of what it means to be a woman.

In past generations this exploration of womanliness occurred more naturally as part of a routine. Women spent time with their mothers and sisters doing tasks and sharing experiences. Extended female kinship networks would convene to birth and bury family members and to share large projects like quilting and making jam. With the ascendancy of busy nuclear families and the modern lack of clarity about what it means to be a woman, it makes sense that the exploring nature of young women will cause them to ask quite explicitly, "How do you *be* a woman?"

Young women quite naturally focus their exploring consciousness on themselves. Their penchant for keeping diaries and talking with friends for hours reflects their desire to know themselves by processing the minute nuances of their interactions and their feelings. At times, this concern with the self appears to be a complete preoccupation. At this stage in their lives, women have been labeled "pregnant virgins."[1] In this apparent paradox, we sense the notion of a young woman who is full of her own possibility; the woman is pregnant, not with a biological child but with her own self, and as with any woman who is carrying within herself a child, the woman turns her attention inward, focusing on the activity that is taking place inside herself. In this case, however, what is gestating is not a fetus, but the woman's own essential and true self.

In her concern with the self, the young woman passionately values being true to her own beliefs. External consequences do not weigh heavily against the alternative of compromising the self. Consider, for example, Joan of Arc, a young woman so identified with this stage of female development that she chose to be called "La Pucelle" or "the Maid."[2] She was a woman whose passionate attachment to her beliefs led her to the stake —an outcome for which she was eventually beatified. Young

women feel intensely that it is important to honor the self and not betray their own needs and desires for the sake of conformity or in order to keep the peace. Consequently, women who are forced to go against their own will at this time of their lives often experience profound guilt toward the self that has been betrayed. In treating women who are survivors of incest, I have found that one of the most difficult parts of a woman's recovery is forgiving herself for what she believes to be her complicity in the incestuous act. The woman experiences herself at the point of acquiescence as betraying her true self; her guilt toward "the girl that she was" is often difficult to overcome in the process of recovery. Her unconscious reasoning tells her she would have been more genuine if, like Joan of Arc, she had died true to herself.

At times, a woman's allegiance to her own inner standards at the expense of or in opposition to external prescriptions may appear to be self-righteous and intolerant. She believes that she knows what is right and she does not respect those who must make compromises. Unbridled by reality concerns, she may even take reckless or dangerous action in her pursuit of truth. There is a little-known story about the huntress-goddess Artemis, another archetypal embodiment of unpossessed young womanhood, that illustrates rather graphically the self-certain pursuit of what a young woman believes to be just. While bathing in the woods, the goddess is observed by a young man, Actaeon.[3] She is so appalled that he has observed her private ritual that she changes him into a stag and has him torn to shreds by her hunting hounds. Her action seems violent and extreme for an offense that might be seen as a relatively minor and unintended intrusion on her privacy. Yet, for this young woman, as for many women at this stage of their lives, personal standards of right and wrong are absolute. To compromise or temper one's beliefs feels like a violation of one's true self.[4]

One young woman, Tess, made a name for herself in her conservative high school by standing up in her health education class at age fifteen and protesting the use of a standard and what she believed to be a sexist book on female behavior. Tess already knew that some of the customary ways of explaining a woman's life and biological responses were not accurate.

She said in front of the class, "This is a very sexist book and you should not read it. You should not be required to read it." Tess's outspoken statement caused somewhat of an uproar within her school. However, she was pleased with herself, not only for standing up for her beliefs, but also for attacking a traditional portrayal that she knew to be false.

As Tess grew into a young woman, her parents became increasingly concerned about her outspokenness and free thinking. Despite the fact that she had learned to follow her own instincts from their encouragement, they now were disturbed that her independence was taking her in a direction different from the one which they wanted for her.

When she went off to college, Tess decided to pursue a career in fine arts. Her parents were distressed because they deemed fine art, especially the making of large sculptures, an inappropriate career for a woman. A woman needed a more practical occupation, perhaps one that she could use to support her husband while he was pursuing his education. Tess's parents suggested that she pursue graphic design, something more marketable and commercial. When Tess informed them of her decision to be a sculptor, a field that was not only impractical, but also generally closed to women, they disapproved and withdrew their support of her college education. They demanded that she return home, live with them once again, and take courses at the local community college. If she did not comply, they threatened to terminate all financial support. Tess knew that in order to be happy she must do what felt right for her, so she decided to pursue her career and to defy her parents' wishes. Tess chose to honor herself at the expense of losing her most important relationship.

For almost three years, Tess did not speak to her mother and father. She resumed her college career at her own expense, working full time while attending classes. For many daughters, the lack of support that Tess received while going to college would have been a source of ongoing resentment and tension. Tess, however, does not blame her parents for their decision. She is glad that she is now reconciled with them and they have resumed an amiable, albeit distant, relationship. What was

most important to Tess was that she followed her own heart and that she did not allow herself to be derailed by the temptation to be a good and dutiful daughter. It is ironic that Tess's parents' opposition to her plans only served to strengthen her resolve and to make the decision to be an artist truly her own. She now knows that she is an artist only because she wants to be an artist, not because anyone else needs or wants her to be.

Feminist writers have labeled the young woman "a woman unto herself."[5] She belongs exclusively to herself, not yet possessed by any other person, by any particular idea, nor by any set of commitments. Often her freedom takes the form of not yet having given herself to another person in an exclusive relationship; most commonly, not having given herself to a man.

Literature and history abound with stories of young women who protest a marriage arranged for them by their families. The marriage arrangement symbolizes that the woman belongs not to herself but to her family, and in particular to her father. Within this drama of young womanhood, the heroine demands her right to live her own life. On a personal level, it may be meaningful that she already loves another, desires to pursue a career, or pledges herself to a spiritual goal. Symbolically, however, it is important only that she remain unpossessed. She will not be given to a person, a cause, or a commitment that she herself does not choose; she considers any attempt to force her in an imposed direction as an assault on her essential and unpossessed self.

In the story of Saint Uncumber, we find a young woman who actually transforms herself into a man in order to make herself unattractive to the suitor selected for her by her father.[6] The woman desires to remain chaste, and so she is unwilling to consent to the marriage. When her father discovers that she has grown hair on her face and acquired a manly posture, he has her crucified. The young woman willingly dies rather than give in to the suitor her father has selected for her. She chooses to remain unpossessed and to follow her own inclinations; by so doing, she is refusing to give in to the expectations of a patriarchal society. In stories of this genre, the young woman's opposition is directed toward her father more so than toward the

suitor, who is often an unknown and only incidental individual. She will not bend her personal will to that of her father's and to the society which he represents.

This struggle between acceding to societal expectations and following one's own desires was enacted in a recurring dream of Midge's. In the dream, Midge has the task of crossing over a bridge in order to continue her life journey. On the bridge stands an antiquated knight fully dressed in armor, and Midge knows that this knight represents the approval and expectations of society. She also knows that she will not be able to cross the bridge unless she is able to defeat the knight. In the dream, she feels powerful and strong and says to herself: "I am young and alive, I have a right to my life. He is old and inanimate." As she feels this inner power, the knight crumbles before her and she is able to cross over the bridge. As the dream continues Midge sees herself as building other bridges so that other people might also be able to cross. She hopes others might be able to use the connections that she makes in pursuing their own journey and their own goals.

Midge's dream imagery has relevance for all young women. She must find a way to defeat the expectations that others have of her in order to continue her own personal and unique journey. That these expectations are embodied as a rigidified knight seems fitting. Midge's defeat of the expectations of others comes not from a violent or rebellious confrontation, but rather from the affirmation of her own power and of her own right to have her life. As soon as she is able to speak of her entitlement, the knight disappears and she is able to proceed on her way.

In addition to refusing to be possessed in a relationship, the young woman is not yet committed to a particular vocation. Young womanhood is the time for testing and exploring, and the young woman tries out different lifestyles and explores different interests before she settles on those to which she will commit her life. There is similar variability in friendships, in values, and in attachments of all sorts.

What is characteristic of this time in a woman's life is that she invests herself passionately in each choice she explores; the choices, however, change. The intensity with which they are

explored and valued remains constant, yet it is particular to this time of life that the content changes. A woman does not prematurely commit to a particular choice, yet she is not blasé about the process of exploration. She is intensely and passionately engaged in trying to understand what the options might be.

For some women, this open-ended quality is frightening; they become overwhelmed by the possibility that choices have not yet been made. Being one's own person—unpossessed by another individual, unguided by a single idea or philosophy, and uncommitted to a vocation—becomes a terrifying prospect. When a woman feels frightened or overwhelmed by the ambiguity that is inherent in this phase of her development, she may be tempted to commit herself prematurely to one option over another. Indeed, some teenage pregnancies, certain early marriages, and occasionally very early career choices might be an attempt to put a premature end to this time of open-ended exploration.

In her discussion of adult development in women, Ruth Ellen Josselson describes a group of women whose life course reflects early foreclosure of options.[7] These women made choices about career and lifestyle when they were still young girls. Josselson speculates that these women needed constancy and security, and consequently decided on a particular way of life or a particular career when they were still in early adolescence. These are the young women who report, "I always wanted to be a schoolteacher," or, "I knew from the time that I was five that I wanted to be a doctor or wanted to marry the boy next door." Choices that might have been delayed until the period of exploration had been completed were made much earlier. Interestingly, Josselson does not find that women in the foreclosure group are necessarily unhappy with their lives. It seems that they have just leapfrogged over this stage of female development and passed out of early womanhood rather eagerly.

For some women, fear of the open-endedness of young womanhood results in a preoccupation with issues of control. Feeling that there are too many choices, they limit their own freedom, containing spontaneity, sexuality, and impulsiveness.

One young woman, Celeste, whose mother had been especially irrational and out of control during Celeste's childhood, felt a great need to control her own behavior. In particular, Celeste has been aware of the need to control her own sexual boundaries and to make sure that sexuality is something that she chooses and for which she is ready, not something that is imposed upon her by someone else.

Issues of control have also surfaced around dieting, body weight, and the way Celeste appears and presents herself to the world. Although she is not fanatic about dieting and counting calories, it is important for Celeste to know that she can control the way she looks; that she can control her weight; that who she is and how she appears is something that is not driven by forces outside of her control, but is very much something which she can manage and contain.

While exploration and testing options are the primary activities of the young woman, preparation and anticipation are also important themes. Knowing that eventually they will need to assume certain responsibilities and perform certain functions, some young women actively take on the task of preparing themselves. Like athletes preparing to run a race, they train and acquire the skills they will need in order to perform well later on. Faith, for example, spent much of her young womanhood preparing for the task of being a mother.

From the time she was a young girl, Faith knew that her mother was not a very good mother. Although she appeared lively and gay when neighbors would come to call, Faith's mother was actually quite depressed and spent most of her day locked in her room drinking. Although she had married a successful and charming man, Faith's mother never felt at home in her fancy house and longed to be with her own sisters in the small rural community in which they had grown up. When Faith's father needed a companion to accompany him to a social engagement, Faith's mother would feign illness and insist that Faith go in her place. Because of her mother's alcoholism and depression, Faith missed out on having a mother who was available to share confidences, to provide guidance, and to give love and nurturance. Consequently, Faith resolved as a young woman that she would compensate for her mother's inadequa-

cies by being a good mother herself. She set about watching women other than her own mother in an effort to gather the information that she would need for her eventual career as a mother.

When she was small, Faith spent time listening to her maternal grandmother tell stories of her adventures when she traveled around the community and attended to the needs of the sick. Faith found her grandmother delightful and entertaining and she concluded that good mothers enjoy being with their children and sharing their experiences with them. Her grandmother made Faith feel special and Faith resolved that, as a mother, she would impart that same sense of specialness to her own children.

For a time, when she was a young adolescent, Faith's mother turned her over to a neighborhood woman who functioned as a surrogate mother for her. Faith spent time following this woman as she performed her household chores. When she got older, Faith helped this woman in a small bookstore that she owned. Faith enjoyed spending time with this woman, smiling, laughing, and doing things together. From this experience, Faith learned that part of mothering is spending everyday time and doing everyday tasks with your children. The time does not need to be special as it was with her grandmother. Interestingly, Faith's mother realized that she was unable to nurture her child and she selected a woman to do the job for her who seemed suitably equipped. Like the austere queens in fairy tales, Faith's mother handed her child to a motherly peasant woman to raise.

Faith's search for clues as to how to be a good mother continued when she went off to college. She was delighted by the fact that her college had rules and regulations. There were prescriptions for when she was to be in at night, what she was to wear to meals, and how many times a month she was to attend church. The college provided her with structure and limits, the kind of limits that a good parent should set. Unlike many of her classmates, Faith loved these rules and regulations. She knew that they provided structure and a safety net that she needed in order to develop and to explore her own possibilities. From this experience, Faith added to her list of mothering

qualities the provision of structure and protection for her child. Throughout her young adulthood, Faith was engaged in preparing herself for the task of being a mother, a task which when successfully completed would allow Faith to repair symbolically the bad mothering which had plagued her own childhood.

A Characteristic Young Woman

Although the intent of this book is to bring women down from the pedestal and to avoid the creation of ideal types, sometimes the best way to see how theme, action, and relationship blend together is to look at a particular life. By hearing one woman's complete story, we can begin to see the themes that organize the experiences of all young women.

Paula's Story

Paula is a young woman who loves being a young woman. She says at the beginning of her story, "After all, I'm young and shouldn't I take advantage of that?" To be young means to be free to explore the world and one's self in it, and Paula feels exhilarated by her "youngness."

In high school, Paula was part of a group of young women who were labeled as outrageous and rebellious because they pushed the limits of their exploration. They would occasionally come to school dressed in outlandish outfits simply to see what it felt like. Some of the other students and the school faculty labeled this behavior as rebellious, yet Paula knew that she was not in rebellion. She was not in opposition to her family nor to the school; she was just eager to test out as many possibilities as she could invent or discover. She saw some of the other young women around her as missing out on an important stage in their lives. It seemed to her that they had prematurely become old, they were serious, focused, limited, and missing out on the adventure of being young.

When she graduated from high school, Paula left home and

moved into an apartment with several other young women. It felt good to be on her own and to be away from the constraints of parental and adult expectations. Free of these expectations, she felt herself much more open and receptive to the world around her. Paula allowed herself the freedom to explore within shouting distance of her parents' home. Her first independent adventure occurred within the safe zone created by her family. She was able to move away from her parents' perception of reality and to see familiar people and places in a new light; yet she did so while maintaining a connection to her family and to things that were familiar.

Throughout late adolescence, young women struggle with the dilemma of how to be both autonomous and in connection at the same time.[8] It is important to young women that their autonomy not come at the expense of their existing relationships and their connections to important people and important experiences. For Paula, moving out of her parents' home and taking an apartment in her own hometown was a way to work out a compromise between her need for independence and her need for a continuing relationship with her family. If she had moved far away from home, she might have experienced autonomy and exploration but without a sense of connection. Similarly, if she had taken a job yet continued to live in her parents' home, she would have maintained her important relationship but at the expense of losing the freedom to explore and to take risks. Her compromise solution, to move out but not to move away, allowed her to balance autonomy and relationship comfortably.

After almost a year of living independently with the secure safety net of her family's support underneath her, Paula decided to move a bit further in her exploration. She left her home town and went traveling with another young woman. Throughout the stories of young women, travel emerges as an important form of exploration. It is as if young women need to remove themselves physically from the environment in which they have grown up in order to take certain risks, try new possibilities, and experience themselves fully in a world away from home. The travel might be exotic and far away or it might be

just to the next town, but it symbolizes both movement away from what is known and movement toward something new and different.

Significantly, these adventures frequently occur without an itinerary. The exploration is not a guided tour, and the young woman resists preplanned or prepackaged exploration. Many young women fantasize getting on a bus, a plane, or a train, and arriving in a new place, open to whatever might occur there.

In her particular adventure, Paula went with another young woman to southern Italy and the two of them explored a number of small towns together. Without any plans or any place to stay, they would take a bus to a little town and begin to poke around. Every two days they would go to another small village and each time allow themselves to see what was there to see. What is interesting in this exploration is that these young women had no sense of danger. There was no awareness that they might be jeopardizing their safety by exploring in such an unstructured way. Without a real awareness of their personal limits or vulnerability, young women are often poor judges of what might be dangerous choices.

As she traveled, Paula was often overwhelmed by feelings of awe and wonder. She would frequently sit on a mountain, look out over a beautiful vista, and be filled with the thought, This is amazing, this is absolutely amazing that I am here and that all of this is open to me. This sense of wonder at the world, at one's place in the world, and at one's possibilities is very much part of what it means to be a young woman.

Paula remembers thinking as she was traveling: I want to learn everything; I want to read every book, take every course; there are no options that I want closed off to me; there are so many things that I want to learn; who knows what I'll end up being interested in. In this wide-eyed and naïve statement, we sense a young woman engaged in being a young woman, overjoyed at how much there is for her to learn and to know.

For a period of time, Paula's exploration took the form of what she called "sexual craziness." She explored her own sexuality and had a variety of partners, accepting this part of her exploration as a normal part of testing her own limits and of

being a young woman. She says that her parents were upset by this aspect of her exploration and they struggled with her around the issue of sexual freedom.

While Paula accepted this part of her own learning as a normal part of her development, some young women find sexual exploration especially frightening. A number of the women that I interviewed imposed a moratorium on their own sexual encounters. Believing that they could only assimilate a certain amount of new information, they would confine their explorations to one area at a time. If they were exploring intellectually, socially, or interpersonally, they could not also explore sexually, so they would say to themselves in a somewhat arbitrary fashion, "I will not have any sexual interaction for the next two months, or the next six months, or the next two weeks." An arbitrarily set time limit would curtail this aspect of development and exploration.

Sexual impulses sometimes feel too overwhelming to handle. The young woman fears that this powerful drive might drown out other needs and desires which are just beginning to find a voice. The prospect of merging with another person in a sexual encounter can be frightening for a young woman who is just beginning to feel the power of her own autonomy and her own individuality. It may not be until she feels securely rooted in a personal identity that she can take the risk of engaging another person in a sexual relationship.

Just as she accepted her sexual exploration as a normal part of her young womanhood, Paula also accepted her exploration of relationships as a normal part of learning about herself and learning about other people. She said that she had already met many people with whom she could imagine spending her life if she were to choose to live with only one person; yet at this time in her life she could not imagine limiting herself to just one partner. Paula saw relationships as vehicles for self-discovery, not as permanent commitments that might last a lifetime.

While she was uncertain as to what type of romantic relationship she might want, Paula was quite sure that she wanted to be a biological mother. She herself was an adopted child and the biological connection was mysterious and unknown to her. She had no sense of being biologically similar to any other person.

While she could point to her mother, her grandmother, her aunts, and her siblings and see similarities in terms of personality, interests, and values, she could not see any physical likenesses. She did not look like the other people in her family; moreover, she could not conceive of what it meant to look like another person. She felt that she wanted the opportunity to know this biological bond; consequently, she made a definite commitment to herself that one day she would have a child. As a young woman, her motivation for wanting a child was not to love and nurture another living being but rather to explore a heretofore unexperienced blood connection to another person.

Paula thinks that some day she would like to be a writer yet she knows that at this time she is not yet ready to make a personal and original statement. She hopes that eventually she will be able to say things that will challenge conventional ways of thinking, yet she knows that she is not yet ready to write work that will make people take notice. She needs to learn more about "all kinds of things" and to live more of her life before she is ready to make her statement.

Paula is aware that she is in the stage of preparation and anticipation. She embraces the activities important for this time in her life, knowing that they will lead to the next phase, that of midlife. As a young writer, she hopes to be involved in creating new images or in transforming old ones, forcing people to alter the way they see the world. Yet she knows that in order to take on that particular challenge she herself needs to be prepared and ready.

Paula has a strong belief in herself and knows she will be able to deal with whatever happens even if it is bad. She feels that she is a strong woman, containing a force within her which will allow her to cope with whatever may come her way. She sees much of her strength as coming from her connection to other women in her family. She believes that both her mother and her grandmother are strong women who have had to deal with adversity and challenge and have done so with integrity and strength. Coming from that line of women, Paula believes that she will be able to cope with experiences that may be difficult or traumatic. In addition, she looks to her biological mother as a source for her strength. All she knows about her birth mother

is that she was sixteen years old when Paula was born. Paula believes that it must have taken great strength and courage to have a child and to give that child up for adoption when one was so young and vulnerable. Consequently, she draws on her fantasies about her birth mother to define herself as a woman who will be able to handle adversity should it come her way.

Paula, like many young women, is a "Lady of Free and Untamed Nature."[9] Contained in this name is the idea that she is limited neither by internal restrictions nor by external sanctions and expectations. Her sense of expansiveness and unlimited possibility often fill her with wonder and awe, awe at her own potential and power, and wonder at the opportunities offered to her by the world.[10] So pervasive is the young woman's optimism that we are jarred when we find a young woman who seems jaded, soured on herself, and doubtful of the possibilities available to her in the world. In such cases, we must ask ourselves what has happened to this woman. Has she perhaps experienced too harsh limitations at too young an age? If, for example, she has been abused or unduly restricted, she may have had an early and bitter taste of limitations, limitations which have altered her sense of openness and expansiveness in the face of the world.

Young women often have the subjective sense of being able to soar without limitation. One's wings have not yet been clipped and societal constraints are less apparent than they will eventually be.[11] While there are many limitations that eventually constrain women, for young women these are often as yet unfelt. Young women feel free to engage in a range of activities, to play sports, to pursue intellectual goals, to challenge themselves, and to test their own possibility and potential. They do not yet have a sense as to what might be realistic, consequently, they feel free to construct plans and options that may contain unnoticed contradictions.[12] Those same contradictions which are felt so acutely by older women to be limiting factors do not yet limit the exploration of the young woman. In a very real sense, women at this stage in their lives believe that they can have everything. They do not believe that being the mother of six children and being a career astronaut might be incompatible goals. They trust that they contain within themselves the

possibility for any choice they might want to make, and they equate possibility with actuality.

In addition to the lack of limitations from the external world which the young woman experiences, she has not had to experience a curtailment of her essential self. Unless her upbringing has assaulted her with profound narcissistic injuries that have crushed her self-esteem, she still believes in her own power. If she has an especially competitive or critical parent who repeatedly criticizes her attempts at self-exploration and expansion, she may develop an early sense of herself as limited and incapacitated.

I am reminded of a woman whose mother repeatedly said to her whenever she was engaged in admiring herself in the mirror, "One day your waist will be thick just like mine." This critical and deflating statement was more than a comment on the young woman's figure; the mother was saying in essence, "You can dream all the dreams you want, but reality will smash you down just as it has smashed me down; reality will make you face the limitations you now think are beyond you." In the absence of such systematic damage to one's free and untamed self, the young woman persists throughout this stage of her life in an unconditional belief in her own limitless possibilities.

In this phase of her development as a free and untamed woman, the young woman has been referred to as being in a time of "untamable wildness."[13] She is much more risk taking and courageous than she may be at other times in her life. In part, this is because she has not yet contended with limitations, especially physical limitations—injury and death. A young woman feels invincible and free to take chances and to explore the world in a way that at a later time in her life will seem foolhardy. Indeed, in recounting adventures that they had when they were younger, many women experienced almost a sense of disbelief, as if the women they had become could not imagine being wild and reckless in the ways of their younger selves.[14] This disbelief is often coupled with a tinge of envy; the woman in her middle years may well envy that spirit of abandon and freedom that she herself possessed as a younger woman.

Not surprisingly, women at this age often have a strong at-

traction for wild and free things, for animals that run wild in the forest, and for untamed nature.[15] It is interesting to speculate in this regard on the love affair that young women in literature and myth have had with wild horses. The Freudian interpretation sees this interest as a sexual fascination; however, it seems more likely that young women are fascinated by the power, freedom, and seemingly untamable nature of these beasts. The young woman identifies herself with this unfettered being and longs to run wild in the same way that the wild horse runs without containment. For many women, in recounting the stories of their lives, the time of young womanhood is viewed as their most authentic, most genuine time, the period in their lives when they felt most free to be who they truly were.[16]

Relatedness in Young Womanhood

While the primary focus for women at this stage in development is the relationship to the self, the young woman is not unrelated to other beings nor to her culture and community. Characteristically, at this stage in her life, her relatedness is not defined by her connection to a particular person. Since she has resisted making herself the object of someone else's possession, we might assume erroneously that she is "out of relationship" and is solely unto herself. Such is not the case, however, for young women respond very much to the moral imperative to care for others and to care for the larger society.[17]

Issues of relatedness are often played out in two very different arenas for young women: the larger community in which they feel comfortable and at ease, and their personal families where they are often in conflict, battling to be true to themselves while still being connected and in relationship.

The most compelling relationship for a young woman, other than the relationship to the self, is the relationship to the larger community, society, and environment around her. When the young woman looks beyond herself she sees not her personal family to whom she might be in a state of ambivalent connectedness, but rather the larger human family. Her sense of connectedness to all peoples and creatures make her especially

sensitive to the rights of disenfranchised people, and in fact all vulnerable creatures. Young womanhood is a time when women extend themselves for values, beliefs, and idealistic causes, attending to the needs of those who are less fortunate and hearing the call of the environment and the larger social community.

The object of concern for midlife women is their personal and immediate family; the object of concern for younger women is the larger family of all people. A lost interpretation of the story of the maiden Persephone speaks to this concern that young women have for their larger community. The most well-known version of the Persephone story recounts a young maiden who is abducted and raped by the god of the under-world. Her mother Demeter mourns her loss and brings deso-lation on the earth until Persephone is returned to the world of the living. In the lesser-known version of the story, Persephone observes that there are desolate spirits who seem to wander unattended and she asks her mother whose responsibility it is to care for the spirits of the dead.[18] Demeter tells her daughter that it is her, Demeter's, responsibility to initiate the souls of the newly dead into the underworld. However, because her own preference is for the land of the living, Demeter has ig-nored this responsibility. Upon hearing this, Persephone tells her mother that she will make it her own responsibility to at-tend to these lost souls and she will spend a third of her life in the underworld initiating the dead into the society of the spir-its. In this version of the story, Persephone chooses her destiny; she is not abducted, not taken against her will. Persephone looks beyond the needs and desires of her personal mother to the needs of the larger community. It is not only the land of the living that occupies her concern, but the land of the dead as well, and she empathizes with those who are lost there and wandering without a guide.

This connectedness to the larger community may explain why so many young women volunteer their time and make a commitment to helping those who are less fortunate. This incli-nation to be responsible toward the larger community could be explained as being solely a function of young women's having more time to devote to volunteer endeavors than women who

are in the middle of their lives and actively engaged in pursuing careers or in rearing families. I think, however, this interest in the larger community is not a function merely of time; it derives in part from the fact that central to a young woman's sense of herself is her place in the world at large.

In contrast to this felt harmony and connection to the world community, young women often feel troubled in their relationship with their own immediate families. It often seems to be a struggle for young women to maintain familial connections while remaining true to themselves.

Josie's Story

Josie is a young woman trying to define herself while sustaining relationships with strong and powerful people. She is aware that it would be easy for her fragile and developing self to be overwhelmed by the powerful people that surround her and the relationships that entice her. In each of her three most important relationships—to her father, to her mother, and to her boyfriend—Josie tries to maintain the connection while at the same time defining, developing, and exploring her own self and potential.

Josie's father is a powerful and accomplished man whose position within the family is that of resident guru. Josie and her brothers and sisters seek out their father for advice and consultation, and he holds court within the family. After the evening meal, different members of the family "make appointments" with him to debate and discuss issues and to win his approval for their various plans. While Josie values and admires her father, she is aware that for a young woman in the process of defining herself, this is a potentially dangerous and entrapping relationship, not because her father wants it to be so, but because he is so powerful and sure of himself that her own budding self seems weak and vulnerable by comparison.

Her father has always admonished her to "do the right thing," a somewhat ambiguous message which nonetheless has structured the experience of all of his children. His words stand as an injunction to behave in ways of which he will approve. Josie is aware that her tendency to follow this message to

"do the right thing" reflects her temptation to be her father's good girl, a role about which she is quite conflicted. She wants the love and approval of her father and wants to stay in connection to this important person, yet at the same time she wants to be her own woman. To some extent she has resolved her issue with her father via her passionate attachment to feminist issues, struggles, and values. She challenges her father on issues of women's rights, demanding that he change his sexist language and correct some of his assumptions and beliefs about women in general and about the women in her family in particular.

Josie believes that it is her duty to challenge vigilantly her father and other men because the women's movement is in a "state of emergency." Her sense of emergency and her passionate commitment to feminist values reflect not so much the state of the women's movement, but more the reality within Josie's own life. For her, there is indeed a state of urgency and she must be clear, adamant, and passionate about her commitment to feminism, a commitment which parallels her commitment to herself. She knows full well that only a fervent commitment, only an uncompromising position, will be strong enough to allow her to withstand the powerful force of her father's opinions.

For Josie, defining herself in relationship to her mother is a more complicated and more subtle process. She very much admires her mother and wants to incorporate in her own life many of the ways in which her mother has lived. She feels receptive to the path that her mother has laid out: her mother maintains a lovely home, teaches at a community college part-time, volunteers through her church at a soup kitchen for homeless families, and is the mother of five children and the wife of a successful businessman. However, she is aware that it is important for her not to be a carbon copy of her mother. The two women share many interests and the manner in which their careers have developed has been similar. They chose similar colleges; they have chosen similar majors; and some of Josie's goals parallel those of her mother. Josie has been comfortable in permitting herself this identification with her

mother because she sees herself as building on her mother's life. Josie will take her mother's life and add to it the expanded possibilities of a 1990s woman. In that way, she will be like her mother but also be her own person. She is aware, however, that such an addition will result in a life that is crammed with activities, and she jokingly says, "Won't someone tell me how to have a forty-eight-hour day? Then I'll be able to do everything that I want to do." She knows that she needs to add something that is uniquely her own since it is dangerous for Josie to replicate detail for detail the life that her mother has led. However, she wants to stay in connection and in relation to her mother, who is a valuable person for her and whose life presents her with a useful and constructive image of how a woman might live her life.

It is in her relationship to her boyfriend that Josie is working out the struggle between connection and autonomy most explicitly. Josie's boyfriend is ten years her senior, and like her father, he is a competent and successful man. He is clear about who he is, what he wants, and how he would like to live his life. His own certainty at this point is in marked contrast to Josie's exploration and openness to multiple possibilities and options. She is not yet sure about how she wants to live her life, who she wants to be, and what concerns will be paramount for her as she fashions her own particular story. Her own open-endedness, while appropriate for the phase of her life in which she is currently engaged, often seems less good than his certainty and sureness. Realizing that if she is to have a successful relationship with this man, she must bring to the relationship a strong sense of who she is, Josie imposed a moratorium on the relationship and went into a state of voluntary exile, moving out of the relationship and devoting a year of time to the development of herself, to the exploration of possibilities which were appropriate to her young womanhood.

At the time that she met this man, Josie was planning to spend her junior year of college in Europe. When she fell in love, she temporarily considered changing her plans so that she would not be separated from her boyfriend for an entire year. When she decided that she would honor her commitment

and proceed with the plans to spend a year in Europe, she devised a scheme whereby she and her boyfriend would have frequent contact so that she could have her year away without really being away. Once she went overseas it became clear to her that she would deprive herself of a unique opportunity to explore a new country, a new culture, a new language, and a new self if she continued with the plan to have frequent contact with her boyfriend. Consequently, she asked him for a year just for herself. She conceived of this year as similar to the self-imposed exile a creative artist takes in order to break out of existing constraints and expectations, freeing the self to explore all the possibilities that are available. By taking this year for herself, Josie felt that she was making a statement to her boyfriend and to herself as well: "This is who I am; this is what I need; this is what I want; maybe not forever, but for right now."

She allowed herself to be excited by the newness of everything that she saw, unfettered by a relationship with someone who was unable to experience the same sense of wonder and awe that she felt. It was important for Josie that she explore new places with people who were in a similar state of exploration. She did not want a more experienced mentor who could hold her hand; she did not want a guide. Rather, she wanted to see things with fresh eyes, able to be maximally receptive to what was in front of her without having it filtered through someone else's past experience. She felt that she learned a great deal about herself; learned how to do things that she did not think she could do. She said repeatedly, "This was 'my' time; 'our' time would come later." Josie needed to give priority to the development of her self over the development of her relationship to her boyfriend. She was not saying that relationship was unimportant, but rather that in order to engage in a relationship as an equal partner she needed to develop her self first. Now that she has returned from Europe, she and her boyfriend have resumed their relationship. Josie is hopeful that she has been able to keep or modify her important relationships while still honoring her own development; yet her efforts have not been without a struggle and her constant attention to staying on track.

Transitions in Young Womanhood

More than any other transition, the movement out of young womanhood into midlife has been ritualized within Western culture. Young women are formally given away by their fathers when they marry, an act which symbolizes, among other things, movement into a new phase of life. While a marriage involves both a young woman and a young man, it is the young woman's change in status which is announced by her parents with as much fanfare as their economic resources permit. If she chooses to seek advanced education or training, a graduation ceremony will mark her transition to more midlife responsibilities and expectations.

This first major transition in a woman's life is often bittersweet. We cry at both weddings and graduations although they are joyous occasions. Women often experience a sense of sadness as they leave young womanhood. The time of carefree exploration is past and a woman must assume new and limiting responsibilities. Some women are aware of crying for their younger selves as they pass to the next stage, almost as if they are leaving behind a dear friend.

When the transition is especially difficult, a woman may experience a profound disorientation and disruption. The woman she is becoming may seem foreign to the woman she was. Certain formalized trappings of middle adult life may seem alien. If, for example, a new job or a new relationship requires a new name or title, the young woman may have the disorienting experience of wondering just who this "Dr. Jones" or "Mrs. Smith" everyone keeps referring to really is. The persona of midlife with its uniforms, strictures, and expectations may seem like an entrapment to the woman who remains most comfortable with her unpossessed and free self.

At the point of transition, if she feels unready to proceed or if she is especially attached to her own untamed self, she may feel as if she is indeed killing or betraying her essential self by moving on. In such cases, transition will require mourning the loss of her younger self, forgiving herself for moving on, and reorienting to the task of being an adult woman.

For other women, the transition to midlife flows quite

smoothly. In some cases, women move easily because they never felt quite comfortable with the phase of young womanhood. For these women, young womanhood is merely a time of waiting. They were biding their time, preparing themselves a bit, but primarily waiting for the move into the major task of their lives which they see as adult womanhood. Such women act like someone who has chosen to sit out the first course of a meal. They engage in polite chitchat while waiting for the main course to be served. It is the main event, rather than the preliminaries, that is their primary focus and interest. For these women, there is neither mourning nor loss as they move out of young womanhood; rather, they experience enthusiasm and excitement; they feel they can at last get on with the main endeavor of their lives.

Several writers have noticed that the transition from young womanhood to midlife now takes longer than it once did.[19] It seems more typical for women to prolong this transitional phase and to remain in the stage of preparation and anticipation, exploring options well into their thirties. One reason for this delay may be the increase in anxiety women now experience about the task of midlife development. The path is much less clear than it once was and the options seem more varied, consequently, women often feel that they need more preparation and more time to ready themselves for this big venture.

For other women the movement into midlife flows smoothly because they are truly ready to move on. They have explored, prepared, and anticipated well and now they are ready to move on to the next stage in their own development. One young woman, Tandy, experienced such a relatively smooth transition.

Tandy's Story

Tandy thoroughly enjoyed her time in college and was passionate about learning and exploring new fields, new options, and new courses. She allowed herself to be open to a variety of different relationships: she had relationships in which she was totally absorbed by the other person and also relationships in which she was so distant and disengaged that she almost felt

bored. She played with both extremes of the interpersonal continuum trying to find what felt right for her.

While she was an undergraduate, Tandy also got in touch with her own inner voice and began to write poetry and short fiction. She says that she discovered a playground inside her own mind, a place where she could always go and never again be alone. As Tandy describes this time in her life, one gets the sense that she soared with her own power, excited by everything that lay in front of her.

As her undergraduate years came to a close, Tandy focused her attention on a particular field of study and prepared to go to graduate school. The field which she chose was a rather narrow area of English literature; to Tandy it seemed an exciting and rich field in which she could spend her life. She saw her future as consisting of teaching, writing, having a family, and raising children; the prospects seemed open and exciting to her. Just as she was preparing to head off to graduate school, something happened and Tandy describes herself as "putting on the brakes" and stopping her own momentum. She says: "I think I got a little bit scared. It was like learning how to surf and getting a little bit better and a little bit better and a little bit better, and before you know it you're taking the really big waves and you're going along and all of a sudden you get a little bit uncomfortable. I'm getting good at this, but I'm scared."

Tandy's fear caused her to alter her plans to move on to graduate school. Instead, she chose to move to New Mexico with her boyfriend who was still very much in his own process of exploration. He did not have a job and he was trying to write poetry and find himself. Tandy moved in with him, got a job in a lawyer's office, and proceeded to support both of them for almost two years. In some sense, Tandy was trying out a woman's traditional life pattern. She was subverting her own desires and her own interests in order to support the man of her choice. Tandy says that while she was living in New Mexico, the channels to her own inner voice became cluttered. It was not that the voice had dried up or disappeared, but there was so much, as she says, "junk in the way," that she could not get in and the voice could not get out. Significantly, Tandy's father

is a lawyer and by working in a law office, being the dutiful secretary, that is, the good daughter, she was also returning to a role with which she was quite familiar. She knew how to be Daddy's good girl and to do so at the expense of her own independent development.

At the end of her two-year stint in limbo, Tandy returned to her own life. She reapplied to graduate school and prepared to resume her career. In retrospect, she says the time she spent in New Mexico was like a story she chose to read through to the end so that she could close it once and for all. Tandy had no illusions that the move to New Mexico would be successful or that she and her boyfriend would live happily ever after. It was almost as if she needed to play the story out so that she could be done with it. She likens it to reading the first hundred pages of a novel and knowing full well that this is not a story that one will remember or even that one will like, but feeling compelled to read to the end of the book.

Before she went to graduate school, Tandy returned to her parents' home for a few months to collect herself and to make the transition from young womanhood to early midlife. She spent time talking with both her mother and father, almost interviewing each of them about the limitations that they had to face in order to move from youthful excitement to midlife. Specifically, she wanted to know from her mother if there were any regrets about having children. Her mother was a very creative woman who had pursued a career in addition to raising her family, and Tandy wanted to know if, by choosing to raise a family, her mother's career had been curtailed in ways that were irreparable. Tandy's mother assured her that it was possible to combine career and family. While Tandy knows that some of her mother's reassurances are just that, reassurances from a good mother to her somewhat anxious daughter, she is relieved to know that traditional mothering does not mean total relinquishment of one's independent goals and desires.

Tandy has been more concerned about her father's position with respect to limitations and closed options because she is very much identified as her father's daughter. She sees her father as a brilliant man who was once somewhat of an idealistic rebel but who has, in the course of pursuing his career,

adopted many mainstream values. Tandy spends time engaging her father in quasi-arguments in an attempt to see if she can light the old fires of idealism and enthusiasm. She is always reassured when her father takes the bait and responds in an exuberant and passionate way. For Tandy this means that one can indeed move into the mainstream of midlife and not lose touch with one's own unique and true self.

Tandy knows that as she takes on added responsibilities she will need to compromise, to balance, and to juggle the many different areas in which she will express her creativity. She very much wants to be a mother and she is committed to putting childcare first when that time comes. She knows that there will be a period when her career will be secondary to the raising of children. Yet Tandy knows that she is not in that place today and she says, "I'm not feeling very negotiable right now, but that's because I'm really at the beginning of the race. I'm probably going to get more negotiable as motherhood becomes more real for me." In Tandy's statement she uses the imagery of a race and she knows that she is at the beginning—just starting her midlife process, having successfully transitioned from the time of exploration and preparation to the time of development and fruition. Yet, at the beginning, the need for compromise is less than it will eventually be, and Tandy knows that as she moves along to the middle of her life, her priorities will change. She also believes that when that change occurs, she will be ready for it and will embrace it.

When a woman moves to the second phase of her life, she need not abandon completely all aspects of young womanhood. It is actually desirable that a woman take with her into midlife a young woman's sense of exploration, wonder, and receptivity to new ideas and new possibilities. What she needs to leave behind is the state of anticipation and preparation. One could spend one's life anticipating the future and preparing for events that never come. There must come a time, however, when preparation and anticipation are put aside and one proceeds with the task of living one's life.

Young womanhood is a time for dreams. When a woman

dreams, she takes that which is actual and probable and adds unlimited possibility. What is or can be soars with the added energy of what might be. The young woman imagines herself into the future free of constraints. When she moves into middle life, a woman begins to live in the world of accomplishments and realities. She must deal with actual and limited circumstances, bringing her dreams into line with real possibilities. With these limits, however, also comes the opportunity for genuine creativity and real accomplishments. Creativity and accomplishment become the central themes in a woman's middle years.

Themes of Midlife

In a unique and individual combination, the themes of *creation, transformation, nurturance, preservation,* and *balance* form the core of a woman's middle years. During her middle years, a woman writes what is usually the main body of her life story. Those events which have been prepared, foreshadowed, and anticipated in her earlier years are now brought to fruition. Midlife is alive with creative energy. It is the midlife woman who brings forth new life and makes things happen. She nurtures and protects her creations; at the same time, she balances commitments to a variety of people and concerns.

During midlife, creation is a woman's main activity. When a woman is creative she brings forth something new from inside

of herself. Just as the spider draws the material for her web from deep inside, the creative woman draws on inner resources, tapping that which is central to herself in the creation of something new and unique.[1]

Often, this period of creative activity involves a time of germination.[2] That which will eventually be born in either a literal or metaphoric sense must develop and grow inside before it can be brought forth. The most obvious instance of germination is the nine-month gestation period during which time a baby develops before it is delivered into the world. We also can envision situations in which ideas percolate inside a woman's mind before she puts them down on paper or on canvas. Similarly, new ventures, new businesses, and new adventures must be planned and worked out before they are actually lived. We thus often have an experience of nursing or nurturing within ourselves the material that eventually will be delivered into the world.

One woman, Jill, who is an artist, is at just such a time of delivery. Jill has just begun to show her paintings publicly and likens her readiness to present herself and her work to the public to the stage in the ripening of a fruit just before it is ready to be eaten. She believes that there is a process of personal maturing that must precede the delivery of one's self in public. The language that Jill uses and the metaphors that infuse her speech are the metaphors of gestation and creation.

It has been very important for Jill that her paintings be born into a public arena. She believes that if art remains private, it does not fulfill its essential task of teaching and educating. She sees her paintings as instructing people about themselves and about others. Her work is about emotion and relationship, and she uses her paintings to confront people with some of the deepest secrets they keep about themselves. Jill maintains that "art is an outlet for expressing certain feelings yet it is not just a dumping ground." It is important that the feelings of the artist be transformed into communicable symbols so that other individuals are able to read the artist's language. Jill says: "I want other people to know what I know and see what I see. My paintings are what I pass along to the next generation, my gift to the culture from what I have learned through my education

and my experience." Most of us pass our collected wisdom and experience on through out children. Jill passes on her life experience through her art. She says: "Since I am not having children, these paintings are my children. They will carry forward for me the lessons that I want to teach."

This tendency to liken one's creative work to one's children has appeared in the writings and work of other women artists as well. Louisa May Alcott in a Christmas letter to her mother in 1854 wrote: "Into your Christmas stocking I have put my 'first born' knowing that you will accept it with all its faults (for grandmothers are always kind) and look upon it merely as an earnest of what I may yet do. For with so much to cheer me on I hope to pass in time from fairies and fables to men and realities. . . ."[3] Alcott proudly gives her mother her first book as if it were a child. This is her creation and she presents it to her mother with all the pride with which a new mother might present a grandchild to a new grandmother.

The power of a woman in her middle life has been referred to as "actualization power."[4] This is a time when one takes that which is potential or possible and makes it actual. Whether the arena is artistic, cultural, or biological, the midlife woman brings forth content that originates deep inside the self. This middle phase follows on the period of preparation and anticipation which characterizes the young woman's life. The young woman's task is to recognize and understand the potential within her. The woman in her middle years takes that potential and makes it actual or real in the world.

Transformation is another theme of women during their middle years. Transformation is distinct from creation because it assumes that certain things already exist, and that their nature or character is transformed by the intercession of the woman.[5] For example, one engages in an act of transformation when one takes the wool of a lamb, spins that wool, weaves it, and produces cloth. Similarly, when one assists in the development of a child and helps bring about the transformation of that child from a dependent being to a more autonomous young adult, one engages in transformation.

In ancient times, one of the great feminine mysteries was the process of transformation, the ability of a woman to take sub-

stances of one character or type and transform them into sub-
stances of a different type. Giving birth and producing milk or
food from a woman's body were primary examples of transfor-
mation mysteries.

There is an interesting example of a transformative and cre-
ative woman in the lore of the Keres tribe.[6] A goddess named
Thought Woman brings life into existence by thinking about it;
she thinks and sings and thereby imbues forms with life. She
thinks her extended family into existence and sings her sisters
into life. In this example, the woman infuses existing forms
with energy and causes them to be enlivened or vitalized in
such a way that their very essence or nature is transformed. In
activities of transformation, a woman's endeavor causes an ob-
ject in one state to be changed into a different state. This is
different from the creative activity in which the woman draws
something from within herself and delivers it out into the
world. In transformation, the material already exists and it is
the woman's task to change its essential character into some-
thing different.

In addition to creation or transformation, a woman in her
middle years engages in preservation. Once new beings or new
entities have been brought forward, they must be preserved
and protected if they are to continue to exist. A woman in mid-
life respects the fragility of any new creation. She is occupied
with preserving that which she has brought forth. Within the
Hindu pantheon, the middle-life embodiment of the triple
goddess is known as the "preserver."[7] It is her task to preserve
that which has been created.

Sara Ruddick, in her discussion of the thinking style particu-
lar to women in this middle phase of their lives, describes "ma-
ternal" thinking as that which involves holding and maintain-
ing.[8] The preserving aspect of a woman's self allows her, both
literally and symbolically, to put her arms around fragile crea-
tures and give them needed support and structure. The act of
preservation can have as its object any creation, not merely a
woman's biological child. One can be involved in trying to pre-
serve the species, to preserve the environment, or on a grander
scale, to preserve the entire planet.[9] In these cases, no new

creation or dynamic transformation occurs, but the focus is on preserving that which already exists.

Phyllis, an earth scientist with a Ph.D. in geology, defines herself as "a steward of the earth." She is actively involved both personally and professionally in preserving the planet, safeguarding that which is both vulnerable and valuable. Phyllis is passionate about her desire to preserve the earth and speaks of the fragile balance within the environment the way a biological mother might speak about the fragility of her child. Phyllis is actively involved in the conservation movement and spends evenings volunteering to educate and inform citizens about the needs of the environment. For her, the environment is a living, breathing organism that requires and deserves as much attention and care as any individual might need, and she is devoted to her charge in a passionate and committed way. In her own life, Phyllis, who lives in the Southeast, refuses to use air conditioning because of the damage that it does to the atmosphere.

The fourth central theme for midlife women is nurturance and care-giving. The midlife woman is a nurturing presence not merely in her relationship to her own children but in all relationships in which she guides, sustains, or encourages the activities of other individuals.[10] A woman may bring a nurturing consciousness to a garden or any situation in which tending and caretaking are essential. When one is nurturing, one must be involved in a deep and caring way: one must get one's hands dirty.[11] Literally and metaphorically, one does not nurture at a distance. One can be creative by sitting in a chair and thinking, however, when one nurtures, one must interact and engage the environment in an ongoing way.

The activities of nurturance have been referred to as "attentive love."[12] In nurturing, one pays attention to the small details, the little things that are so important in genuinely taking care of another person or situation. This caretaking attitude can be applied in a personal way to one's immediate family, and on a larger scale to one's community and to one's environment.[13] One can be caretaking toward homeless people who live on the streets, toward people who are ill, or toward those who have been victimized in some way. When one caretakes on

a larger scale, one may become involved in social activism, moving beyond the sphere of one's immediate family and applying nurturing and caretaking energy to a larger group or a larger population.

One woman, Alice, managed to apply a nurturing consciousness while pursuing the stereotypically male career of law enforcement. In her mid-thirties, Alice applied to become one of the first black women admitted to the police academy in her county. To her surprise, she was accepted and she entered the academy aware that one agenda of the senior officers was to weed out the new minority applicants. Alice was determined that she would succeed in her unconventional career. As a trainee, she was given one of the toughest beats in the district in order both to test her skills and to discourage her from remaining in the academy. Alice managed to succeed as a patrol cop, but not by adopting the usual male macho persona. Rather, she integrated what she knew as a woman and a mother into the job of being a police officer. She says that the male approach to this job was "kick ass, throw gas, take names later." This style did not fit Alice's view of other people nor was it consonant with her own physical capabilities. Instead, she patrolled her beat with an eye to care and concern for the residents who lived in the neighborhood. She spent time talking to the mothers, asking about their children. She engaged the young men who were standing on the street corner and tried to know them in a more personal way.

On a hot summer afternoon, Alice would buy ice cream for all the children in the neighborhood and initiate an informal block party. The community came to respect her and at times even to protect her. She became a role model for several of the women in the neighborhood and was eventually promoted to a less dangerous and more prestigious position within the force. By choosing to become a police officer, she defied what is considered normal or usual for a woman; yet she brought to her profession a sense of care and concern that was reflective of her personal style as well as being characteristic of a woman in her middle years.

A final theme of a woman in her midlife is balance; she recognizes and respects a balance in her diverse responsibilities,

roles, and obligations. If the young woman believes that all things are possible and that there are no limitations on what she can do, then it is the woman in her middle years who weighs and balances all the activities and possibilities of an adult life and brings those activities into harmony with one another. A midlife woman must be concerned with balance because her many responsibilities demand that she assume multiple roles.[14] Even if she focuses her energy in a single direction, just by virtue of having lived more years, encountered more people, and taken on more obligations, a woman in her thirties or forties will of necessity have varied roles and many functions. These multiple commitments will necessitate that she weigh and balance priorities. When women fail to balance their activities, they allow themselves to be seduced by the myth of Super Woman, the belief that they can continue to do everything even as their obligations expand. It is easy for the younger woman to be filled with expansive options because her real responsibilities are often very limited. If a woman in midlife feels similarly limitless, she has a much harder task ahead of her because her genuine responsibilities and obligations have usually expanded enormously. She is affected by and in turn affects people in her immediate environment, in her immediate family, in her workplace, and in her neighborhood. Each of these interpersonal domains makes demands to which she must respond and react in some way. A woman so pulled must strive toward balance.

The preservation of balance was one of the responsibilities of many of the ancient mother goddesses.[15] It was their task to bring nature, the individual, and the larger community into a dynamic balance. A belief in harmony and a reciprocal give and take was part of earlier systems of natural law. One example is the laws of Maat, an ancient mother goddess of the Egyptians.[16] It was required that men and women give a negative confession to Maat in which they were expected to declare that they had not taken more than their share from other individuals or from the environment, and that they had respected other persons, the earth, the ground, the air, and the streams. Maat demanded that individuals be guided by a sense of balance in their intercourse with the world, recognize their place in the

universe, and strive to be in harmony with other people and with natural forces.

Despite its obvious importance, balance is the unsung theme of a woman's middle years. Many women do not even realize the energy they expend or the skill they demonstrate by keeping their lives and the lives of their families running smoothly. While balance and harmony are the backdrops against which we play out the grander dramas of our lives, they are not only background. Balance is itself a theme of midlife. Like the trains that run on time, we only notice balance when our lives seem out of kilter.

Unlike most women, Hope has been acutely aware of the role balance has played in her middle years. For the last twenty years, she has been involved in juggling the demands of career and motherhood. Throughout this time, she has known that the juggling and balancing of multiple interests and responsibilities has itself been more important to her than any of the particular balls she has kept in the air. Hope is a wonderful juggler and has managed to have a stable and loving marriage, to raise four children, and to maintain an active part-time career which both helps to support her family and also gives her a measure of professional satisfaction.

When she chose a career and a mate, Hope was cognizant of the fact that part of being a midlife woman was to balance several different activities at the same time, and Hope made her choices with an eye to this balancing act. She remembers the message from her mother, who was a bookkeeper: a woman's career must be able to accommodate to her family life. In one of her early dating experiences, Hope observed her boyfriend's mother, a talented and gifted woman whose career was not easily amenable to the demands of motherhood. This woman had been forced to abandon her own professional activities in order to attend to the needs of her family. Hope concluded that a career would have to be flexible and transportable in order to accommodate the demands of motherhood. As a result, Hope eliminated several career options from consideration, careers that might well have suited her particular talents and intellectual interests.

Although Hope says she "fell head over heels in love" with

the man who became her husband, one of the important qualities that this man brought to the marriage was his interest in being a supportive father and his willingness to share many of the tasks of raising a family. To Hope, he seemed the ideal mate for a team juggling act. She was right; he has proven to be a loving and supportive father and has been a real partner in running the household and raising their three sons and one daughter.

The middle years of a woman's life are wonderfully rich. The midlife woman weaves the themes of creation, transformation, and preservation. She gives herself in a nurturing and caretaking way to others and maintains balance in all her activities.

The folktale about the Bairn and the Sidh illustrates for us these midlife themes.[17] The story begins with a young woman who is traveling along a mountain path. She is accompanied by her young son, who is just a small baby. The child is in need of water so the woman risks her own safety to go off to find him something to drink. The woman is concerned with nurturing her child and with preserving his life. She is a biological mother, a woman who has experienced maternal creativity.

In her search for water, she slips and falls and is temporarily rendered unconscious. During this lapse, her child is kidnaped by powerful fairies. When she recovers from unconsciousness, the young woman's first thought is to rescue her child. Once again, she is concerned with preserving his life and with taking care of her young baby. She is told that the likelihood that her child is alive is very slim, yet she is steadfast in her determination to find him. As she slowly regains her own strength, the woman listens to members of the village, trying to gather information and wisdom that might lead to the recovery of her child. She learns from an old grandmother of the tribe that her baby has been stolen by the powerful fairies. She seeks guidance from an old woman, a source of feminine power and female wisdom. The young woman does not act impetuously; rather, she allows herself to gather information and to respect the proper order of things. She will find her child in good time. When she is strong enough, the woman sets off to the land of the fairies to search for her baby.

She discovers that these particular fairies are individuals who

are greedy and desirous of material possessions, yet they have no power within themselves to create or to transform objects. Hearing this information, the woman sits down and draws forth from her memory images and examples of wonderful and miraculous things. She devises a plan whereby she will create objects that will enchant the fairies and entice them to return her baby. From ordinary and everyday objects the young woman makes a beautiful cloak and a melodious harp. With these objects she proceeds into the land of fairies to buy back her young child. At the conclusion of the story, the young woman is successful in her quest and returns home to live a balanced and settled life with her son.

This woman blends within herself many of the themes of a creative woman in her middle life. She is a biological *mother;* she is a *nurturing* and caretaking person; she is concerned with the *preservation* of life; she *creates* a clever plan for her own salvation and the salvation of her child; and she *transforms* everyday objects into magical inventions that allow her to accomplish her goal. She is in every sense a midlife woman.

Characteristic Midlife Women

Because the options for actualizing the themes of midlife are so many and varied, it makes sense to present the stories of two midlife women, each fully engaged in her middle years but with quite different results.

Pam's Story

Pam's life resembles the traditional life script of a woman in her mother's generation. She is the mother of five children, a full-time homemaker who does not work outside of the home despite having a graduate degree in law. Pam says that she has always known that she wanted the life that she now has. However, when she was a college student, she was aware that this particular life option was not popular among women of her generation. In fact, as a child of the 1960s, she had to keep her

plans to herself because it was not socially acceptable for a young woman to want to grow up and embrace the life that her mother had led. In order to conform to the expectations of her generation, Pam drifted into law school. She knew that she would have to embrace, at least nominally, the life of an independent career woman.

Pam was aware of two different agendas: one her own, the other sanctioned by her peer group and by the "zeitgeist" or prevailing spirit of the times. What she wanted to do was be a mother and raise children. But her culture dictated that she *should* want to be a career woman, a professional. Interestingly, women of her mother's generation often felt a similar pull between two separate agendas; however, for them the content was different. For many of these women there was a personal desire for an independent or professional life. However, the prevailing zeitgeist demanded that they live the life of homemaker, mother, and wife. Consequently, many of these women described themselves as unconsciously drifting into motherhood, an option about which they did not have much choice and one which they felt compelled to embrace in order to be women of their times. For Pam, a similar dynamic tension operated; the content, however, was reversed. Her personal choice was to be a mother and a parent; however, she also needed to acknowledge the choice that her culture sanctioned, so she drifted somewhat absentmindedly into a career, reserving for herself the option of choosing eventually what felt right for her, namely to be a mother and to raise children.

It is interesting to speculate on the speed with which cultural norms change. If Pam had grown up in the 1950s instead of the 1960s it would have been perfectly natural for her to want to live a life similar to her mother's. However, because of the social and political upheaval that characterized the 1960s, it was not acceptable for a woman to want to be like her mother. Defining one's adult woman status at that time meant that one had to denounce the life of one's mother and one's parents and actively choose to be different. Ironically, when Pam describes her decision to leave a high-powered New York law firm to get married and have a family, she says, "I did the unheard of, the

thing that everyone said you could not do as a woman." A woman deciding *not* to marry and have children might have made the exact same statement forty years earlier.

Unlike other decisions in her life, Pam was never ambivalent about her decision to have a child. This was a conscious choice and one that has always felt right to her. In some sense, Pam was born to the role of mother. From the time that she first became sexual, Pam wanted to have a baby. Indeed, she has no experience of herself as a sexual woman without linking sexuality to biological mothering. Pam says: "Having children seemed like the most natural thing in the world. I feel like a peasant who has been brought up to work the fields; that's what your hands do, that's what you know." This was such a natural choice for her that there was never really any question as to whether or not it fit or was right. She attributes the ease with which she moved into the role of mother to her own mother's lack of ambivalence about mothering. Pam always felt that her mother loved being a mother and that this was a role which her mother embraced freely and with great joy. Mothering seemed to Pam to be a natural and appropriate activity for an adult woman.

Prior to meeting her husband, Pam was worried that she would never meet someone with whom she could raise a family. She felt that if she were not to have children and join the society of mothers, she would feel like a street person, a woman cut off from the essence of what it means to be a woman. She feared this exile, believing she would be consigned to the fringe of society unable to participate in the most fundamental of human activities. Pam could not conceive of an alternative way to actualize her mothering possibilities other than to be a biological mother. Consequently, when she thought of the possibility of not having children in her life, she felt bereft, as if she would exist merely as a spectator, not a real participant in adult life.

As the mother of five children, including one set of triplets, Pam participates in all the activities of adult womanhood. She enjoyed her pregnancies and felt full and excited by the new life that was growing inside her. For Pam, being pregnant was a creative act and although she enjoys mothering and raising her

children, she would not want to have missed actually birthing these children from her own body. She would have felt less creative had she adopted children. As the mother of infants, Pam enjoyed the one-to-one bonding that existed between herself and a young child, and she felt excited at being the center of the universe for a young and growing person.

As her children have grown, Pam has been involved in educating and nurturing them. She spends time doing homework with each of her five children and much of her day and her activities are structured around helping these young people to develop and grow. She has been involved in the life of her school and has served as classroom aide and as president of the PTA; currently she offers a course in civics and politics for children in the junior high school. It is not the process of educating solely her own children that has involved and intrigued Pam, but the process of educating the next generation that forms an important part of her daily activities. When she considers what she will do as her children grow older, Pam is intrigued by the prospect of starting a school of her own. Even though her own training has not been in education, she wants to continue educating and nurturing young people.

With a family of five children, Pam has to juggle and balance priorities, and she takes great pride in the fact that she manages the schedules of six different people successfully. In this sense, she is almost running a small business and she has to consider the needs of different individuals and also to balance and juggle priorities. This organizational skill, which seems so important for women in midlife, is very much a defining activity for Pam. As her oldest daughter reaches adolescence, Pam is aware that she has the responsibility for socializing this young woman and facilitating her daughter's transition from girlhood to young womanhood.

For Pam, being a mother forms the core of her sense of personal identity. She loves the connection that she experiences in relation to her children, feeling that her children touch her essence in a way that work never could. When her first child was born, Pam thought she might return to work at least part time, but after she held her small son in her arms she no longer felt as if there was any choice or any decision to be made. She

knew that she could not go back to work and that her own growth and her own sense of who she was would best be served by staying home and raising her child.

Because of the unique configuration of her family, containing a set of triplets, Pam has experienced a sense of specialness at being the mother of this particular brood. She is cognizant of the fact that being the mother of her particular family elevated her own status within her community and in her own eyes at a time when motherhood in general was not valued as an occupation for women. She was a mother who drew special attention to herself, especially when she walked down the street with a triple stroller, achieving a special status of which she was proud. Pam has loved the extra attention that she has received because of her multiple birth and enjoys going into school and having her three young children run up to her and be excited to see her. She feels she is more than "the average mother."

Robin's Story

Robin is the youngest child of a large Italian Catholic family and she remembers her mother saying to her when she was entering young womanhood: "I don't need any more grand-children. Do something different. Do something more." Robin took her mother's admonition as permission to explore all the different options that were open to her. She did not have to replicate the life that her mother and grandmother and aunts had had, rather she could be different and could do so with the approval and the encouragement of her mother.

Robin is the academic dean of a small college and has been married for almost twenty years to a man that she describes as her partner or teammate, never as her husband. Robin has been very clear that she will not be defined by her role as wife and that she will maintain her own identity despite the fact that she is very much in love with her husband and very committed to their relationship. She remembers walking down the aisle as a young bride and crying tears of trepidation. She feared that marriage would signal her failure to live up to her mother's expectation that she do something different and something more with her life. Marriage might have meant sacrificing her

independent identity to the needs of another person. She soon discovered, however, that her husband respected and admired her dynamism and her professionalism and wanted her to be her own person as much as she wanted this for herself.

In her position as an academic dean, Robin is responsible for the education and nurturance of young men and women. She is always excited when she connects with a student and when she has, by her words and ideas, made a difference in the life of a young person. Robin is committed to leaving her mark on the college where she works, yet her expectations are not grandiose. She knows that there is a certain structure within the organization that must be respected and, consequently, there are limits to what impact any one individual can have. Despite those limitations, Robin does not want to be an anonymous administrator. She strives to make her mark on the intellectual climate of the college so that it is a better place because she is there.

Because she is administratively responsible for a large staff, Robin often has to juggle the priorities and interests of several different people. She feels like the mother of a large family who must attend to the needs and wishes of all her children. She believes that it is important to make each individual feel as if he or she counts. Robin is as concerned with the relationships among her staff as she is with accomplishing her administrative tasks. Projecting a nurturing attention toward her staff, she strives to ensure that each individual feels his or her unique contribution is valued. This nurturing attention is similar to the attention which mothers focus on their children. In Robin's case, however, this attention is focused on the staff and students of a small college.

Many women who choose to focus their midlife energies on environments other than the family liken their work to the activities of mothers. Constance Lytton, a British prison reformer at the turn of the twentieth century, in a letter to her mother wrote: "What maternity there lurks in me has for years past been gradually awakening over the fate of prisoners, the deliberate, cruel harm that is done to them, their souls and bodies, the ignorant, exasperating waste of good opportunities in connection with them, 'til now the thought of them, the yearning

after them, burns in me and tugs at me as vitally and irrepressibly as ever a physical child can call upon its mother."[18] For Robin, this same passionate attention is directed toward the students and faculty at the college where she works.

The decision Robin and her husband made not to have children has been supported by her family. She says, "I know I would be a good mother, but I do not need a child to prove that." She is confident of her ability to provide a nurturing, supportive environment because she does that every day in her work with students and faculty. While her family feels very comfortable with her decision, she occasionally receives some pressure from peers who assume that something must be wrong either with her marriage or with herself because she has chosen not to have children. One of her friends in particular tells her repeatedly that she needs to straighten out her priorities and start a family.

Robin feels that not having children has given her tremendous responsibility for her own life. There is no third person on whom she and her husband can focus in order to give meaning or direction to the lives that they lead. The choices that Robin makes are her choices, they are not being made for the good of her children or her family. She is aware that she has to answer only to herself about the life that she has lived. She will not be able to attribute responsibility or blame to someone other than herself. There is something exhilarating for Robin about being responsible for her own life and serving as the architect of her own existence. Yet it is also somewhat frightening, and Robin is aware that it would be easier if there were children onto whom she could shift some of the rationale for her choices. If she could say to herself, "Well, I did it for my children," or "I didn't do it because of my children," she might lessen the weight of personal responsibility that she feels for creating her own life.

For Robin, her most creative endeavor is the creation of her own personal self. She accepts responsibility for who she is whether it is good or bad, and she is aware of her own strengths as well as her limitations. She has no regrets about the life that she has chosen, and when she looks back on the choices that she has made, it is with fondness and nostalgia, not

with regret or longing. She is aware that different activities seem appropriate for different times in her life, and while she very much enjoyed the young woman that she was, she now embraces the midlife woman that she has become.

Robin feels a strong sense of purpose in her life. A spiritual and religious tone colors how she thinks about herself. She feels that she has been lucky and blessed with a good life, consequently, she feels an obligation to give back, with commitment and enthusiasm, to her community and to her work.

Robin believes that she has not opted for the path most chosen. Within her own culture and within her family, her life stands out as different from that of her siblings and cousins. She has more education, more autonomy, and more independence than most of the other women in her family who were not educated beyond high school and who chose to follow a traditional script of being primarily wives and mothers.

When she thinks about her future, Robin is somewhat concerned about being a lonely old woman without children. When she sees mothers and fathers bringing their young sons and daughters to college, she feels a twinge of being left out of that community and missing the rewards of a parenting relationship. She is aware, however, that she will be able to say about her life, "I did it my way and I made the choices that I wanted to make." She is also aware that if she is to avoid being lonely and regretful, there are things that she can do to ensure that that does not happen, such as nurturing peer relationships and remaining active within her church. Once again she feels in control of her future, determined to create the kind of older womanhood that she wants to have.

Relatedness in Midlife Women

Midlife women are enmeshed in a web of relationships. They know more people and interact with more people than they will at any other time in their lives. Some of these interpersonal connections meet emotional needs, some supply tangible resources, and some serve to define a woman's place in the world.[19] It is difficult to understand the middle phase of a

woman's life without addressing her relationships to others, to her community, and to herself.

When speaking of biological motherhood, for example, several writers have stressed the relational component of motherhood, arguing that motherhood, rather than being an institution or a profession, is first and foremost a reciprocal relationship that develops between two people.[20] When we put motherhood in the same category as any other career or job option, we miss its primarily relational quality.

Yet for many women, "mother" is not a career or a relationship; it is Mother, the idealized image of the midlife woman, synonymous with normalcy, a necessary ticket for entering the world of adulthood. The time of midlife has been called the "time of the mother." The task for a woman in her middle years is the development of her mother self,[21] and while authors who use this terminology intend that we should think of motherhood and mother/self as all-inclusive terms that capture the full range of a woman's options and possibilities, it is difficult to use the term "mother" without suggesting a biological mother nurturing her child.

So associated is the term "mother" with a woman in her middle years that some cultures refer to all women as "mother."[22] A woman only has to be of a certain age and a member of the clan in order to earn the name "mother." This term does not refer to any specific biological or genetic connection, rather it just denotes the woman as being in a particular phase of her life. Similarly, in some urban street jive all adult women are called "momma." This term again does not imply anything particular about a woman's status as a biological mother, rather, "momma" or "mother" have become so synonymous with adult woman that the terms are used interchangeably. Yet midlife woman does not equal biological mother. Some women chose not to have children; others are unable to give birth. Some women who have children prefer not to define themselves by their mothering relationships.

For those women who do define themselves and their adult status by their ability to have a child, being unable to give birth may mean not only the loss of an important potential relation-

ship, but a disrupted adult development as well. For Jackie, the inability to have a baby has put her life on hold. She, like many women, sees parenthood as a precondition for being an adult.[23] She always assumed that she would be a biological mother, believing that the middle phase of her life would commence when she had a baby. Couples who are unable to conceive children often feel, as Jackie does, stuck in their progression to the next stage of adult development.[24]

Before the advent of so much biological technology aimed at helping infertile couples, Jackie's inability to move on may well have resolved itself earlier. However, technology now presents couples with a several-year course of infertility treatment before they finally make a decision about adoption or remaining childless. Jackie has been involved for more than five years in trying to have a baby. Each new technological advance further delays her decision-making about the rest of her life. Being unable to have a baby has left Jackie not only stuck in her own development but also feeling out of control, furious, and inadequate. For many women, the inability to have a child is an enormous blow to self-esteem.[25] Women feel guilty, ashamed, and angry when they are unable to do what it seems other women can do easily.[26] Infertility has been referred to as an invisible handicap, and for Jackie it is very much a disability that she bears with great shame and discomfort.

Jackie's life plan derailed when she and her husband tried to have a child. At the end of the first year of trying to get pregnant, Jackie began to worry that she would be unable to conceive. At this time, she and her husband embarked on a series of tests and treatments designed to "cure" their infertility. Jackie's first response to this problem was to be baffled. She could not understand how her well-laid plans had gone awry: "There is no baby and there is no answer to why. We planned our lives. Everything we did, we did for a reason, and this is totally out of our hands. That's part of the frustration."

The last five years have been filled with a series of medical tests and infertility treatments—tests and treatments that Jackie has found both physically and psychologically painful. Her entire life has been disrupted and she finds it impossible to focus

on any plans or dreams other than having a baby. One of the most difficult aspects of her problem is that Jackie has felt excluded from certain important friendships and relationships. Mothering not only meant a relationship with a child for Jackie, it was also imagined to be the source of her continuing connection to other women. Because she has failed to become a mother, Jackie's relationship with her best friend has all but ended. Both women planned to start their families at about the same time. Jackie's friend easily conceived a child, and that event initiated the breach in their friendship. Jackie admits that she felt jealous and envious of her friend's easy pregnancy, however, she also felt excluded. It was as if her friend felt uncomfortable including Jackie in family events, almost as if Jackie was an outcast, someone who no longer belonged to the community of other women.

Jackie continues to get depressed when she finds out that one of her friends is pregnant. Although she tries to be supportive and involved, it is hard for her not to feel excluded and angry. Jackie is especially bitter when she sees women who do not want their children or who abuse them. It all seems so terribly unfair to her that she, who wants a child desperately and would make a good mother, has been deprived of the opportunity. Jackie often feels angry at no one in particular. She says, "It is as if some cosmic force is laughing at me." She thought she could plan her life; she thought she could have some modicum of control; but she is being taught a bitter lesson: control is impossible in this unpredictable world. Jackie likens herself to a hamster on a wheel, running in circles unable to get on with her life until the pregnancy issue is resolved.

Jackie knows that she is biding time. She does not know if she wants to adopt a child, and she is unclear as to how she might change her career plans if she were to be childless. The move into midlife, the time when Jackie will take on her main creative task, has been delayed. Jackie is uncertain now that her plan has been derailed as to what form her midlife activity will take. She feels confused and at a loss.

While Jackie and her husband try to get on with their lives

and make plans, it is difficult for them to think beyond the infertility. Recently they have instituted a plan whereby every Sunday evening they stop, take stock, try to spend some quiet and romantic time with one another, time reminiscent of the days when they were not so busy trying to conceive a child. They have also tried to take more vacations to get away from this life which seems so consumed by the issue of infertility. Jackie says it was wonderful to escape for a week recently, leaving behind the medications, plans, and schedules about pregnancy and just enjoy one another's company again. Yet when she thinks about her future, Jackie says, "a wall comes down." Infertility is like a barrier that she cannot get under, over, or around. If Jackie could find another way to express the themes of nurturance and creativity in her life, she might feel less blocked in getting on with the main tasks of her middle years.

Whenever women merge their relational identity with their independent sense of who they are, they risk the pain, anger, and confusion that Jackie is experiencing if those relationships are disrupted. If, for example, one comes to think of one's self as the mother of this particular child or the wife of this particular man, then one may feel something akin to an identity crisis if those relationships end. One woman experienced a physical and emotional breakdown when her husband of twenty-five years left her. Her marriage had defined her life, and without it, she felt a confusion not unlike an adolescent identity crisis.

In the worst of circumstances, the self no longer exists; one's personal identity becomes synonymous with one's primary relationship.[27] A woman no longer sees herself as an independent and separate person; she is only the wife of X or the mother of someone. We often refer to a married woman by the title Mrs. and then the first and last names of her husband; the only thing distinguishing her name from his is the letter "S"; no separate or independent identity is recognized. Women are not even granted the autonomy of their first names. They exist only as the relational appendage of their husbands.

While relationships hold certain dangers for midlife women, they also hold the promise of much personal enrichment and fulfillment. In the context of important relationships, women

test their mettle and learn who they really are; they also experience joy in their simple connections to others.

As mentioned before, the opportunities for all relationships expand for women in the middle phase of their lives. This is due in part to the increased connections which they have with other individuals.[28] As one moves into one's thirties and forties, it is difficult, just by virtue of having been alive a certain number of years, not to have multiple relationships and connections. One usually has worked and been educated in several places. One has a family of origin and perhaps a new primary family. One may have in-laws, neighbors, and friends. As one experiences major life events—the birth of a child, the death of a friend, the move to a new city—one's relational context expands and alters. Midlife women are at the height of their relational involvement.

Relationships are built up as women go about the daily activities of their lives.[29] One does not decide arbitrarily to become involved in a relationship; rather one goes through routine and often circumscribed tasks, and in the process of doing these repetitive and small activities creates a bond with other individuals. Mary Bateson, in her book *Composing a Life*, emphasizes the importance of these everyday and ordinary activities. She maintains that it is in doing familiar and simple tasks that are limited in space and limited in time that interpersonal communication is built and strengthened. These daily activities are essentially the nurturing and caretaking mode of the midlife woman, and it is in these nurturing and caretaking activities that a relational connection develops.

While it is easy for us to see how issues of relatedness and caring form the core of a woman's homelife, many women found these issues to be equally alive in the workplace. One woman, Cora, who heads a large corporation, is quite concerned with the "human" dimension of her office. She attends to the needs of the people within her business organization and has found that, as a corporate executive, she is not only motivated by bottom line considerations, but is also very concerned for the well-being and welfare of her employees.

Another woman, Dale, actually left a very successful career

over relational concerns. While she was successful at her job and rose within the firm, Dale felt increasingly empty and dissatisfied over decisions concerned only with the bottom line of profit and loss and not with the effect that the company's policies had on people's lives. Her dissatisfaction came to a head one day when she and her colleagues were discussing an investment strategy that would dramatically disrupt the lives of several families. As she passionately argued against this strategy, Dale found herself near tears. She could not explain to her male workers why people's lives mattered more than profits. Dale had inadvertently discovered her caring female self—what Carol Gilligan and her colleagues have called a "care orientation"[30]—and she could not go back to being "one of the guys." Her concern with people, relationships, and the human impact of economic decisions caused Dale to feel quite estranged from the men with whom she worked.

For many women in midlife, issues of relationship are intimately tied to issues of commitment. While a young woman can have relationships while remaining "unto herself" and without limiting her options, a midlife woman's relationships are of necessity limiting. Being a mother or choosing to live with one person rather than another brings a deep sense of connection but also limits one's possibilities. We often find that in midlife, commitment is a necessary price we must pay in order to enter into relationships that are caring, dependable, and long term. In the absence of commitment, we may find that our relationships retain a somewhat adolescent quality: they are intense but superficial, passionate but short-lived.

One way in which women grow and develop is through their important relationships. They not only experience the joys of connection and caring but they also come to know themselves more fully. Because of their centrality during a woman's middle years, however, relationships also pose certain dangers. A woman can lose herself in her primary relationships, substituting a relational identity for a more individual and personal one. She can also allow her commitment to her relationships to eclipse her commitment to herself. While these dangers are enough to scare some women away from the challenges of rela-

tionships entirely, most women feel sufficiently drawn by the possible rewards to at least attempt to build connections in midlife.

Transitions for Midlife Women

When we think about the process of transition for women in their middle years, we must consider transition at both ends. Midlife is a phase that women both enter and exit. The entry into midlife activity can be cautious and slow, it can also be precipitous and sudden.

Many young women seem to dive into middle life all at once, assuming all the responsibilities and activities of adult women. We can speculate that many young girls who have children when they are in their teens are catapulted from the state of young womanhood into the state of midlife mother, overnight. While these women take on the activities, responsibilities, and the outward trappings of adult, midlife women, many remain girls within their own minds, more identified with the young woman who anticipates, dreams, and looks with awe and wonder on the future than with the woman in the middle of her life who understands her responsibilities, weighs and balances her obligations, and involves herself in nurturing and caretaking activities. Some of the dilemma young mothers face may well derive from a conflict between inner and outer behaviors. The woman's public self is consonant with one phase of adult female development, but her own inner psyche remains locked in another phase.

Although at age forty she is now comfortable with being a midlife woman, Felicia spent many years during which she prematurely assumed midlife responsibilities and felt like a girl acting out a woman's story. During her adolescence, Felicia felt drawn by the cultural script of so many black teenage girls to grow up as fast as she could. Despite her own family being intact and economically secure, Felicia chose to spend her social time with children from the public housing projects. She would hang around, as she says, "with the worst people she could find," and if her parents ever questioned her choice of friends

she would accuse them of racial prejudice. Within her social circle, most of the girls with whom she spent time were the products of broken homes or single mothers attempting to raise several children. These girls had no future to look forward to and saw themselves consigned to leading lives similar to their mothers'. Felicia remembers going to parties when she was only sixteen years old and having her friends ask her, "When are you going to have a baby? You're not a woman 'til you have a baby." By the time Felicia was a senior in high school, most of her friends already had children and she herself was desirous of finding a man so that she too could get pregnant and join the club of other girls.

Her parents had different plans for Felicia. They wanted her to go to college, become educated, and be financially successful. A major goal within the family was that she and her siblings not only achieve a level of academic success, but that they achieve financial success as well. Despite this family script, Felicia was more drawn by the cultural script that she shared with the girls in her neighborhood. In order to be a young black woman, one needed to produce a baby.

Felicia was successful in high school, but for the most part she found it to be a disappointing experience. She felt as if the teachers and the academic system had given up on the black children in her neighborhood. If students were polite, mannerly, and able to read, they received A's and B's regardless of whether they attended class or performed assignments. Felicia says that she floated through high school and graduated with a 3.8 average.

Felicia made few plans for going to college and rather haphazardly applied to only two universities in the summer after she graduated from high school. Although she was an intelligent and gifted young woman, Felicia did not really see college as fitting into her plans. She was going to become a woman "overnight" by having a baby, not by educating and preparing herself for the tasks of adulthood. At the very last moment, and despite her own ambivalence about going to college, Felicia was accepted with a scholarship at one of the two universities to which she had applied, and she began college in the fall already three months pregnant.

Felicia was overjoyed by the fact that she was pregnant. She did not tell her parents about her pregnancy until her mother discovered the news by reading a letter that Felicia had written to a friend. Once she found out about the pregnancy, her mother was devastated and insisted that Felicia marry the young man in question. Felicia had no particular objections to this plan, and she and her boyfriend were married shortly thereafter.

Significantly, Felicia had no real interest in being either a parent or a wife. She did have an interest in proving her female credentials, and within her community that was only done by having a baby. She was also invested in identifying with the cultural script for young black women, which meant getting pregnant and rushing as quickly as possible into a pseudo-adulthood. When Felicia's child was born, she turned him over to his two grandmothers, who shared the raising of the child. Within three months, however, she was pregnant again. This time she was no longer thrilled, but was ashamed and embarrassed that she had allowed herself to get pregnant a second time. She asked her husband if they might get an abortion and he refused. At that time, a woman needed her husband's signature in order to secure an abortion, and Felicia was left to bear a second child within fourteen months.

At this time, Felicia began to feel confused about her own identity as a woman and about some of the choices she had made. She had two babies; yet she still did not feel like a woman. Consequently, Felicia began searching for other ways besides motherhood to become a woman. She joined a campus group of the Black Panthers and asked these young people to tell her how she should be a black woman. Within a short time the men who led the group told Felicia that the "cause" needed lawyers, doctors, and scientists and that she should change her major from art to science. In robotlike fashion, Felicia complied with their orders. She had never evidenced any interest in science, but she was willing to do anything she needed to in order to win the approval of her black peers. Felicia majored in physics and despite the fact that she was attending to two children and a somewhat irresponsible husband, she managed to graduate from college Phi Beta Kappa. At age twenty-two, Felicia

looked to the outside world like a successful midlife woman. She was a college graduate, a wife, and the mother of two children. Yet on the inside she felt like the young woman that she in fact was. She wanted to be exploring, testing out possibilities, and dreaming, not juggling the responsibilities of midlife.

For another group of women, the entry into midlife is often very slow and delayed. Feminist Betty Friedan has identified a group of women who have moved slowly into the responsibilities of middle life.[31] Many of these women now feel concerned and worried that they have perhaps delayed this important transition too long. Because biological motherhood is limited by both age and physical resources, the delay into midlife activities may mean that certain options for actualizing midlife process are curtailed or even closed off.

To a large extent, the transition out of midlife development reflects the way in which a woman has participated in her own middle years. The story she has told herself about herself and about her life will determine the way in which she manages her transition out of midlife. Some women view their midlife activity as being composed of two parts: mothering and working.[32] For these women there is a transition within midlife itself. They begin midlife by actualizing their creativity as biological mothers. Often, in their early forties they make a switch, turning their creative energy toward other endeavors, thus providing a transition from one way of actualizing the themes of midlife toward another. These women are still engaged in being creative; the expression of their creativity has changed from children to career.

Throughout her midlife years, Hannah worked to combine the role of mother with the role of professional career woman. Initially she was a full-time mother to her children, then gradually she became both a mother and a worker, with mothering still clearly the first priority. In her late thirties, the balance shifted and Hannah became a woman who mothered within the home but who also had a career which allowed her to actualize her potential outside of the home. Eventually, with the departure of her children for college, the balance shifted once again and Hannah identified herself primarily as a career woman.

This final shift to being a career woman involved Hannah in a transition within midlife. Shortly after her fortieth birthday Hannah began to feel unsure about her plans for the first time in her life. Her uncertainty reached such proportions that she developed anxiety attacks and became somewhat phobic. At this time Hannah decided to enter psychotherapy and try to understand the origin of some of these unusual and unsettling feelings. As a result of her therapy, Hannah decided that she would need to find ways to be her mothering self other than just by raising her children. Her son and daughter were no longer small and no longer needed her constant attention and nurturance. Yet nurturing, caretaking, and tending to the needs of others were activities that were important for Hannah and had always been part of the way in which she defined herself. Hannah chose to go back to graduate school to pursue a career in nursing, a career that would allow her to be her mother self outside the home.

For another woman, Fran, the transition within midlife took the opposite direction. Until her early forties, Fran was a successful career military officer who enjoyed a great deal of responsibility and prestige. When she was presented with the option of early retirement she chose to leave the military and to have a child. Being a mother presented Fran with the chance to actualize her creative and nurturing self in a way very different from how she had expressed herself during the first half of midlife. During the birthing process Fran says: "I just felt like I was a woman doing the most important work in the world. Not work that anybody pays any attention to or you get a paycheck for, but it was the essence of life and only women can do it, and I felt so proud."

Popular psychology and social mythology often assume that the transition out of midlife will be experienced as an empty-nest syndrome, believing that as women move out of the time in their lives when mothering has been their primary concern, they will experience depression and disorientation. In fact, interviews with women who are exiting midlife seem to indicate that the empty nest is more of an imaginary construct than it is a real factor in how these women transition from one phase of

their lives to another.[33] Indeed, many women experience relief at leaving their other-directed mothering years behind them.

We can speculate for a moment on how it is that the "empty-nest phenomenon" has achieved such popular belief when it does not reflect the real experiences of many women. If we view the woman in her middle years as the idealized biological mother, totally defined by her nurturing, caretaking, selfless activities, we might well assume that when those activities cease she will be unable to define herself or to make the transition to another meaningful phase of her life. However, if women have other identifications and are not so connected to this idealized image of mothering, then we might begin to consider that the transition away from middle years and away from biological mothering might be seen as a challenge or an opportunity by some women rather than a cause for despair or distress.

The clearest examples of being stuck in midlife development come from the stories of women who have actualized their mid-life potential only as biological mothers. Many of these women find it difficult to fashion a new and equally valid and constructive identification after their mothering years cease. There are numerous examples of women who attempt to perpetuate or extend the mothering phase of their lives long beyond what is appropriate. Some women keep a child dependent solely for the purpose of continuing their role as mother. I have heard women say when told that their children will not need them one day: "Oh no, not my children, my children will always need me." While this somewhat defensive response can be seen as a woman's own difficulty in conceptualizing a time when her children will have a different relationship to her, such a statement also has a chilling impact because one can imagine that a woman might well keep her children, or one particular child, dependent in order to maintain her own identification with biological mother as the primary definition of her self.

A woman may subtly encourage her teenage daughter to have a child who will then be given over to the grandmother to raise. In this way, a woman can once again extend her identification with biological mother and also extend the amount of time that she remains in the midlife phase of development. Of

course, women can also increase their time as mother by having another biological child. There are numerous examples of women who have a menopausal baby, a baby that is born many years after their other children have long since ceased to be dependent. While some of these pregnancies are unplanned and accidental, one might wonder how many of them are designed to fill the woman's unconscious need to continue her identification with Mother, the only identification she has found to be comfortable and fulfilling.

For one woman, Jennifer, who is spending her middle years raising her four children, the temptation of having another baby is all too clear. When Jennifer anticipates what it will be like when her mothering years are over, she visualizes a blank screen. She knows that once she becomes a grandmother and is in her sixties and seventies, she will know how to live her life and that she will once again be comfortable, engaged in nurturing and mothering activities. It is the years between forty-five and sixty, however, that worry her, because she does not have a model for how she will take the themes of creativity and nurturance and move beyond the role of biological mother. It is interesting that Jennifer has considered having another baby. She knows how to be a mother and how to engage in the activities of adult womanhood when she is mothering a child. She is aware that if she were to have another baby at this point in her life she would bridge this fifteen-year span that currently worries her.

Jennifer's dilemma highlights the need for shifting from images to themes when we think about a woman's life. If Jennifer could see her middle years as a time of creating, nurturing, and juggling, her problem of how to "mother" once her children are grown might be solved. She could easily apply her skills to areas and endeavors outside her home. When she labels herself solely as "a mother" she limits her midlife options and makes her transition to older womanhood much more difficult.

It has been suggested that if a woman has a daughter to whom she can pass some of the tasks of midlife—nurturing, creating, and giving affection and care—her own transition from midlife to older life might be made easier.[34] In her mid-

dle years, a woman is at the height of her creative, energized power, and if she is able to pass not only the tasks, but her own sense of herself as a powerful person, to a daughter, it may be that she can ease her own transition to the next phase of development. In some sense, she leaves behind in the body of her creation some of the power and energy that she experienced herself. If we think more broadly of the connection between one generation of women to the next, we can see how even women who do not have biological daughters can take pleasure in passing their accumulated wisdom to the next generation of "daughters."

The way in which one exits this stage of life is strongly determined by the way in which one participated in the stage. The more limited one's options have been, the more difficult it may be to move on. The more broadly based has been the understanding of what it means to be a midlife woman, the easier it may be to transition into the last phase of life.

Chapter 9

Themes of Older Womanhood

Integration, meaning, perspective, and remembrance are the themes on which older women weave their unique stories.

Older women function as living ancestors who, like Spider Woman in Navajo mythology, serve as guides, both literal and spiritual.[1] An older woman is available to give advice, to issue warnings, to tell how to live. She has participated in life experience and from that participation comes wisdom and the privilege to speak her mind. As an ancestress, she initiates those who are beginning their lives in what it means to be a woman. Just as the young woman and the midlife woman have ways of being that characterize how they live in the world, so too does

the older woman have a characteristic way of being. Older women engage in *integrating* and *making sense* of the experiences of their lives; they *sort out* and evaluate relationships as well as things, *gaining a sense of perspective* as they go; they *remember* what has gone before. These core functions pertain regardless of the specific content that might define a woman's later life. Whether she is in a relationship or living alone, whether she is a grandmother or a woman without biological offspring, she will still experience the themes of older womanhood.

The primary theme of the last phase of a woman's life is integration, a bringing together of the various parts and aspects of one's life, connecting them and uniting them into a logically consistent whole. In the process of integration, one need not necessarily affirm the actions of one's life, but one must bring them together in a meaningful unity. In order to accomplish this task, a woman needs to be willing to look honestly at the events of her life. In her later years, the time for deception both of the self and of others has passed. The task of integration demands that one name and label events honestly. The time for distorting and artificially coloring particular events is over. In order to weave discrete events into the whole fabric of one's life, one must know of what material those events are made. One cannot, for example, come to terms with the abusiveness of an alcoholic husband if one continues to say, "He just liked to have fun when he got high, that's all." To do the work of integration, older women must be willing to call things by their rightful names.

For one woman, Rose, the process of introspection has been a painful one. At times she even envies people who continue to live their lives in "oblivious bliss," unaware of some of the mistakes they have made, not needing to resolve conflicts nor realign priorities. Rose has had to come to terms with certain aspects of her personality that are not especially flattering. She has had to see herself in an honest and clear light and to acknowledge that at times she has been insecure and has not done well by herself or by her family.

While she has regrets, Rose does not continue to feel bad about herself. She has come to accept who she is and this accep-

tance has resulted in her being more demanding of her friends and her relationships. She feels that if she has had to do the hard work of being honest with herself, then she is not interested in supporting others in their self-deception. Consequently, she insists that other people deal with her in an honest and forthright manner. She is aware that this resolve sometimes alienates people and that in recent years she has been accused of being tactless and somewhat abrupt.

One of the main tasks of integration is the assimilation of the shadow side of the self.[2] The shadow is that part of an individual that has been disowned, unlived, and often devalued, yet it is a partner in the total personality. One's self consists not only of one's public self, one's acceptable self, but also includes those aspects of the personality that have been denied and labeled as publicly unacceptable, only to flourish underground. Responses such as anger, assertiveness, and rebelliousness are often confined in the shadow of adult women. As a woman ages, she must take those shadow elements and integrate them into the totality of who she is.

One of the Greek goddesses who represented a woman in her older life was Hecate; her symbol was the key.[3] One of the tasks of the last stage of life is to unlock those doors that have been locked, to gain access to those parts of the personality that have been closed off and hidden. We need a metaphoric key to free parts of the personality that have been buried and forgotten.

As a part of the theme of integration, older women engage in the activity of finishing unfinished business. While this may involve making amends, repairing relationships that have been disrupted, and bringing tasks to completion, it may also mean a psychological putting to rest of certain issues that have been troublesome.[4] One brings open-ended situations to closure as part of the task of taking stock of one's life, and this allows one to assess what still needs to be done.

As one engages in the process of integration, one comes to experience a sense of what Erik Erikson has termed "personal integrity," that is, an acceptance of one's life course as meaningful.[5] In order to be meaningful, a life need not have altered the course of human history or come to the attention of public

notice or scrutiny. Rather, each individual can judge his or her own life to be meaningful by affirming and validating those experiences that have occurred and those choices that have been made.[6] A life holds together, has integrity, and possesses meaning, when there is internal coherence and meaningful relationships among events and choices. The alternative, when an individual is unable to achieve integrity or integration, is the experience of despair, a belief that one's life makes no sense.[7] Without integration one feels one has lived a series of random and fragmented events without a sense of individual control or any personal, cultural, or cosmic purpose.

For one woman, Helena, making sense of her life meant coming to terms with the enormous loss of her entire family during World War II. The recent death of her husband has served as a catalyst for Helena to think about her entire life, to make sense of the experiences that she has had, and to integrate the seminal event of her young adulthood, the Holocaust. She saw herself as someone who had endured tremendous hardship, yet who had survived through personal resourcefulness and luck. Helena now reminisces about her experiences and has written the story of her escape from Europe so others in future generations may learn of her struggles. She has sought out other Holocaust survivors and in sharing memories with them continues the process of coming to terms with her losses. Her efforts have given her perspective on her life; she understands what is important and what is not. Helena believes that there has been a purpose to her survival. Her successful mothering of her three children and her contributions to community, friends, and family have justified her existence; she feels affirmed in the life she has led. The loss of her husband served to spur the process of integration for Helena, allowing her to successfully make sense of her lifelong encounter with loss and survival.

In addition to integrating the events of her life, the older woman is engaged in putting things into perspective. The first place that perspective comes into play is in a woman's understanding of her own life. Older women have been called the "long-lasting ones," the women who have survived, who have made it past early and midlife into the last phase of their devel-

opment.[8] With this accomplishment comes an appreciation for one's place in the universe, an understanding of where and how one fits, of how truly important one's individual life is, and at the same time of how truly unimportant it is.

As a woman in her mid-seventies, Sylvia is actively engaged in making sense of her life and trying to put the events of her life into perspective. Perhaps more than anything else, she has come to appreciate the role that luck and circumstance play in the evolution of an individual life. While she is willing to take credit for her personal achievements and accomplishments— the raising of two healthy children, a fifty-year marriage that has endured with continuing love and communication between her and her husband, and a successful career both as an accountant and a community activist—she is also aware that unplanned and unfortunate circumstances can dramatically change the course of an individual life. One senses a certain spiritual resolve in Sylvia's attributions about luck and good fortune. She seems to have come to a realization that there are events over which individuals do have control and there are also events over which they have no power. Sylvia now believes that those fortuitous events have as much role in shaping our lives as the events over which we have more direct control. She has seen in the lives of several of her friends how one unfortunate accident can irrevocably change the course of an individual life. When Sylvia talks about her life, she now gives credit to good fortune, good luck, or what she calls in a more religious spirit, "God's blessing" on her life.

Feminist theologian Carol Christ has labeled the knowledge of one's place in the universe as the essential religious insight.[9] One knows that one is only a minute part of the never-ending cycle of life and death. This fundamental insight causes an individual both to rejoice and to weep, to stand in awe before the complex and infinite experience of life. As part of this perspective, one understands the proper place of particular events in one's life. Events, behaviors, and experiences that were unimportant recede into the background. With the perspective of old age to reevaluate the events of one's life, grievances that at one time seemed important recede as well.[10] Perspective involves knowing what is important and what is unimportant.

Older women often talk about the process of separating out the essential from the inessential, the wheat from the chaff. As an individual engages in this reevaluation, elevates the important events, and deemphasizes those that are unimportant, there may indeed be a chance to create a new story for one's self.[11]

For Nora, becoming an older woman has meant abandoning the stories of Selfless Mother and Adoring Wife. For many years, Nora played at being Super Mom to her children and Super Wife to her controlling husband. While it now seems rather silly to her, Nora confesses that the idealized images of Selfless Mother and Adoring Wife influenced the way she lived much of her middle years.

Because her husband worked out of town during most of their marriage, Nora felt responsible to her children to be both Mother and Father. Nora felt responsible to provide not only the emotional support that her children needed but also the practical support in the form of chauffeuring them to activities and sports events and helping them with homework and other school assignments. It now seems to her that she was effectively a single parent.

When her husband was home, Nora planned family outings to give the children a chance to relate to their father and to give them a sense of being part of a happy and connected family. To accomplish this, she would stifle her own needs and her own resentment at having been left alone to raise her children. She was concerned primarily that her family project the appearance of a happy unit; she was willing to give her own needs lower priority. Nora believed that if she were truly a good mother, then her children would be happy and carefree and would be able to spend joyful times with their usually absentee father.

As an older woman, Nora is writing a different story for herself. After a series of life-threatening illnesses, she has shifted her priorities. She now believes that her greatest responsibility is to herself and she must, after a life of pleasing others, look to how she can please herself. She volunteers at a local museum, takes art classes, and travels extensively.

A sense of perspective allows the older woman to view experiences at a distance. She is no longer engaged in the labor of

life as a birth-giver, an active worker, or a creator. Rather, she is an observer of labor, one who is able to watch with the "cold eye of the witch" and see what is important and what is unimportant.[12] This sense of perspective occasionally makes others feel uncomfortable. The older woman is more likely to "tell it as it is" because she is able *to see* it as it is.

With her own children now grown and out of the house, Margot feels that the time has come for her to focus on her own development, on her own self. With fewer demands from other people to balance, she has more time to devote to her own growth. Professionally, Margot has made a shift in her career over the last few years, away from providing direct service to patients and toward lecturing, consulting, and writing. She now sees herself as a mentor, somewhat of a guru who is "an expert in something." In her role as consultant, Margot enters a system, observes, provides expert advice, and then leaves. She is now in the role of older, Wise Woman, able to serve and comment on the process from a distance. "The mother is always in labor, always too close."[13] The grandmother, however, is able to operate from a position of distance, somewhat objective, somewhat dispassionate, yet expert in the process of laboring and able to comment on what is happening. Margot no longer needs to do the labor herself. She can instruct others and can provide expertise based on her own years as a mothering, midlife woman.

In the process of reevaluating the events in her own life, the older woman also removes what is unimportant and dispenses with those things that are no longer necessary. This scaling back may take the form of divesting one's self of certain possessions or of ending or deemphasizing particular relationships; it may also mean altering certain roles and responsibilities. Particular expectations that at one time had been important and had played a role in shaping the way in which one lived one's life may now be set aside. The process of letting go of that which has become unimportant has been called the "law of devolution."[14] Instead of the progressive increase in possessions, relationships, and responsibilities that occurs in midlife, there is a decrease in what one believes to be of value and a

passing on of those things that one no longer needs, wants, or affirms.

Not surprisingly, when some of the clutter of one's life has been removed, individuals often find themselves more focused on the center, on the core of their own being, sensing that which is essential not only to themselves, but to life and development in general.[15] Centering and focusing have historically been the province of the older woman. One of the Greek goddesses associated with the old woman was the goddess Hestia, who was considered to be the goddess of the center, the home, and the hearth.[16] Although she herself was unmarried and did not have a family, she was given a place of honor at the center of the home, the center of the city, and the center of the holy place at Delphi. It was Hestia's task to bring the soul home, creating a sense of inwardness and illuminating for the individual what was important and what was not important.[17] As an individual gains perspective and separates out those aspects of herself and of her life that seem trivial and expendable, that which remains is what is essential to her own being.

Another theme of older womanhood is remembrance. Part of the last stage of adult development is to remember what has gone before. In Norse mythology the name for a female sage was "Saga," which meant "speaking woman."[18] This name has come to mean a tale or a story. It was the task of the older woman, of the sage of the clan, to know, to keep, and to tell the stories of her personal life, her family, and her culture. In order to do this, a person must allow herself to remember and to recollect that which has gone before.

Within Jungian theory it has been suggested that our collective stories and folklore actually embody the archetype of the older woman.[19] It is as if stories and folktales represent older womanhood, and when we consult stories, myths, and rituals for knowledge and wisdom, we are in fact consulting the old woman who resides as a potential within all of us. Within Jewish culture, the stories that are passed on from one generation to another are called *bubbe meises*, which literally means "grandmothers' stories." These were the tales told by grandparents and elders, and passed from one generation to another. They

were associated with the older woman who was seen to be the keeper of the tales.

Sometimes remembrance takes the form of an active life review in which the individual both catalogs and chronicles the events of her life, going back over what has happened and putting it in some temporal and logical order.[20] Individuals do this both for themselves, because it aids in the process of integration, as well as for future generations. Older women within some families actually write down the story of their lives so that it will be available for their descendants.

In looking back over her life, Eleanor has begun to collect a scrapbook of important events. Because of some of the work that she has done in the community, she has been the subject of articles in the local newspaper and in her church gazette. She has a large collection of information and mementoes that chart her course across her life. She has decided to collect this memorabilia and leave it to her children. In this way, her personal reminiscing over the last several years will serve as a legacy for her children, allowing them to look back over her life and hopefully learn from some of her experiences.

In Hans Christian Andersen's story "Elder Tree Mother," a little boy conjures up a potent ancestral image while he is sick in bed, nursed by his mother and a neighbor man.[21] The image is of a large tree with an old woman seated among the branches. Under the tree are a man and woman reminiscing about their lives. As the young boy asks what relevance this story has for him, he is taken on a journey in which the events of his own life are foreshadowed. He sees that he will one day become the old man who sits under the tree and reminisces. He asks the old woman in the elder tree who facilitated his personal reverie what her name is, and she says to him, "My real name is Remembrance. I sit in the tree which grows and grows. I remember things and tell stories."[22] She is an embodiment of this aspect of the older woman whose task it is to remember and to repeat the stories that she has learned throughout her life.

The knowledge of the older woman is the knowledge that comes from a life lived. It is not the knowledge which an individual gains by formal education or by reading books. Rather,

it is the knowledge which each woman is able to discover if she looks at her own life and pays attention to its rhythms and its patterns.[23]

At the end of a woman's life, certain aspects of her being come full circle; the older woman resembles in some ways the younger woman more than she does the woman at midlife. The young woman is full with potential; however, her fullness is of unlived possibilities, everything for her being possible and anticipated because she has not yet begun to live the main story or action of her life. The older woman also experiences a sense of fullness, however, she is now full with actual and lived possibilities. She contains within herself all of those actualized possibilities that were at one time only potential. She has come to integrate and to bring together those actual experiences, placing them in an order and relationship to one another.

A Characteristic Older Woman

Ann's Story

Ann, a widow in her early sixties, is living her own life, perhaps for the first time. Throughout her marriage her own identity was obscured. She was defined almost exclusively by her role as wife and mother. Who she was in her own right was invisible not only to other people but also to her own self as well.

In retrospect, Ann remembers rarely having any goals that were well articulated. When she graduated from college, she passively followed what was the expected life script for women of her generation. She thought to herself: "I'll get married, I'll be a mother, and I'll have a happy family." Her own planning did not go beyond this traditional set of expectations. She just "went along," never thinking about how she wanted to live her life, accepting the roles of Wife and Mother as her personal definitions of self.

Ann married a very traditional man whose expectations of her were similar to the expectations she had of herself. She would fulfill a woman's role: cook, take care of the children,

take care of the home, and be the connection between the family unit and the larger community. She would be the parent who interacted with the schools, with the church, and with the neighbors.

She remembers early in her marriage feeling the need to escape from the confines of these defined roles. While she had two small children, she arranged nonetheless for a weekend getaway for herself. One of her sisters came and watched her children and Ann went off by herself for two days to try to find the woman that she was before she had poured herself into the molds of Wife and Mother. Her husband could not understand her need for escape. He reasoned that she should be pleased to be living the successful life that most women would have envied.

During most of her married and mothering years, Ann believes that her own wishes and needs came after she had fulfilled the needs and wishes of everyone else. Because of the way in which she spaced her children, Ann's mothering years extended from her early twenties into her mid-fifties. Consequently, she experienced herself as defined by these traditional roles and by typical midlife activities for almost thirty-five years.

In the last phase of her life, commencing with her widowhood, Ann has begun to define her own life in a more independent and personal way. Without really being aware, she began to prepare for this stage of her life several years before her husband died. When her two oldest children moved away from home, Ann began to feel her role as Mother beginning to crumble. She decided to seek employment and was delighted when an administrative position within her church came open. Ann attributes this movement to a combination of inner stirrings and good fortune. She is not sure what she would have done if this church position had not presented itself. Ann's new job outside of the home introduced her to a larger community of people and at the same time encouraged her to think of herself as someone other than a traditional wife or mother.

Ann feels that it is important that her new identity was forming prior to her husband's death. When she lost her husband, she lost the official designation as "Wife." She did not, like so

many women within her social circle, become a widow with a capital "W," allowing the status as Once-upon-a-time Wife to be as much of a social role as the status of Wife had been. For these women, the role of Wife is replaced by the role of Widow, and they continue to live as if their husbands were still alive, reminiscing, talking about their husbands, staying attached in imagination and fantasy to the role that occupied much of their adult lives.

Ann is both proud of and surprised by her own independence and assertiveness. Given the way she lived her midlife years, Ann would have assumed that she would have chosen a different kind of widowhood than the one she is experiencing. In her work outside of the home, Ann feels that she has learned new things about herself; she has been open to experiencing herself in different relationships and to seeing herself as a woman with different skills and talents than those she manifested as a mother.

Ann has discovered that she has a gift for communicating with people and for supervising and encouraging people in their own growth and development. When she was actively involved in raising her children, Ann felt that she had to occupy a position of authority. In retrospect, she believes she may have been rigid and dogmatic in her style of disciplining her children. Ann felt driven to socialize her children to become good adults. Because they would be a reflection of her, she needed to be careful and controlling in the way in which she raised them. Now, as a supervisor and guide to her employees, she is able to be more flexible, freer to take a step back and to allow people to grow and develop without tight controls and rules. She feels more available to hearing diverse opinions and has a flexibility and openness which she did not have as a midlife woman. She has more distance and does not feel nearly as dogmatic and in need of being in control as she did in midlife.

In commenting on her own change, Ann says, "I think of myself now as a person; I don't even think of myself as a woman in particular." It seems that as she has broken out of the restrictive categories of Wife and Mother, Ann has allowed herself to enter into a more expansive and unrestricted per-

sonhood. Ann says that for the first time in her life she has friends of all ages. She no longer believes that she can associate only with women who are Mothers or women who are her own age. She now learns from and spends time with both men and women who are young enough to be her children and others who are her own age or older. She says, "My world is wider now than it was when I was a mother and a homemaker."

Her changing role outside of her family has also had implications for the way in which she relates to her children. Ann now says that she engages her three children as a person, not as a Mother. This transition has been easiest with her youngest daughter, who experienced Ann in her role as a traditional mother for a much shorter time than did Ann's other children. For her two older children, who moved away from home when Ann was still identified as Wife and Mother, the transition from Mother to person has been somewhat slower in coming, yet she is committed with all of her children to breaking out of traditional and conventional roles and to being the woman that she is, a more full and well-rounded person.

When she was performing the tasks and duties of a mother, Ann feels that she was appreciated within her family and by her children for the things that she did. She now feels that she is appreciated for the person that she is, an important distinction. As she says: "No one needs me anymore. People love me, they enjoy being with me, but they don't need me in the same way that children need their mother."

Ann takes great joy in the fact that she is no longer responsible for anyone but herself. While she certainly fulfilled her responsibilities and obligations as a wife and mother without resentment or anger, it is a relief to her that those responsibilities are now behind her. When she plans her weekend or thinks about what to do during an evening or how to spend her vacation, she knows that she only has to be responsible to one person. This freedom allows her to attend to what it is *she* needs and what it is *she* wants. She does not have to subjugate her own desires to the desires of other people.

It is not surprising that Ann has decided that she will probably not remarry. When she looks back on her own marriage

she feels pleased and satisfied, yet she now concludes, "My need for love, support, and companionship are not such that I would sacrifice my independence." Being her own person after so many years of being defined by a role and by a set of obligations and expectations is very important to Ann, and she doubts that she could be in an intimate relationship without sacrificing some of her personhood. At this point in her life, Ann chooses to listen to her own voice rather than relinquish any of her autonomy in an intimate connection with another person.

Despite not wanting to be married again, Ann is very much a relational individual. She spends time with her daughters and also with friends from church and from her community. Other people are important to her, but what is most important is that she be able to relate to those other people as a whole and independent person. As she gets clearer about who she is and what her priorities are, Ann has found that she is letting go of certain things, both material possessions and certain attitudes and values. In so doing, she makes room for other parts of herself that have been ignored in the past. Ann refers to these years as a "time of scaling things down." She no longer has any desire to acquire material possessions. In fact, she says, "I don't want to get anything more. I would like to get rid of half of what I already have."

The accumulations of forty years feel somewhat burdensome to Ann, and while she would like to reduce some of the complexity of her life, stripping things down to what is essential and important, she does not want to take time away from her current development to clean up the basement of her house. She is clear that she wants to spend her time on activities that expand her knowledge and increase her perspective. She likes to travel, go to the theater, and attend concerts. She has come to realize that much of what seems important, much of what occupies us, especially in terms of the accumulation of possessions and wealth, is not what accounts for an individual's ultimate happiness.

In this last phase of her life, Ann has acquired a new appreciation for her mother. As Ann was growing up, she saw her

mother as a somewhat austere woman, aloof and independent but someone who provided the support and nurturance that her six children needed. Now that she looks back on her own life, Ann has come to appreciate many things about her mother who was a rather independent and avant-garde woman.

Prior to marrying, Ann's mother founded a business of her own and was quite financially successful. In fact, she did not marry until she was in her mid-thirties, at which point she brought to the marriage a dowry large enough to purchase a home and to set her husband up in business. She came to her marriage as more than an equal partner. Her marriage was unusually egalitarian and she and her husband divided chores between them. Ann remembers that her mother used to enjoy sleeping late in the morning, so it became her father's chore to get their six children dressed, fed, and ready for school. This did not seem unusual to Ann since it was the only reality she knew. As she came to have experience with other families, she saw how unusual it was for a woman to have as much independence within the home as her mother had. Within their community, Ann's mother frequently took unpopular political stands, advocating for human rights and thus setting herself apart from her rather conservative community. She was also involved in women's education and attended a women's support and discussion group that was a precursor to feminist consciousness-raising groups.

Only recently has Ann come to realize that her mother was an independent woman who was not limited by society's or familial expectations of how a woman should live her life. As she herself has broken out of certain traditional models and molds, Ann has come to identify with this more independent and self-focused mother. This personal portrait has been integrated into her own consciousness as she has moved into the last phase of her life. This linkage to her own mother is especially significant given that as an older woman one establishes links and connections not only with the next generation but with past generations as well. In a personal, psychological sense, Ann is more connected to her mother and to her mother's message now than she was in her middle years.

Relatedness in Older Women

Relatedness is an important part of an older woman's life. To be an ancestress implies that one has connections and relationships of both a personal and universal nature. However, relationships change for women in the latter part of their lives. Old relationships are often redefined or given new meaning. Some relationships that had been important cease to exist; people die or move away. Often connections to a more cosmic or universal community are forged as older women seek out Nature, God, or the society of other women.

As a woman enters the last stage of her adult development, she is most likely to alter those relationships which tend to deny or limit her own self-expression. Those relationships which demand that she conform to certain expectations, roles, and responsibilities often recede into the background. Women find themselves less willing to compromise who they are for the sole purpose of remaining in a relationship.

This change in a woman's posture toward her connections with others derives from several sources. First, some of the individuals who made excessive demands no longer exist; authoritarian fathers are dead and gone, and patriarchal husbands are often less powerful, more needy, and no longer in a position to make autocratic demands.[24] Also, as they get older, women report that they have less desire to please others, less desire to conform to external pressures and external standards.[25] Age brings with it certain privileges; having survived for so many years, a woman often feels freer to be herself.

An older woman has more belief in her own staying power and is confident that she can survive whatever life puts in her path.[26] Consequently, she needs to bend her will less to those who make demands upon her. An individual feels more secure that she can take risks, even lose relationships, in order to be true to herself, therefore some relationships change in importance as a woman gets older. One stays in connection, but one is no longer willing to put relationships above the actualization and the development of the self.

For many years Connie tolerated her husband's family de-

spite how frequently they snubbed her and made her feel un
wanted. Invitations to weddings, baptisms, and confirmations
would come addressed to her husband only, excluding Connie
in a careless and hurtful fashion. She often wondered if she was
being left out because her husband's family did not like her or
because they thought her so unimportant that it did not occur
to them to include her. Because of her desire to accommodate
her husband and to preserve the relationships that her chil-
dren had with their extended family, Connie endured these
repeated slights for years. However, as she entered the last
phase of her life, she felt clear that these insults were not some-
thing that she needed or wanted to endure.

Fifteen years ago, in her early sixties, Connie completely
broke off relations with her husband's family. Following their
failure to invite her to the baptism of a nephew, Connie de-
cided that she would no longer take part in any activities that
involved these people. It seemed to her that she did have a
choice as to how she would spend her time and that she valued
herself sufficiently such that she no longer needed to interact
with people who devalued and denigrated her. Her ability to
set limits with her husband's family came not only from an in-
creasing sense that she could control certain interactions, but
also from her decreasing concern about what other people
thought about her.

When she was younger, Connie was concerned with her
status in the community and about her relative position with
respect to friends and family members. She and her husband
are of modest means and she has often felt less good than other
people because of her financial status. As she got older, Connie
stopped judging herself and other people by these external
yardsticks. She came increasingly to feel that her value was set
not by how much she had but by the kind of person she was
and by the character of her interactions with others. She now
judges people on their personal merits and spends less time
than she once did looking past people to see if there is some-
one "better" with whom she could be talking. Her ability to
accept people for who they are has allowed her to accept her-
self for who she is and to stop valuing external status over and
above personal merit. The older woman can afford to be hon-

est in her relationships.[27] If a woman values herself and is clear about who she is, then she knows she has nothing to lose by being direct.

Another reason that relationships change as a woman gets older is that longevity brings with it genuine loss. Some of the people to whom one has been connected, people that one has loved and valued, die. An individual must mourn the loss of those who have been important, yet at the same time be willing to continue to engage others and to engage new life experiences in a positive and affirmative way. Loss does not mean the loss of one's own life experience or the loss of all relationships. It does mean the genuine loss of people who have been important. With the perspective of a life lived, a woman is able to mourn her losses, appreciating important people for who they were, without overvaluing or devaluing the losses that have occurred.

It is important that a woman face the loss of loved ones without bitterness.[28] Occasionally, a woman feels angry and betrayed by those who die before she does. She may use her bitterness as a reason for withdrawing from current relationships. By mourning fully, she will allow herself to value not only the loved one she has lost but also those relationships which she still has, and new relationships which lie ahead.

One must find a way to maintain one's psychological relationship to those who have died without living in the past or being unable to let go of memories that have been important. Continuing to value reminiscences and staying connected to lost relationships through one's imagination and one's internal world can be a valuable experience.[29] This continued connection allows one genuinely to move on rather than remain alive only in the past.

While it is important that women stay open to new relationships even in the last stage of their lives, these new relationships must be entered into with a sense of perspective. The individual needs to appreciate the relationship for what it is. Less pretense and less game playing often occur in relationships that are inaugurated in the last stage of one's life. The relationship is accepted "as is," whether it be for companionship, for a creative adventure, or for a chance to sit and talk

and reminisce. One's expectations are realistic and as a result, relationships that begin in the last stage of one's life have the possibility of being more genuine and more honest. These new relationships are entered into by people who are clearer about who they are, what they need, and what they want.

As an older woman, Connie feels that she has more power and autonomy to make choices about how she spends her time. In particular, she has become very selective about the friends that she has. Connie is a vivacious and gregarious woman and one senses that she could have all the social interaction and contact she would want. As we were talking and conducting the interview, her phone rang a number of times with people just calling to chat or to make plans for an eventual get-together. Connie feels, however, that she does not need to engage everyone who wants a piece of her time. She can make choices about how she spends her time and has no tolerance, as she says, for "complainers and idle chitchat." She is much more interested in spending her time with people who want to engage in meaningful emotional or intellectual dialogue. Significantly, Connie now feels that she has a right to assert her own preferences when it comes to relationships and that she does not have to accommodate everyone who wants to see her.

The latter stage of a woman's life also affords her the opportunity to forge relationships beyond the familial or the personal, to connect herself to the species, to the race, and to the planet in some meaningful way.[30] Older women are engaged in passing wisdom from one generation to the next. This wisdom may pass to one's personal family, but it may also be passed to the larger community of men and women. This information can be passed along in the form of stories, of personal genealogy, of accumulated life wisdom written down in poetry or prose, or in the form of a collection of recipes that get handed down through one's church or one's community. One shares what one has learned with the larger world and in that way builds a living connection to others beyond the self.

In the last phase of their lives, women may experience a connection or a relatedness to cultural images of more general or transpersonal feminine development. Older women have been called the ultimate authority on what it means to be a woman.[31]

They have experienced all of the stages of a woman's life and they contain within themselves the many and varied possibilities that a woman can actualize. In that sense, each older woman is a symbolic summation of feminine life experience, and in that way, she participates in a connection to feminine experience that extends back in time beyond her and forward in time long after she ceases to exist. This connection to what has been called the "mother line" is an important experience for women as they get older.[32] The older woman feels herself to be a part of a more transpersonal cycle of feminine development. Regardless of how one has chosen to live one's particular life, one belongs to the chain of feminine possibility. One does not have to bear children or have grandchildren in order to be part of the mother line that connects women of one generation to women of the next.

The dreams of older women often contain magical objects, rituals, and temples.[33] It is as if at an unconscious level women are aware of their connection to a transpersonal feminine presence, choosing in their dreaming life images that span the personal and connect them to others who have lived in a different time, but have had similar feminine experiences.

At the latter part of their lives, women also forge a stronger relationship to the self. Those individuals who have defined themselves in terms of their ability to relate to and care for others often come to see that caring for the self is also a kind of nurturing.[34] Women report that they give themselves permission to attend to their own wishes, desires, tastes, and inclinations.[35] Frequently, an interest that has been neglected because a woman has been focused on nurturing or creative activities during her midlife years becomes important in the last stage of her life. One of the reasons that college programs in lifelong learning attract so many older women may be that these women are coming into relation with parts of themselves that have been ignored or denied. They are now choosing, through educational programs, through travel, and through a variety of experiences, to nurture those parts of themselves that had been placed in abeyance.

When Rose, one of the women mentioned earlier, was a young woman, she had aspirations to be a writer, having re-

ceived encouragement for her creative writing throughout her high school career. Her parents offered her the opportunity to attend college, but she was eager to be out on her own and to begin earning money, and so she rejected her parents' offer. Her lack of a college education has been a source of great regret for Rose and has influenced her sense of self and her particular life experiences. Despite her accomplishments, when she compares herself to friends and even to her own children, she often feels inadequate because of her lack of formal education. Most significantly, Rose has had to accept responsibility for failing to pursue her education and the literary career to which she aspired. These paths were blocked, not by thoughtless parents or economic necessity, but by the impetuous judgment of her young-woman-self. With the cool vision of old age, a woman sees more clearly than with the more impulsive and rash perspective of young womanhood.[36]

In her late fifties, Rose decided to repair the deficit in her education by enrolling in a local college. For the next three years, she went to school as a matriculating student, taking courses for credits, sitting for exams, and writing term papers. She wanted to test herself and avoid the easier path of simply auditing courses or attending adult education programs. She felt that by opting as a young woman for the immediate financial gratification of a job with a steady paycheck, she had cheated herself of opportunities. Rose succeeded in her college career and takes pride in having gone back and in part repaired the mistake she had made earlier.

As they get older some women change their outward style, redecorating their homes and redecorating themselves.[37] While this change may mean the emergence of something new, it may also signify the appearance of a woman's *own* sense of style, a sense that has always been part of herself but that has been submerged or denied because she has been attending to the needs and expectations of others. Now that she can honor herself, aspects that others thought did not exist become expressed. Many women find themselves saying as they get older, "Now it's my turn, my turn to do what I want, to be who I want, to have the experiences that I want, without any limitations, without demands placed upon me." Coming from a

woman who has been selfless for so long, such a statement may seem like a selfish one. Instead, it is a statement that reflects a new relationship to the self, a new respect for and an honoring of an individual's core self, which may well have been in the background throughout her middle years.

Transitions in Older Womanhood

In part because the last stage of a woman's life has been so devalued and so denied, there is a dearth of rituals to mark a woman's passage from midlife to later life. While it has been suggested that there is an absence of ritual to mark movement over the course of a woman's life in general, the transition to later life is especially lacking in religious, social, or cultural rituals.[38]

Within some circles there is now an attempt to inaugurate a croning ceremony when a woman reaches age fifty-six, the age of the crone, marking in a joyous and noticeable way a woman's movement into this last part of her life.[39] However, so far such ceremonies have been limited to a very small group of women. There are many reasons for this absence of rituals to mark the transition into later life. The most obvious reason is that what has been termed "old age" is not a valued stage of life. No one wants to acknowledge that she has moved into this last, important part of her development. The denigration of this stage of life and the lack of ritual markers reflect our discomfort with some of the activities of the older woman, in particular reflection, introspection, and integration. As a culture we do not put high premium on inner work; it is easier for us to honor with ceremony or ritual a phase of life that is connected to a concrete product or outwardly directed task.

As a society, we attempt to deny the passage into older womanhood. It is assumed that women will want to lie about their age, as if acknowledging a certain age is to reveal a deficiency rather than to proclaim that one has arrived or that one is part of a respected community.[40] We are exhorted by the advertising media to look and feel young and are told that, in fact, "one is only as old as one feels." Forces all around us collude

and conspire to deny the transition into the last stage of one's life. If we believe that we can stay young forever, then we do not have to age beyond our middle years.

In ancient times, a woman's wrinkles were considered a sign of honor. Each wrinkle indicated increased wisdom, years well lived, and valuable experience and insight.[41] Consider how far this notion is from our current perception of wrinkle lines, that they are not wisdom lines but rather frown lines, signs of bitterness and frustration. The advertising industry and the media encourage women to hide, deny, and even surgically remove those lines that physically mark their years of experience and lived life.

Another reason that the transition into the last stage of one's life is difficult is because of the relative obscurity of old age itself. When we devalue old age, we keep it masked in the shadows, consequently, it is unclear to us just what the actions and the activities of the last stage of our life might be. The province of the older woman has been so poorly defined that women are reluctant to move from what they know and what they have successfully accomplished into something that is unknown and devalued. As a society we are often unclear, for example, as to how a woman might define her sexuality once she reaches a certain age. Many women feel as if they are no longer women when they are post-menopausal; it's as if they become what Simone de Beauvoir called a "third sex," a woman who is neither female nor male, but moves into some anonymous "other" category.[42] Similarly, younger women often approach older women as if they are anomalies, curious antiques who used to be real people but who no longer have a clear place within the society. Indeed, some feminists have criticized the women's movement as being a young and middle-aged woman's movement, admonishing all women to recognize the value and the role of older women. Women must not treat older women as the rest of society has done, as if they were nonentities, dinosaurs on their way to becoming extinct.[43]

Claire has no model for how to move out of the direct, creative, and educating role of her midlife career despite the fact that she is in her mid-sixties. Her own mother ended her life as a bitter and lonely woman; Claire's image of an older woman is

a woman who lives alone in a cave, receiving only occasional visitors from the outside. This isolation seems like death to Claire, and she worries that when she moves away from the more active, creative phase of her life she will be left only "to have lunch with the ladies" and to live her life alone.

At a personal level, many women experience difficulty in transitioning into older age because the identity that they have fashioned for themselves is so attached to the activities and the appearance of midlife. Many women have the experience of looking in the mirror and being unable to recognize the woman who looks back at them.[44] The internal image that they have of how they look and who they are does not include a woman whose hair is gray and whose face is wrinkled. Similarly, if a woman's identity is connected in an intimate way with certain activities, whether they be mothering, raising a family, or running a business, when and if those activities cease a woman may experience a profound rupture in her sense of who she is, making the movement to the next stage of her life feel jarring and abrupt.[45]

If women are to undertake the transition from midlife to later life, they must have some sense that they are moving to a phase of their lives that is both valued and valuable, a life phase that is more clearly articulated than it has been in the past. Some authors have suggested that we take the term "change of life" quite literally. "Change of life" has been the vernacular term for a menopausal woman and has referred to the biological changes that a woman undergoes at that time of her life. It has been suggested that women might take this "change of life" as an opportunity to make profound psychological and real changes in the lives that they lead.[46]

Some women report that they experience a new sense of freedom and a sense of relief when their adult children are finally established on their own.[47] If a woman has defined herself in terms of her nurturing responsibilities, the prospect of having those responsibilities over may, if she embraces the opportunity positively, be a chance for her to explore other parts of herself. During midlife, some women experience a shift from childrearing activities to creative and nurturing pursuits outside the home. The transition from midlife to older wom-

anhood requires deemphasizing nurturing activities altogether. One often hears women who no longer have to care for their families or who are widowed say, "I am so glad I don't have to cook for anyone anymore." While this statement may have many meanings and may reflect a woman's denial of her sense of loss and the change which she has experienced, the statement may also be symbolic of the woman's relief at not having to care for others, not having to give all of her life energy and her creative power to someone else.

This "change of life" may involve a change away from other-directedness toward a greater focus on the self and on its development. This can be a time when women try things they have never done before, moving out of the narrow orbit of their immediate families to become more independent, more self-focused, and more differentiated.[48] A woman who has been enmeshed or overly involved in her family, in the raising of her children, in the running of a business, or in the creating of an enterprise may feel freer and more her own person as she makes the transition to the last stage of her life. This separateness, rather than being felt as loneliness and isolation, may be a chance for autonomy and differentiation.

Writer Ursula LeGuin says that "one must birth one's third self into old age."[49] There are no midwives available to birth women into the last stage of their lives. The transition to the last stage of one's life may be the most difficult transition a woman makes. As a woman moves into her later years, she carries with her all the experiences of her past. She contains within herself the young woman that she once was, the woman whose nature was at one time free and untamed. She also contains within herself her midlife sensibilities, the woman who nurtured, preserved, and created things. These are no longer fantasies or imagined options, but rather real actions and real experiences that have been lived. All aspects of one's self must be integrated and brought forward into this next, new stage of life.

Furthermore, the way that the attitudes of the young woman and the actions of the middle life woman are brought forward must reflect the perspective and integration of the older woman. One can continue to anticipate certain activities, but

anticipation is not the center or focus of one's life. A woman who continues to wait for the man of her dreams or the adventure of her life when she is seventy years old is a woman who has not moved beyond the themes of the young woman.[50] The older woman must anticipate with perspective, knowing that there are adventures and opportunities ahead, but that these exist only within the context of an already lived life.

The woman in her later years brings forward her creative possibilities, but also in perspective, with knowledge that creations are often only temporary, that they are subject to the forces and rhythms of nature, and that one may create something beautiful and powerful but that creation is not all that there is to life. The creative self is only a part of who one is. The older woman is aware that there is a full circle to her life; a circle that contains both death and loss as well as birth and creation. This awareness does not decrease the joy that the older woman has in her experiences, rather it enriches those experiences because she now knows they contain ends as well as beginnings.

As women move into the last stage of their lives, it is important that they accept this stage as being part of the totality of female development. This last stage should be affirmed as being good and valuable in and of itself, although it should not be glorified. A tendency exists to want to repair the damage that has been done to the image of the older woman. Within some of the goddess literature, for example, there has been an attempt to glorify and resurrect the image of the old Wise Woman.

Old women have particular life themes; they have their particular value; they have their place in the overall life of a woman and the overall life of a culture. They have a place that is different from the younger woman and different from the midlife woman. It is not better; it is not worse. In order for us to achieve a balanced view of the movement of a woman's life, each stage of her life must be valued in and of itself; not idealized because it meets the needs of others nor denigrated because it is of no use to others. Each stage must stand on its own as important in the life of each individual woman and in the life of the feminine self.

Chapter 10

From Images
to Life Themes

Almost one hundred and fifty years ago, a courageous re-
former and suffragette declared, "Daring hands are raised to
sweep from its pedestal, and dash to fragments, this false image
of woman."[1] Some fifty years later another champion of
women's rights claimed victory: "Here she comes, running out
of prison and off the pedestal; chains off, crown off, halo off,
just a live woman."[2] Yet as we approach the twenty-first cen-
tury, women still find themselves sitting securely on the pedes-
tals of idealized images.

When we allow images to define us, we know how to behave.
We are spared the challenge, the responsibility, and the ambi-

guity that are part of creating our own life. We get to know how the story ends without ever having to read the book.

Carolyn Heilbrun has suggested that women wait for a sense of closure.[3] They wait for a monumental event to occur which will place them in a state of harmony in which their lives will become stable, settled, and no longer subject to the vagaries of chance and to the inevitable change that comes with passing time. A woman will tell herself, "If only I get married then everything will be okay." "If only I get this job then everything will be okay." "If only my children graduate from college then everything will be okay." This desire for closure is repeated like a mantra throughout a woman's life, so much so that it suggests a fear of the ongoing engagement of adult life. She longs to be frozen in time, to have events achieve a point of harmony and homeostasis and then to remain secure in that static and unchanging mode. By sitting on the pedestal, identified with an image, a woman attains an illusion of closure. Just follow the ideal script and everything will be fine.

The desire for closure suggests that many women may be fearful of actively engaging in the main body of their lives. If we are to lead lives which feel authentic, in which who we are is truly visible, we must change from being passive participants, forego our reliance on static images and roles, and instead focus on the life themes that connect the many actions of our experience. What we do and how we do it, not who we are, must become the text of our stories.

The confines of role and category can be so powerful that we may only understand certain life themes in the context of role. When we start to judge behavior by whether it is role-appropriate or inappropriate, we are saying that a social category is more valid than a woman's active experience. Ironically, the very same behaviors may be judged as appropriate if performed by one woman and inappropriate if performed by another. For example, if a woman desires to have a child, we applaud her decision when she is in a heterosexual marriage. If, on the other hand, a woman embraces the choice to be a mother and is in a lesbian relationship or is a single woman without a primary relationship to a man, we are more likely to judge her decision to mother negatively. The woman is labeled

as selfish, willful, and naïve. Living out the themes of creativity and nurturance is given less weight than the role status of the woman desiring to have a child.

Giving birth is often taken to be synonymous with feminine creativity, yet, giving birth is but one way to express the theme of creativity. One woman who was living happily in a committed lesbian relationship with no plans to get pregnant came to me with the following account:

"I know you'll think I'm absurd, but I feel like I am going to have a baby. Now at some other time in my life I might have taken this to mean that my biological clock may be ticking and I should rush out and get myself pregnant, but I don't want a child and this isn't about babies anyway—it's about creativity. Lately I have been feeling like painting a picture or writing a poem or composing a song. I haven't done anything yet, it's still just an urge, just energy."

She was referring to her experience of creative potential—theme without object. Her feelings presented themselves in the predominant metaphor, namely creativity as biological birthing. However, she was aware that for her the image was merely a metaphor. She had not yet found the medium for expressing the theme of creativity in her own life.

Women choose to live their lives in a variety of ways—having children, being without children, being in committed relationships, living alone, working outside the home, staying exclusively within the family environment. If a woman's story is thought of in terms of themes, not images, no woman need be excluded from feeling like a woman. When the focus is only on content and images, women who feel that their lives do not fit often feel forced to develop counternarratives, stories of their own that exist outside of the main stream[4] or to act as if existing stories *do* fit, establishing a split between their own needs and beliefs and their external presentation to the world.

By focusing on themes rather than images and prescribed scripts, a woman can feel satisfied with the life she lives even when certain options are closed to her. There are times when specific life circumstances prevent a woman from acting or living in a particular way that she desires. If she is fixed on a certain role as the only way in which she can live her life, then

these personal limitations will cause her to feel that she is unable to have a full life. If, on the other hand, the focus is on life themes which can be actualized in a variety of different ways, then a woman can live her life regardless of the limitations imposed upon her. For example, a woman who feels that the only way in which she can live her adult life is to be a biological mother may be devastated if she is unable to have a child. On the other hand, if she sees her midlife as revolving around the theme of creativity, then not being able to have a child would still be experienced as a loss but not as a total devastation of who she is. With one option closed off, she will find other ways to actualize her creative self.

Many women with whom I spoke mentioned their need to be true to themselves. They were aware of a small flickering flame of selfhood deep inside, a point of authenticity that was often suffocated by the need to conform to a prescribed role or an expected category. When women have the freedom to do and be who they are, they can honor their true self. The need to live someone else's life falls away and women feel they are living a life that is truly their own.

Examples Versus Images

Throughout this book, women's real stories have been used to illustrate both the powerful trap posed by idealized images and the potential freedom offered by understanding the life themes that structure our experience. These stories are examples of how women actually live their lives. Paula, Robin, and Ann—women whose stories I have selected to illustrate typical young, midlife, and older woman life themes—are ordinary women and their life experiences are presented in the hope of being useful to the rest of us.

An example is one woman's unique story. It tells of how she solved a problem, made a decision, or lived her life. It is not a tale of mythic proportions nor should it be. Part of its utility and value is that it is an everyday story.

Writer and suffragette Inez Haynes Irwin tells the story of one of her ancestors during the Revolutionary War.[5] When the

call to arms came, this woman's husband picked up his musket and ran off. Without missing a beat, the woman assumed her place behind the plough. The story does no more than tell the tale of the strong woman who does what she needs to do without asking any questions. It is certainly not a myth; it does not present us with an idealized image of female virtue or female possibility; it is just an example of how one woman dealt with a challenge that faced her. In order to be useful, our examples must remain anecdotal. When anecdote is the prelude to myth, it risks being reified, bringing with it all of the problems of images.

The distinction between examples and images is similar to the distinction between fictions and myths. Fictions are for finding things out, for making sense in the here and now, and as such, fictions are disposable. We use them for a time and then we can dispense with them.[6] Myths, on the other hand, are absolute, they are the agents of stability. A myth is, always has been, and always will be.

Literary critic Frank Kermode warns that we are always in danger of coming to live by that which was only intended to know by.[7] Our examples help us to know how other people have lived their lives. They are not prescriptions, nor are they intended to be such; we should avoid the temptation to make them into prescriptions. Examples are approachable stories because they are real stories, and that is part of what makes them valuable and useful. Rather than being heroic and beyond our reach, they present us with solutions fashioned by everyday women, solutions which are sometimes courageous, sometimes ambivalent, and sometimes misguided, but solutions which we can use nonetheless in helping to understand our own lives.

Carolyn Heilbrun understands well the need for women to use their lives as examples for one another when she says, "Women must share the stories of their lives and their hopes and their unacceptable fantasies."[8] By being examples for one another, women not only can reach out and connect to each other, they can also make the task of living easier for one another.

Artists and women who live outside of traditional categories

have always known that they must share the examples of their lives with one another if they are to survive in what often feels like an alien culture. One of the young women with whom I spoke who was a painter said, "I think that artists live on the edge, live on an imaginative edge, and I think they speak their own language." Knowing that the idealized images of the culture do not constitute a language that makes sense for them, many artists have looked to the lives of other artists for examples of how to live a creative and authentic life. This same woman told me: "If you are feeling like an outsider, and artists I think generally feel like outsiders, you go to the notebooks of other artists. There you might find ways to live." I was surprised by how many young women artists with whom I spoke were reading the journals of another artist at the time that they shared their stories with me. It seemed quite commonplace for these women to turn to other women's lives in order to find guidance as to how they might live their own lives.

In the course of doing interviews with a number of women, I had not a few who asked me about my own life. In particular, women who had chosen not to have children wanted to know how and why I had made that same choice. When one woman in particular saw that I felt comfortable and affirmed in my own decision, she got up from her chair and hugged me. She was struggling with her own decision about whether or not to have children, and she said to me: "It's so good to hear someone else talk about having made that same decision. It makes me feel less alone." This woman was not using me and my life as an idealized image of womanhood; rather, she was taking from my story an example of how she might solve a similar problem in her own life. Knowing that there were examples of women who had made similar decisions made her feel calmer and more assured as she went along the path of making her own decision.

Adrienne Rich, in arguing for a woman-centered university, has said that it is necessary for women students to have as models women of "maturer attainments who can provide intellectual guidance along with a concern for the wholeness of students."[9] Women mentors serve as living examples to young

female students, giving them examples of how a woman might live her life. When a woman learns from a man, she learns two things: she learns the content he has to teach and she also learns that men can be competent, skilled, and accomplished. When a woman learns from another woman she also learns the content of what that woman has to teach, but she sees in that other woman a living example, a model for how a woman might live her life. A few years ago, first lady Barbara Bush was asked to address the graduating class at Wellesley College. Her commencement address met with mixed reviews. There were some women in the audience who felt disappointed when Mrs. Bush failed to give them some examples of how they might live their lives into the twenty-first century. These women were not asking for idealized images—they already knew the traditional models that had been put forth by their culture—instead they were asking Mrs. Bush to be a living example, a role model who might serve as a guide for them living their own lives.

Women do not need images in order to build the stories of their lives. Images tell them how they must be. Examples give them guides for how they might be. However, when there is a dearth of examples, we rely on images to guide us in crafting our stories. When we come to rely too heavily on images, we run the risk of becoming what Gloria Steinem has labeled "the best female impersonators," women trying desperately to live up to idealized images of womanhood.

Themes Over Time

Because the three phases of a woman's life are ordered in time and follow a linear progression, we may ask ourselves, What is the precise relationship of one phase or stage to the next? Indeed, when we use the language of stages we are tempted to think in terms of a developmental ordering, assuming that one period of time is not only temporally connected to the next but is hierarchically connected as well. In such a schema, each successive stage is more advanced, more sophisticated, and more integrated than the one that precedes it.

When thinking about the different phases of a woman's life,

we risk a conceptual error by using this developmental metaphor. The themes and activities of midlife are not more sophisticated than the themes of the young woman, nor are they less coherent than the life themes of the older woman. They are just different, appropriate to a particular time in life, but not related to other themes in a developmental or hierarchical way. It makes more sense to employ a metaphor of the seasons of the year, which are also related to one another in time. Spring follows winter and precedes summer, yet one season is not better or more advanced than another. They are merely connected in time with one season flowing naturally into the next. What the themes and activities of one season do is foreshadow the themes of the next. Just as planting leads to the harvesting, anticipation and preparation beget creation. As with the seasons of the year, the seasons of a woman's life are ordered in an invariant sequence. One does not begin with reflection and end with exploration, rather the themes of the young woman come before the ways of being of the midlife woman which in turn precede the themes of the older woman.

It is important to offer a caveat at this point and to note that even though the general ordering of one phase to the next is consistent across women, there are still individual differences. Because of their personalities, their life experiences, the culture in which they live, and the vocations they enter, some women express particular themes at what may seem like phase-inappropriate times. For example, a woman who is a research scientist may well be involved in exploration for much of her life; however, one would assume that her exploration will blend with other themes when she is a midlife woman and still other ways of being when she is an older woman.

Women contain within themselves the potential to act on all life themes throughout their lives.[10] The young woman is capable of creation and reflection, the midlife woman can explore and reminisce, and the older woman can nurture and anticipate. But clearly certain themes are more ascendant at one time than another.

Perhaps more than anything else, however, an unanticipated traumatic event has the potential to disrupt the way a woman lives her life. Themes and actions appropriate one minute no

longer seem viable. A woman must struggle to make sense of tragedy and in so doing she makes use of whatever she can to help ease her pain. When events occur outside of anticipated order, they jar us and result in a personal trauma.[11] When a parent dies while a child is still young or a child dies before he or she has had a chance to grow, the individual experiences not only a personal loss but also a sense of being thrust out of time, as if the event defies the normal order.

It is not uncommon for individuals in such circumstances to say that they were not ready for the event that occurred. While it is certainly the case that in some sense we are never ready for the loss of important people, I think that when an individual says "I was not ready" that individual is referring to this violation of the usual and expected ordering of events. The event happens when one is not prepared, and one does not have the skills necessary to cope with the particular trauma. One young woman, for example, repeatedly felt as if she was not ready for the changes and transitions in her life. Her sense of being "not ready" referred primarily to the death of her father when she was only five years old. In fact, she was not ready to lose her father and as a result, she had a nagging sense of never being ready for the next step in her life.

I remember as a child making magical bargains with God about the death of my own parents. I would ask that they be allowed to live until I had reached a certain important milestone; just let them live until I get married, so that I would psychologically be ready for the trauma of their death. One has a sense that readiness speaks not only to psychological preparedness but to some temporal readiness as well; an event needs to occur somewhere in the correct place in our normal life sequence for us to be able to integrate and absorb it. When important events occur outside of expected sequence, the individual has the experience not only of loss, trauma, and disruption, but also the experience of being disordered in time. Individuals often say that life stopped at the time of the trauma; that when a parent died or when a sibling died, events became arrested in time.[12]

Virginia Woolf, who was thirteen when her mother died, re-

marks that she felt as if everything came to an end with her mother's death.[13] Often this sense of ending or death refers to a part of the self; it is as if a part of the individual's own development dies at the time when the trauma occurs. Another woman who lost her father when she was four felt as if she could not envision a future. It was as if time literally stopped for her when her father died and she was no longer able to see events or people as attached to some future reality. When she lost her father, the future was cut off.

For some women, the experience of a traumatic disruption occurring "out of time" catapults them ahead to the next stage or phase of their lives. A woman who experiences such a disruption when she is engaged in the exploring and expansive time of young womanhood may very well leap ahead into the stage of midlife and become a mother or a woman in the middle of her life rather than a young woman full of possibilities. Similarly, a woman who experiences a disruption in the middle of her life from the loss of a spouse or the loss of a child may abruptly move forward into old age. It is as if the trauma catapults the individual ahead in time into another phase of her life.

Some women actually struggle to go back to the time of their lives when the disruption occurred, and to resume development from that point forward.[14] It seems appropriate to take what was left unfinished, that which was frozen or perhaps put asleep by the trauma, and move that part of the self and that part of one's development forward in a healthy way. For other women, the possibility of returning to the woman who existed at the time the disruption happened is not a possibility. Too much real time has passed. For these women it becomes important to integrate aspects of the lost self into the woman that they have become.

Despite the activities in which they are engaged, women seem to know what they should be doing at different points in their lives. If they are anticipating well into the phase when they should be creating or transforming, they seem to have a sense of dis-ease, a feeling of being out of sync with the themes that are appropriate for that particular time in life. Such a

sense of being out of balance is reminiscent of the experiments that have been done with children in cafeterias. Left to their own devices over a period of time, children naturally select the foods they need in order to nourish themselves. In a similar way, women gravitate toward those themes that are right for them at particular times in their lives. It is only when trauma or disruption occurs that a woman is thrown out of sequence and unable to engage the life themes that seem right for her.

One way to understand the relationship among the different phases of a woman's life is to look at the way women of varying ages view the preceding or forthcoming stages. Even though it is often difficult for women to step outside the perspective of their particular time in life and view objectively the phase that has gone before or the phase that is yet to come, it seems natural for women to comment on where they have been and where they are going and to do so with the perspective of the stage in which they are living.

Younger women, when they imagine moving into midlife, fear being limited and depressed. Even though they may talk to midlife women who are active, vibrant, and creative, they cannot imagine a time when their own possibilities will be more limited, and equally important, they cannot imagine that they will come to embrace and appreciate that time of more focused energy and fewer options. Not surprisingly, when asked about their mothers who were midlife women, younger women tended to report that their mothers were depressed regardless of the mother's actual life circumstances. From within the visual field of young womanhood, they imagined that if they had to deal with the responsibilities, limitations, and demands of midlife, *they* would be depressed. Looking at the middle years from the perspective and with the eyes of a young woman, the midlife woman appears burdened. Because she is so removed from the older woman in both time and experience, the young woman often cannot even imagine what it might be like to be a woman of seventy or eighty years. In fact, grandmothers and great aunts seem more like mythological figures than like real women to their younger relations.

Regardless of how they were actually living their lives, young

women felt empowered by the possibilities that lay before them; and they brimmed with enthusiasm as they told their stories. Their voices were the most animated, their pace the most racy; they almost exploded out of the interview session, so enthused and full were they with the options that lay before them.

When they are in their middle years, women look forward and backward with different eyes. When they look at their daughters, they are often filled with worry and concern. The impetuousness and naïveté of the young woman seem as if they might lead her in dangerous directions. Women in their middle years worry that their daughters will be harmed or lost by the speed of their exploration. When they recall their own younger selves, they are often amazed at what they did; the rashness of some of their behavior seems dangerous and foolhardy to their middle-life eyes.

Mothers provide a much-needed anchor for their daughters, a point of stable reference, during the time of free and untamed exploration. The mother encourages her daughter's exploration but does so with the vision of a midlife woman. She is able to see some of the risks and is aware of the limitations. Consequently, she is able to guide her daughter through this time of exploration. While daughters need the safety and security their mothers provide, this protective midlife function may well be one of the causes of the fighting and disagreement that occur between mother and daughter during this time. Despite their struggle with their mothers, even to the point of rebellion, daughters are aware that their mothers exist as an outer limit, a boundary containing their behavior. The mother serves to control and bound the daughter's exploration into the world. Paradoxically, this safety net actually allows the daughter to explore more freely than she might without her mother's structuring support.

At times, midlife women experience a sense of envy both toward younger women and toward their own younger selves. Women look back and recall the freedom and expansiveness of their early development and they sometimes look longingly on the time when they were not burdened by so many responsibil-

ities to juggle and balance. To a mother, her daughter may seem to be a younger version of herself and the mother may want to correct certain mistakes that she herself made as a younger woman, almost as if her daughter's life gives her the opportunity to repair errors that occurred. The constant plea of the middle generation is "Don't make my mistakes, learn from what I did." Yet when the midlife woman says these things she is looking with the eyes of a midlife woman. She has forgotten at that moment what it feels like to be a young and free woman, unbridled by responsibilities.

I recently heard a story of a woman who was quite concerned by her adolescent daughter's decision to postpone college and to travel around the world with a group of other young women. The woman was concerned that her daughter was making a terrible mistake and perhaps putting herself in danger by undertaking such an adventure. As she expressed her concerns, she temporarily forgot that when she herself was a young woman she had spent a year living with a church group in Africa and traveling without an agenda. Although she did not regret her own time of exploration and in fact valued it highly, it seemed so far removed from her current responsibilities that she could not imagine what it felt like to make that kind of decision. As her daughter planned to make a similar decision, the mother felt frightened by her daughter's impetuousness.

Anne Sexton in a letter to her daughter Joy, who was eighteen years old at the time, summarizes many of the responses that the midlife woman has toward the expansiveness and impulsivity of the younger woman:

> I'm afraid those feelings go with you no matter what your environment or what cage you look upon at the moment, you do need certain limits, rules, despite the fact that you are 18 and in many, many ways a grown woman and want to burst forth upon the world and be free, free as if you were flying your own airplane or skiing the perfect mountain or galloping on the most beautiful autumn day on the most beautiful horse, I do know how you want

to be free and can only say like an old philosopher and sufferer that I am, that freedom, that freedom comes from within and with it comes many responsibilities and restrictions that you must set for yourself."[15]

Sexton is able to appreciate her daughter's desire to run with the wind, yet she now sees that desire through the eyes of a midlife woman who knows only too well what restrictions and responsibilities come with a woman's middle years.

When she looks forward to the time in her life when she will be an older woman, a midlife woman often feels concerned that increased years will bring limitations far greater than those she already knows. She worries that she will lose her health, that she will lose her role in life, and that she will lose her important relationships. Her husband will die; her children will move away. The time of old age appears to contain limits, losses, and restrictions. When I shared with women in the middle years the stories of older women, telling midlife women that older women did not feel constrained or limited, midlife women seemed relieved, almost as if a scout to the future was telling them that what lay ahead did not look so bleak.

Ironically, when older women look at the lives of midlife women and reminisce about their own middle years, they are often relieved to be free of midlife burdens. The time of older womanhood brings with it a freedom from responsibilities, a chance to focus on one's own development, and a freedom from social constraints and expectations far greater than a woman has ever known. Older women may long for the health or vitality of their younger years, but they do not long for its responsibilities and restrictions. They are pleased to be done with the years of nurturing and mothering. Interestingly, older women often feel an affinity for the openness of the young and as yet untamed woman. The young woman who has yet to explore her possibilities is full in a way similar to the fullness felt by the older woman who has lived her possibilities. Both the young and the old woman now have an opportunity to develop their own interests; they are free of certain binding restrictions and responsibilities; both are experiencing changing relation-

ships within their primary family units, rendering them freer to be themselves than they will be or were in the middle years.[16] While younger women do not see this connection with their grandmothers, older women are very aware of the special bond they share with the generation two levels away.

In telling their stories, older women, more than any other group with whom I spoke, wondered if their stories were worth telling. They had a sense, even if they had lived full and satisfying lives, that their one individual life did not amount to a very significant story. It is certainly possible that this perspective reflected a feeling that any woman's life was not very important, a feeling learned in past generations where indeed the life and accomplishments of a woman counted for very little. However, it is possible that some of the feeling of insignificance expressed by older women came from the very nature of being an ancestress. Even when their lives had been fulfilling and personally meaningful, they realized that they had led just one life and that as such they had a limited significance for the world at large.

Regardless of the stage in which they themselves were living, all women hoped that life for women in subsequent generations would be better than it had been for them. It was not surprising to hear such a wish for the future from older women, who had lived through decades of greater restrictions on women's activities. It was somewhat more surprising to see such wishes in the stories of midlife women, who were often able to enjoy the advantages of career and family, advantages that had been denied to their mothers. What was most surprising, however, was to hear this wish in the stories of young women, women who had really not yet lived the full body of their lives. They too felt the restrictions of traditional expectations and roles and hoped that their as yet unborn daughters would grow up in a world in which women were freer to actualize their possibilities in a wider variety of ways.

Without specific images of content, we are limited only by our imaginations in the creation of ourselves. We are not confined by externally imposed ideas of how we should live or what it

means to be a woman. It is only our own inclination which limits the way we live our lives. The call for new stories must really be a call for a new emphasis, a new way to tell stories.

Just as Penelope, the Faithful Wife of Homer's Odysseus, undid her weaving every night to preserve her honor, we must deconstruct the images that consign us to a life on the pedestal. Hidden in the ritualized prescriptions of many idealized images are life themes worthy of being preserved. The Eternal Girl anticipates and receives new information, the Selfless Mother nurtures, and the Wise Woman integrates and makes sense of things. In rejecting particular images, women may be tempted to abandon the themes associated with those images. A woman, alienated from the *image* of Mother, may forego nurturing or the creative process as well—in this sense she metaphorically and literally throws the baby out with the bath water.

Most of us are so busy with the everyday activities of our lives that rarely do we have time to stand back, think about how we are living, and become aware of the themes that give coherence to our stories. Usually we pay those themes no mind; most of the time we are not even conscious of them. Yet themes of living are always present as the underlying structure of any life. They help us to make sense of our lives and to guide us toward meaningful activity. If we become aware of the themes which connect our experiences, we enrich our lives and increase our ability to make authentic and creative life choices.

NOTES

Preface

1. Sam Keen, *Fire in the Belly.*
2. Simone de Beauvoir, *The Second Sex.*
3. Rachel Siegel, "Love and Work After Sixty," in Evelyn Rosenthal (ed.), *Woman, Aging, and Ageism,* pp. 69–80.
4. Mary Belenky et al., *Women's Ways of Knowing.*
5. Emily Hancock, *The Girl Within.*
6. Polly Young-Eisendrath, "Rethinking Feminism, the Animus, the Feminine," in Connie Zweig (ed.), *To Be a Woman,* pp. 158–72.

Chapter 1

1. Karen Payne (ed.), *Between Ourselves*, p. 4.
2. Nancy Cott, *The Grounding of Modern Feminism*, p. 37.
3. Sam Keen, *Fire in the Belly*, p. 13.
4. *Ibid.*, p. 13.
5. *Ibid.*
6. Elemire Zolla, "Archetypes."
7. Marina Warner, *Monuments and Maidens*.
8. Zolla, "Archetypes."
9. *Ibid.*
10. Mirra Bank, *Anonymous Was a Woman*, p. 50.
11. George Kelly, *A Theory of Personality*.
12. *Ibid.*
13. Laurel Ulrich, *Good Wives*.
14. *Ibid.*
15. Keen, *Fire in the Belly*, p. 12.
16. Nor Hall, *The Moon and the Virgin*.
17. Nancy Friday, *My Mother/Myself*.
18. Julie and Dorothy Firman, *Daughters and Mothers*.
19. Judith Arcana, "Our Mothers' Daughters," in Payne, *Between Ourselves*, p. 215.
20. Sheila Moon, *Dreams of a Woman*.
21. Charlene Baldridge, in Karen Payne (ed.), *Between Ourselves*, p. 40.
22. Jean Baker Miller, *Toward a New Psychology of Women*.
23. Carol Gilligan, *In a Different Voice*.
24. Carol Gilligan, Janie Victoria Ward, and Jill McLean Taylor (eds.), *Mapping the Moral Domain*.
25. Sara Ruddick, *Maternal Thinking*.
26. Barbara Welter, "The Cult of True Womanhood, 1820–1860."
27. Barbara Ehrenreich and Deirdre English, *For Her Own Good*, p. 65.
28. Carroll Smith-Rosenberg, *Disorderly Conduct*.
29. Sara Evans, *Born for Liberty*.
30. *Ibid.*
31. Andrea Dworkin, *Right Wing Women*.
32. Andrea Dworkin, *Woman Hating*.
33. Sarah Stevenson, *Physiology of Woman*, p. 68.
34. Dworkin, *Woman Hating*.
35. *Ibid.*

36. *Ibid.*
37. Ethel Johnston Phelps, *The Maid of the North.*
38. *Ibid.*
39. *Ibid.*

Chapter 2

1. Anna Wilson Scharf, *Women's Reality.*
2. Ramona Mercer et al., *Transitions in a Woman's Life.*
3. Simone de Beauvoir, *The Second Sex.*
4. Esther Harding, *The Way of All Women,* p. 251.
5. Joan Hertzberg, "Feminist Psychotherapy and Diversity: Treatment Considerations from a Self Psychology Perspective."
6. Betty Friedan, *The Feminine Mystique.*
7. Adrienne Rich, "Anne Sexton," in *On Lies, Secrets, and Silence,* pp. 121–24.
8. Kathryn Rabuzzi, *Motherself.*
9. Jean Baker Miller, "Women and Power."
10. Sara Evans, *Born for Liberty.*
11. Nancy Cott, *The Grounding of Modern Feminism.*
12. *Ibid.*
13. Rabuzzi, *Motherself.*

Chapter 3

1. Ann Ulanov and Barry Ulanov, *The Witch and the Clown.*
2. Susan Brownmiller, *Femininity.*
3. Esther Harding, *The Way of All Women.*
4. Adrienne Rich, "Vesuvius at Home," in *On Lies, Secrets, and Silence,* pp. 154–84.
5. Madonna Kolbenschlag, *Kiss Sleeping Beauty Goodbye.*
6. Marcia Lieberman, " 'Some Day My Prince Will Come,' " in Jack Zipes (ed.), *Don't Bet on the Prince,* pp. 185–200.
7. James Hillman, *Anima.*
8. Carl G. Jung, "The Psychology of the Child Archetype," in *Essays on a Science of Mythology,* pp. 70–98.
9. Andrea Dworkin, *Woman Hating.*
10. Henrik Ibsen, *A Doll's House.*
11. Ann Dally, *Inventing Motherhood.*
12. Kathryn Rabuzzi, *Motherself.*

13. Marianna Mayer, *Beauty and the Beast.*
14. Miriam Johnson, *Strong Mothers, Weak Wives.*
15. Martha Banta, *Imaging American Women.*
16. E. V. Rieu (trans.), *The Odyssey of Homer.*
17. Catherine Keller, *From a Broken Web.*
18. Marla Powers, *Oglala Women.*
19. Barbara Walker, *Women's Encyclopedia of Myths and Secrets.*
20. *Ibid.*
21. Dworkin, *Woman Hating,* p. 57.

Chapter 4

1. Madonna Kolbenschlag, *Kiss Sleeping Beauty Goodbye.*
2. Elizabeth Schussler-Fionenza, "In Search of Women's Heritage," in Judith Plaskow and Carol Christ (eds.), *Weaving the Visions,* pp. 29–38.
3. Esther Harding, *The Way of All Women.*
4. Erich Neumann, *The Great Mother.*
5. *Ibid.*
6. Emily Hancock, *The Girl Within.*
7. Ann Dally, *Inventing Motherhood.*
8. Barbara Walker, *The Skeptical Feminist.*
9. Marina Warner, *Alone of All Her Sex.*
10. *Ibid.*
11. Neumann, *The Great Mother.*
12. Carol Pearson and Catherine Pope, *The Female Hero in American and British Literature.*
13. Miriam Johnson, *Strong Mothers, Weak Wives.*
14. *Ibid.*
15. Jean Shinoda Bolen, *The Goddesses in Every Woman.*
16. *Ibid.*
17. Sara Ruddick, *Maternal Thinking,* p. 99.
18. Chung Mi Kim, in Karen Payne (ed.), *Between Ourselves,* p. 357.
19. Payne, *Between Ourselves.*
20. Dally, *Inventing Motherhood.*
21. Maxim Newmark, *Dictionary of Foreign Words and Phrases.*
22. Barbara Welter, "The Cult of True Womanhood, 1820–1860."
23. Faye Crosby, *Juggling.*
24. Ethel Person, "Working Mothers: Impact on the Self, the

Couple and the Children," in Toni Bernay and Dorothy Cantor (eds.), *Psychology of Today's Woman,* pp. 121–38.

25. *Ibid.*
26. *Ibid.*
27. C. Mackenzie Brown, "Kali, the Mad Mother," in Carl Olson (ed.), *The Book of the Goddess,* pp. 110–23.
28. Erich Neumann, *Amor and Psyche.*
29. Alexander Afanasiev, "Baba Yaga," in *The Magic Ring,* pp. 36–39.
30. *Ibid.*
31. Neumann, *The Great Mother.*
32. "Hansel and Gretel," *Complete Grimm's Fairytales,* pp. 86–93.
33. Susan Faludi, *Backlash.*
34. *Ibid.*
35. Kathi Maio, *Feminist in the Dark.*
36. Faludi, *Backlash.*
37. Dana Jack and Rand Jack, "Women Lawyers: Archetypes and Alternatives," in Carol Gilligan, Janie Victoria Ward, and Jill McLean Taylor, *Mapping the Moral Domain,* pp. 263–88.

Chapter 5

1. Meridel Le Seuer, "Remarks from 1983 Poetry Reading," in Jo Alexander et al. (eds.), *Women and Aging,* pp. 9–19.
2. Patricia Garfield, *Woman's Bodies, Woman's Dreams.*
3. Jane Yolen, *Favorite Tales from Around the World.*
4. Sarah Pomeroy, *Goddesses, Whores, Wives and Slaves.*
5. Barbara Walker, *The Crone.*
6. *Ibid.*
7. *Ibid.*
8. Ann Ulanov and Barry Ulanov, *The Witch and the Clown.*
9. Carol Karlsen, *The Devil in the Shape of a Woman.*
10. Walker, *The Crone.*
11. *Ibid.*
12. Shevy Healey, "Growing to Be an Old Woman: Aging and Ageism," in Alexander, *Women and Aging,* pp. 58–62.
13. Jean Swallow, "Both Feet in Life: Interviews with Barbara MacDonald and Cynthia Rich," in *Ibid.,* pp. 193–203.
14. Ulanov and Ulanov, *The Witch and the Clown.*
15. Rosemary Minnard, *Womenfolk and Fairytales.*

16. Andrea Dworkin, *Woman Hating.*
17. Walker, *The Crone.*
18. Maxine Harris, *Sisters of the Shadow.*
19. Karlsen, *The Devil in the Shape of a Woman.*
20. Ann Mankowitz, *Change of Life.*
21. Charlene Spretnak, *Lost Goddesses of Ancient Greece.*
22. Karlsen, *The Devil in the Shape of a Woman.*
23. Ulanov and Ulanov, *The Witch and the Clown.*
24. E. Sue Blume, *Secret Survivors.*
25. Diane Russell, *The Secret Trauma.*
26. Judith Herman, *Trauma and Recovery.*
27. Robin Lakoff, *Language and a Woman's Place.*
28. Max Scheler, *Ressentiment.*
29. Marcia Lieberman, " 'Some Day My Prince Will Come' " in Jack Zipes, *Don't Bet on the Prince,* pp. 185–200.
30. Scheler, *Ressentiment.*
31. Ann Ulanov and Barry Ulanov, *Cinderella and Her Sisters.*
32. Karlsen, *The Devil in the Shape of a Woman.*
33. Walker, *The Crone.*
34. Garfield, *Woman's Bodies.*
35. Walker, *The Crone.*
36. Barbara Walker, *Women's Encyclopedia of Myths and Secrets.*
37. Marla Powers, *Oglala Women.*
38. *Ibid.*
39. Marjorie Agosin, "Mirror of Strength: Portrait of Two Chilean Arpilleristas," in Alexander, *Women and Aging,* pp. 188–92.
40. Karla Halloway and Stephanie Demetrakopoulos, "Remembering Our Foremothers," in Marilyn Bell (ed.), *Women As Elders,* pp. 13–34.
41. Sheila Moon, *Changing Woman and Her Sisters.*

Chapter 6

1. Esther Harding, *The Way of All Women.*
2. John Dunne, *Time and Myth.*
3. Monica Sjoo and Barbara Mor, *The Great Cosmic Mother.*
4. Jeremy Campbell, *Winston Churchill's Afternoon Nap.*
5. Susan Hardy Aiken, "Writing (in) Exile: Isak Dinesen and the Poetics of Displacement," in Mary Lynn Broe and Angela Ingram (eds.), *Women's Writing in Exile,* pp. 113–32.

6. Erich Neumann, *Amor and Psyche*.
7. Sara Ruddick, *Maternal Thinking*.

Chapter 7

1. Marion Woodman, *The Pregnant Virgin*.
2. Marina Warner, *Joan of Arc*.
3. Esther Harding, *Woman's Mysteries*.
4. *Ibid*.
5. *Ibid*.
6. Warner, *Joan of Arc*.
7. Ruth Ellen Josselson, *Finding Herself*.
8. Carol Gilligan, Annie Rogers, and Lyn Mikel Brown, "Epilogue," in Carol Gilligan, Nona Lyons, and Trudy Hanmer, (eds.), *Making Connections*, pp. 314–34.
9. Marija Gimbutas, *The Goddesses and Gods of Old Europe*.
10. *Ibid*.
11. Emily Hancock, *The Girl Within*.
12. *Ibid*.
13. Karl Kerenyi, *Athene*.
14. Woodman, *The Pregnant Virgin*.
15. Kerenyi, *Athene*.
16. Hancock, *The Girl Within*.
17. Carol Gilligan, *In a Different Voice*.
18. Charlene Spretnak, *The Lost Goddesses of Ancient Greece*.
19. Ramona Mercer et al., *Transitions in a Woman's Life*.

Chapter 8

1. Catherine Keller, *From a Broken Web*.
2. Barbara Walker, *The Crone*.
3. Karen Payne (ed.), *Between Ourselves*, p. 114.
4. Riane Eisler, *The Chalice and the Blade*.
5. Paula Gunn Allen, "Grandmother of the Sun," in Judith Plaskow and Carol Christ (eds.), *Weaving the Visions*, pp. 22–28.
6. *Ibid*.
7. Barbara Walker, *Women's Encyclopedia of Myths and Secrets*.
8. Sara Ruddick, "Maternal Thinking," in Joyce Treblicot (ed.), *Mothering*, pp. 213–30.

9. Faye Ginsberg, "Dissonance and Harmony," in Personal Narratives Group, *Interpreting Women's Lives,* pp. 59–84.
10. Naomi Goldenberg, *Changing of the Gods.*
11. Barbara Walker, *The Skeptical Feminist.*
12. Ruddick, "Maternal Thinking."
13. Ginsberg, "Dissonance and Harmony."
14. Mary Catherine Bateson, *Composing a Life.*
15. Nor Hall, *The Moon and the Virgin.*
16. Walker, *Women's Encyclopedia of Myths and Secrets.*
17. Rosemary Minnard, *Womenfolk and Fairy Tales.*
18. Payne, *Between Ourselves,* p. 199.
19. Erich Neumann, *Amor and Psyche.*
20. Adrienne Rich, *Of Woman Born.*
21. Kathryn Rabuzzi, *Motherself.*
22. Rich, *Of Woman Born.*
23. Martha Gimenez, "Feminism, Pro-natalism and Motherhood," in Treblicot, *Mothering,* pp. 287–314.
24. Patricia Conway and Deborah Valentine, "Reproductive Losses and Grieving," in Deborah Valentine (ed.), *Infertility and Adoptions,* pp. 43–64.
25. Naomi Pfeffer and Anne Wollett, *The Experience of Infertility.*
26. Dina Afek, "Sarah and the Women's Movement: The Experience of Infertility," in Jane Knowles and Ellen Cole (eds.), *Woman Defined Motherhood,* pp. 95–204.
27. Emily Hancock, *The Girl Within.*
28. Ramona Mercer et al., *Transitions in a Woman's Life.*
29. Bateson, *Composing a Life.*
30. Carol Gilligan, "Adolescent Development Reconsidered," in Carol Gilligan, Janie Victoria Ward, and Jill McLean Taylor (eds.), *Mapping the Moral Domain,* pp. i–xxxix.
31. Betty Friedan, *Second Stage.*
32. Mercer, *Transitions in a Woman's Life.*
33. *Ibid.*
34. Judith L. Herman and Helen B. Lewis, "Anger in the Mother-Daughter Relationship," in Toni Bernay and Dorothy Cantor (eds.), *The Psychology of Today's Woman,* pp. 139–66.

Chapter 9

1. Sheila Moon, *Changing Woman and Her Sisters.*
2. Christine Downing, *Journey Through Menopause.*

3. *Ibid.*
4. Shevy Healey, "Growing to Be an Old Woman: Aging and Ageism," in Jo Alexander et al. (eds.), *Women and Aging*, pp. 58–62.
5. Erik Erikson, *Identity and the Life Cycle.*
6. Ramona Mercer et al., *Transitions in a Woman's Life.*
7. Erikson, *Identity and the Life Cycle.*
8. Downing, *Journey Through Menopause.*
9. Carol Christ, "Rethinking Theology and Nature," in Judith Plaskow and Carol Christ (eds.), *Weaving the Visions,* pp. 314–25.
10. Healey, "Growing to Be an Old Woman."
11. Carolyn Heilbrun, *Writing a Woman's Life.*
12. Naomi Lowinsky, "Mother of Mothers: The Power of the Grandmother in the Female Psyche," in Connie Zweig (ed.), *To Be a Woman.* pp. 86–97.
13. *Ibid.*
14. Esther Harding, *The Way of All Women.*
15. Margaret Randall, "From the Journals," in Jo Alexander et al. (eds.), *Women and Aging,* pp. 127–29.
16. Barbara Kirksey, "Hestia: A Background of Psychological Focusing," in James Hillman (ed.), *Facing the Gods.*
17. *Ibid.*
18. Barbara Walker, *Women's Encyclopedia of Myths and Secrets.*
19. Hans Deickmann, *Twice Told Tales.*
20. Patricia Garfield, *Woman's Bodies, Woman's Dreams.*
21. Hans Christian Andersen, *Fairy Tales.*
22. *Ibid.*
23. Penelope Shuttle and Peter Redgrove, *Wise Wound.*
24. Judith L. Herman and Helen B. Lewis, "Anger in the Mother-Daughter Relationship," in Toni Bernay and Dorothy Cantor (eds.), *The Psychology of Today's Woman,* pp. 139–66.
25. Jean Swallow, "Both Feet in Life: Interviews with Barbara MacDonald and Cynthia Rich," in Alexander, *Women and Aging,* pp. 193–203.
26. *Ibid.*
27. Marion Woodman, "Conscious Femininity," in Zweig, *To Be a Woman,* pp. 98–110.
28. Garfield, *Woman's Bodies, Woman's Dreams.*
29. *Ibid.*
30. Riane Eisler, *The Chalice and the Blade.*

31. Barbara Walker, *The Crone.*
32. Lowinsky, "Mother of Mothers."
33. Garfield, *Woman's Bodies, Woman's Dreams.*
34. Carol Gilligan, *In a Different Voice.*
35. Irene Claremont de Castillejo, *Knowing Woman.*
36. Lowinsky, "Mother of Mothers."
37. Claremont de Castillejo, *Knowing Woman.*
38. Downing, *Journey Through Menopause.*
39. Z. Budapest, *The Grandmother of Time.*
40. Kathryn Rabuzzi, *Motherself.*
41. Susan Brownmiller, *Femininity.*
42. Simone de Beauvoir, *The Second Sex.*
43. Barbara MacDonald, "Outside the Sisterhood: Ageism in Women's Studies," in Alexander, *Women and Aging,* pp. 20–25.
44. Theodore Seifert, *Snow White: Life Almost Lost.*
45. Ann Mankowitz, *Change of Life.*
46. Claremont de Castillejo, *Knowing Woman.*
47. Margot Tallmer, "Empty-Nest Syndrome: Possibility or Despair," in Bernay and Cantor, *Psychology of Today's Woman,* pp. 231–52.
48. Emily Martin, *The Woman in the Body.*
49. Mankowitz, *Change of Life.*
50. Harding, *The Way of All Women.*

Chapter 10

1. Mari Jo and Paul Buhle (eds.), *The Concise History of Woman Suffrage,* p. 142.
2. Nancy Cott, *The Grounding of Modern Feminism,* p. 37.
3. Carolyn Heilbrun, *Writing a Woman's Life.*
4. Personal Narratives Group, *Interpreting Women's Lives.*
5. Elaine Showalter, *These Modern Women.*
6. Frank Kermode, *The Sense of an Ending.*
7. *Ibid.*
8. Heilbrun, *Writing a Woman's Life.*
9. Adrienne Rich, "Toward a Woman-Centered University," in *On Lies, Secrets, and Silence,* p. 139.
10. Catherine Keller, *From a Broken Web.*
11. Ramona Mercer et al., *Transitions in a Woman's Life,* p. 157.
12. Terri Apter, *Altered Loves.*

13. Virginia Woolf, "A Sketch of the Past," in Susan Kahill (ed.), *Mothers: Memories, Dreams, and Reflections by Literary Daughters*, pp. 303–31.
14. Theodore Seifert, *Snow White: Life Almost Lost*, p. 112.
15. Karen Payne (ed.), *Between Ourselves*, p. 15.
16. Malkah Notman, "Midlife Concerns of Woman," in Carol Nadelson and Malkah Notman (eds.), *The Woman Patient*, pp. 135–44.

BIBLIOGRAPHY

Afanasiev, Alexander, "Baba Yaga," in *The Magic Ring* (Moscow: Raduga Publishers, 1978).

Afek, Dina, "Sarah and the Women's Movement: The Experience of Infertility," in Jane Knowles and Ellen Cole (eds.), *Woman Defined Motherhood* (New York: Harrington Park Press, 1990).

Agosin, Marjorie, "Mirror of Strength: Portrait of Two Chilean Arpilleristas," in Jo Alexander, Debi Berrau, Lisa Domitrovich, Margarita Donnelly, and Cheryl McLean (eds.), *Women and Aging* (Corvallis, Oregon: Calyx Books, 1986).

Aiken, Susan Hardy, "Writing (in) Exile: Isak Dinesen and the Poetics of Displacement," in Mary Lynn Broe and Angela In-

gram (eds.), *Women's Writing in Exile* (Chapel Hill: University of North Carolina Press, 1989).

Allen, Paula Gunn, "Grandmother of the Sun," in Judith Plaskow and Carol Christ (eds.), *Weaving the Visions* (San Francisco: Harper and Row, 1989).

Andersen, Hans Christian, *Fairy Tales* (New York: Weathervane Books, 1932).

Apter, Terri, *Altered Loves* (New York: St. Martin's Press, 1990).

Arcana, Judith, "Our Mothers' Daughters," in Karen Payne (ed.), *Between Ourselves* (Boston: Houghton Mifflin, 1983).

Bank, Mirra, *Anonymous Was a Woman* (New York: St. Martin's Press, 1979).

Banta, Martha, *Imaging American Women* (New York: Columbia University Press, 1987).

Bateson, Mary Catherine, *Composing a Life* (New York: Atlantic Monthly Press, 1989).

de Beauvoir, Simone, *The Second Sex* (New York: Vintage Books, 1952).

Belenky, Mary; Clinchy, Blythe; Goldberger, Nancy; Tarule, Jill; *Women's Ways of Knowing* (New York: Basic Books, 1986).

Blume, E. Sue, *Secret Survivors* (New York: John Wiley Sons, 1990).

Bolen, Jean Shinoda, *The Goddesses in Every Woman* (New York: Harper and Row, 1984).

Brown, C. Mackenzie, "Kali, the Mad Mother," in Carl Olson (ed.), *The Book of the Goddess* (New York: Crossroad, 1988).

Brownmiller, Susan, *Femininity* (New York: Fawcett Columbine, 1984).

Budapest, Z., *The Grandmother of Time* (San Francisco: Harper and Row, 1989).

Buhle, Mari Jo, and Buhle, Paul (eds.), *The Concise History of Woman Suffrage* (Urbana: University of Illinois Press, 1978).

Campbell, Jeremy, *Winston Churchill's Afternoon Nap* (New York: Simon and Schuster, 1986).

Chesler, Phyllis, *Women and Madness* (San Diego: Harcourt Brace Jovanovich, 1972).

Christ, Carol, "Rethinking Theology and Nature," in Judith Plaskow and Carol Christ (eds.), *Weaving the Visions* (San Francisco: Harper and Row, 1989).

Claremont de Castillejo, Irene, *Knowing Woman* (New York: Harper and Row, 1973).

Conway, Patricia, and Valentine, Deborah, "Reproductive Losses

and Grieving," in Deborah Valentine (ed.), *Infertility and Adoptions* (New York: The Haworth Press, 1988).

Cott, Nancy, *The Grounding of Modern Feminism* (New Haven, Connecticut: Yale University Press, 1987).

Crosby, Faye, *Juggling* (New York: The Free Press, 1991).

Dally, Ann, *Inventing Motherhood* (New York: Schocken Books, 1983).

Deickmann, Hans, *Twice Told Tales* (Wilmette, Illinois: Chiron Publications, 1986).

Downing, Christine, *Journey Through Menopause* (New York: Crossroad, 1987).

Dunne, John, *Time and Myth* (Notre Dame: University of Notre Dame Press, 1973).

Dworkin, Andrea, *Right Wing Women* (New York: Perigee Books, 1978).

———, *Woman Hating* (New York: E. P. Dutton, 1974).

Ehrenreich, Barbara, and English, Deirdre, *For Her Own Good* (New York: Anchor Books, 1978).

Eisler, Riane, *The Chalice and the Blade* (San Francisco: Harper and Row, 1987).

Erikson, Erik, *Identity and the Life Cycle* (New York: International Universities Press, 1959).

Evans, Sara, *Born for Liberty* (New York: The Free Press, 1989).

Faludi, Susan, *Backlash* (New York: Crown, 1991).

Firman, Julie and Dorothy, *Daughters and Mothers* (New York: Continuum Publishing, 1989).

Friday, Nancy, *My Mother/Myself* (New York: Dell Books, 1977).

Friedan, Betty, *Second Stage* (New York: Summit Books, 1981).

———, *The Feminine Mytique* (New York: Summit Books, 1963).

Garfield, Patricia, *Woman's Bodies, Woman's Dreams* (New York: Ballantine Books, 1988).

Gilligan, Carol, *In a Different Voice* (Cambridge, Massachusetts: Harvard University Press, 1982).

Gilligan, Carol; Rogers, Annie; and Brown, Lyn Mikel; "Epilogue," in Carol Gilligan, Nona Lyons, and Trudy Hanmer (eds.), *Making Connections* (Cambridge, Massachusetts: Harvard University Press, 1990).

Gilligan, Carol; Ward, Janie Victoria; and Taylor, Jill McLean (eds.); *Mapping the Moral Domain* (Cambridge, Massachusetts: Harvard University Press, 1988).

Gimbutas, Marija, *The Goddesses and Gods of Old Europe* (Berkeley: University of California Press, 1982).

Gimenez, Martha, "Feminism, Pro-natalism and Motherhood," in Joyce Treblicot (ed.), *Mothering* (Totowa, New Jersey: Rowman and Allenheld, 1983).

Ginsberg, Faye, "Dissonance and Harmony," in Personal Narratives Group, *Interpreting Women's Lives* (Bloomington: University of Indiana Press, 1989).

Goldenberg, Naomi, *Changing of the Gods* (Boston: Beacon Press, 1979).

Hall, Nor, *The Moon and the Virgin* (New York: Harper and Row, 1980).

Halloway, Karla, and Demetrakopoulos, Stephanie, "Remembering Our Foremothers: Older Black Women, Politics of Age, Politics of Survival as Embodied in the Novels of Toni Morrison," in Marilyn Bell (ed.), *Women as Elders* (New York: Harrington Park Press, 1986).

Hancock, Emily, *The Girl Within* (New York: E. P. Dutton, 1989).

"Hansel and Gretel," *Complete Grimm's Fairytales* (New York: Pantheon Books, 1944).

Harding, Esther, *The Way of All Women* (New York: Harper and Row, 1970).

———, *Woman's Mysteries* (New York: Harper and Row, 1971).

Harris, Maxine, *Sisters of the Shadow* (Norman: University of Oklahoma Press, 1991).

Healey, Shevy, "Growing to Be an Old Woman: Aging and Ageism," in Jo Alexander, Debi Berrow, Lisa Domitrovich, Margarita Donnelly, and Cheryl McLean (eds.), *Women and Aging* (Corvallis, Oregon: Calyx Books, 1986).

Heilbrun, Carolyn, *Writing a Woman's Life* (New York: Ballantine Books, 1988).

Herman, Judith, *Trauma and Recovery* (New York: Basic Books, 1992).

Herman, Judith L., and Lewis, Helen B., "Anger in the Mother-Daughter Relationship," in Toni Bernay and Dorothy Cantor (eds.), *The Psychology of Today's Woman* (Hillsdale, New Jersey: The Analytic Press, 1986).

Hertzberg, Joan, "Feminist Psychotherapy and Diversity: Treatment Considerations from a Self Psychology Perspective," in *Women and Therapy*, 9 (1990): 275–97.

Hillman, James, *Anima* (Dallas: Spring Publications, 1985).

——— (ed.), *Facing the Gods* (Dallas: Spring Publications, 1980).

Ibsen, Henrik, *A Doll's House* (New York: Every Man's, 1958).

Jack, Dana, and Jack, Rand, "Women Lawyers: Archetypes and

Alternatives," in Carol Gilligan, Janie Victoria Ward, and Jill McLean Taylor (eds.), *Mapping the Moral Domain* (Cambridge, Massachusetts: Harvard University Press, 1988).

Johnson, Miriam, *Strong Mothers, Weak Wives* (Berkeley: University of California Press, 1988).

Josselson, Ruth Ellen, *Finding Herself* (San Francisco: Jossey-Bass, 1987).

Jung, Carl G., "The Psychology of the Child Archetype," in *Essays on a Science of Mythology* (Princeton, New Jersey: Princeton University Press, 1979).

Kahill, Susan (ed.), *Mothers: Memories, Dreams, and Reflections by Literary Daughters* (New York: New American Library, 1988).

Karlsen, Carol, *The Devil in the Shape of a Woman* (New York: Vintage Books, 1987).

Keen, Sam, *Fire in the Belly* (New York: Bantam Books, 1991).

Keller, Catherine, *From a Broken Web* (Boston: Beacon Press, 1986).

Kelly, George, *A Theory of Personality* (New York: W. W. Norton and Company, 1963).

Kerenyi, Karl, *Athene* (Dallas: Spring Publications, 1978).

Kermode, Frank, *The Sense of an Ending* (London: Oxford University Press, 1966).

Kirksey, Barbara, "Hestia: A Background of Psychological Focusing," in James Hillman (ed.), *Facing the Gods* (Dallas: Spring Publications, 1980).

Kolbenschlag, Madonna, *Kiss Sleeping Beauty Goodbye* (San Francisco: Harper and Row, 1979).

Lakoff, Robin, *Language and a Woman's Place* (New York: Harper and Row, 1975).

Le Seuer, Meridel, "Remarks from 1983 Poetry Reading," in Jo Alexander, Debi Berrow, Lisa Domitrovich, Margarita Donnelly, and Cheryl McLean (eds.), *Women and Aging* (Corvallis, Oregon: Calyx Books, 1986).

Lieberman, Marcia, " 'Some Day My Prince Will Come,': Female Acculturation Through the Fairytales," in Jack Zipes (ed.), *Don't Bet on the Prince* (New York: Routledge, 1989).

Lowinsky, Naomi, "Mother of Mothers: The Power of the Grandmother in the Female Psyche," in Connie Zweig (ed.), *To Be a Woman* (Los Angeles: Jeremy Tarcher, 1990).

MacDonald, Barbara, "Outside the Sisterhood: Ageism in Women's Studies," in Jo Alexander, Debi Berrow, Lisa Domi-

trovich, Margarita Donnelly, and Cheryl McLean (eds.), *Women and Aging* (Corvallis, Oregon: Calyx Books, 1986).

Maio, Kathi, *Feminist in the Dark* (Freedom, California: The Crossing Press, 1988).

Mankowitz, Ann, *Change of Life* (Toronto: Inner City Books, 1984).

Martin, Emily, *The Woman in the Body* (Boston: Beacon Press, 1987).

Mayer, Marianna (retold by), *Beauty and the Beast* (New York: Four Winds Press, 1978).

Mercer, Ramona; Nichols, Elizabeth; Doyle, Glen Caspers; *Transitions in a Woman's Life* (New York: Springer Publications, 1989).

Miller, Jean Baker, *Toward a New Psychology of Women* (Boston: Beacon Press, 1976).

———, "Women and Power," Work in Progress (Wellesley, Massachusetts: The Stone Center, n.d.).

Minnard, Rosemary, *Womenfolk and Fairytales* (Boston: Houghton Mifflin Co., 1976).

Moon, Sheila, *Changing Woman and Her Sisters* (San Francisco: Guild for Psychological Studies, 1984).

———, *Dreams of a Woman* (Boston: Sigo Press, 1983).

Neumann, Erich, *Amor and Psyche* (Princeton, New Jersey: Princeton University Press, 1956).

———, *The Great Mother* (Princeton: Princeton University Press, 1955).

Newmark, Maxim, *Dictionary of Foreign Words and Phrases* (New York: Philosophical Library, 1950).

Notman, Malkah, "Midlife Concerns of Woman," in Carol Nadelson and Malkah Notman (eds.), *The Woman Patient*, Vol. 2 (New York: Plenum, 1982).

Payne, Karen (ed.), *Between Ourselves* (Boston: Houghton Mifflin Company, 1983).

Pearson, Carol, and Pope, Catherine, *The Female Hero in American and British Literature* (New York: R. R. Bowker Co., 1981).

Person, Ethel, "Working Mothers: Impact on the Self, the Couple and the Children," in Toni Bernay and Dorothy Cantor (eds.), *Psychology of Today's Woman* (Hillsdale, New Jersey: The Analytic Press, 1986).

Personal Narratives Group, *Interpreting Women's Lives* (Bloomington: University of Indiana Press, 1989).

Pfeffer, Naomi, and Wollett, Anne, *The Experience of Infertility* (London: Virago Press, 1982).

Phelps, Ethel Johnston, *The Maid of the North* (New York: Holt, Rinehart, 1981).

Plaskow, Judith, and Christ, Carol (eds.), *Weaving the Visions* (San Francisco: Harper and Row, 1989).

Pomeroy, Sarah, *Goddesses, Whores, Wives and Slaves* (New York: Schocken Books, 1975).

Powers, Marla, *Oglala Women* (Chicago: University of Chicago Press, 1986).

Rabuzzi, Kathryn, *Motherself* (Bloomington: University of Indiana Press, 1988).

Randall, Margaret, "From the Journals," in Jo Alexander, Debi Berrow, Lisa Domitrovich, Margarita Donnelly, and Cheryl McLean (eds.), *Women and Aging* (Corvallis, Oregon: Calyx Books, 1986).

Rich, Adrienne, "Anne Sexton," "Vesuvius at Home," and "Toward a Woman-Centered University," in *On Lies, Secrets, and Silence* (New York: W. W. Norton, 1979).

Rieu, E. V. (trans.), *The Odyssey of Homer* (Middlesex, England: Penguin Books, 1946).

Ruddick, Sara, *Maternal Thinking* (New York: Ballantine Books, 1989).

————, "Maternal Thinking," in Joyce Treblicot (ed.), *Mothering* (Totowa, New Jersey: Rowman and Allenheld, 1983).

Russell, Diane, *The Secret Trauma* (New York: John Wiley Sons, 1990).

Scharf, Anna Wilson, *Women's Reality* (San Francisco: Harper and Row, 1981).

Scheler, Max, *Ressentiment* (New York: The Free Press, 1961).

Schussler-Fionenza, Elizabeth, "In Search of Women's Heritage," in Judith Plaskow and Carol Christ (eds.), *Weaving the Visions* (San Francisco: Harper and Row, 1989).

Seifert, Theodore, *Snow White: Life Almost Lost* (Wilmette, Illinois: Chiron Publications, 1986).

Shakespeare, William, *Macbeth* (New York: Simon and Schuster, 1959).

Showalter, Elaine, *These Modern Women* (New York: The Feminist Press, 1979).

Shuttle, Penelope, and Redgrove, Peter, *Wise Wound* (New York: Grove Press, 1978).

Siegal, Rachel, "Love and Work After Sixty," in Evelyn Rosenthal (ed.), *Woman, Aging, and Ageism* (New York: Harrington Park Press, 1990).

Sjoo, Monica, and Mor, Barbara, *The Great Cosmic Mother* (San Francisco: Harper and Row, 1987).

Smith-Rosenberg, Carroll, *Disorderly Conduct* (New York: Oxford University Press, 1985).

Spretnak, Charlene, *Lost Goddesses of Ancient Greece* (Boston: Beacon Press, 1978).

Stevenson, Sarah, *Physiology of Woman* (Chicago: Fairbanks, Palmer and Co., 1882).

Swallow, Jean, "Both Feet in Life: Interviews with Barbara Mac-Donald and Cynthia Rich," in Jo Alexander, Debi Berrow, Lisa Domitrovich, Margarita Donnelly, and Cheryl McLean (eds.), *Women and Aging* (Corvallis, Oregon: Calyx Books, 1986).

Tallmer, Margot, "Empty-Nest Syndrome: Possibility or Despair," in Toni Bernay and Dorothy Cantor (eds.), *Psychology of Today's Woman* (Hillsdale, New Jersey: The Analytic Press, 1986).

Treblicot, Joyce (ed.), *Mothering* (Totowa, New Jersey: Rowman & Allanheld, 1983).

Ulanov, Ann, and Ulanov, Barry, *Cinderella and Her Sisters* (Philadelphia: The Westminster Press, 1983).

———, *The Witch and the Clown* (Wilmette, Illinois: Chiron Publications, 1978).

Ulrich, Laurel, *Good Wives* (New York: Vintage Books, 1980).

Walker, Barbara, *The Skeptical Feminist* (San Francisco: Harper and Row, 1987).

———, *The Crone* (San Francisco: Harper and Row, 1985).

———, *Women's Encyclopedia of Myths and Secrets* (San Francisco: Harper and Row, 1983).

Warner, Marina, *Monuments and Maidens* (New York: Atheneum, 1985).

———, *Joan of Arc* (New York: Knopf, 1981).

———, *Alone of All Her Sex* (New York: Vintage Books, 1976).

Welter, Barbara, "The Cult of True Womanhood, 1820–1860," *American Quarterly*, 18 (1966):151–74.

Woodman, Marion, *The Pregnant Virgin* (Toronto: Inner City Books, 1985).

Woolf, Virginia, "A Sketch of the Past" in Susan Kahill (ed.), *Mothers: Memories, Dreams, and Reflections by Literary Daughters* (New York: New American Library, 1988).

Yolen, Jane, *Favorite Tales from Around the World* (New York: Pantheon Books, 1986).

Young-Eisendrath, Polly, "Rethinking Feminism, the Animus, the Feminine," in Connie Zweig (ed.), *To Be a Woman* (Los Angeles: Jeremy Tarcher, 1990).

Zolla, Elemire, "Archetypes," *The American Scholar,* 48 (1979):191–207.

ABOUT THE AUTHOR

MAXINE HARRIS is a clinical psychologist with a private practice in psychotherapy, and the cofounder and codirector of Community Connections, a nonprofit community-based mental health agency in Washington, D.C. Author of *Sisters of the Shadow* and co-author of the forthcoming *Women of the Asylum* (Anchor Books), she lives in Chevy Chase, Maryland.